WHERE AND HOW TO PHOTOGRAPH WILDLIFE

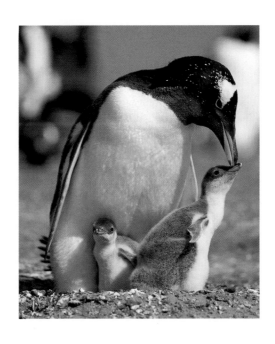

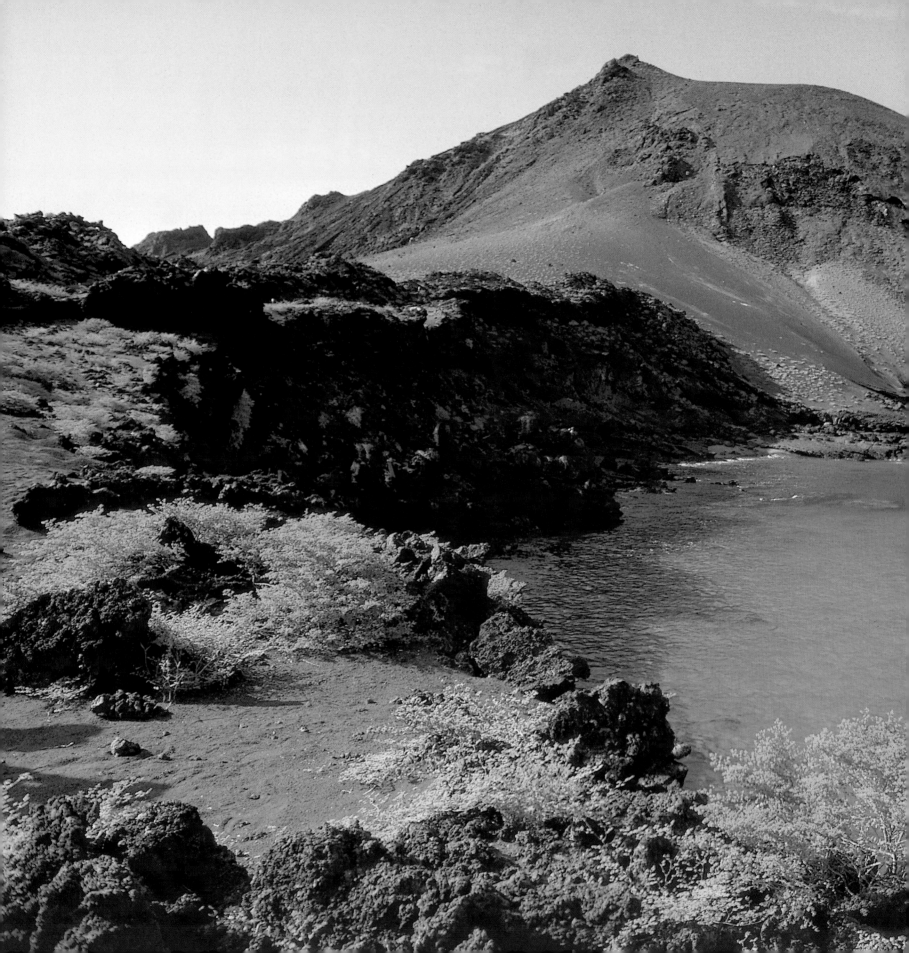

WHERE AND HOW TO PHOTOGRAPH WILDLIFE

PETER EVANS

GUILD OF MASTER CRAFTSMAN PUBLICATIONS LTD

To all who have shared the good and the bad with me, especially John Knight,

Ken Smith, Denis and Margaret Summers-Smith, and Joy Ryan. But most of all to my wife, Valerie,

who has frozen in Iceland, starved on the Danube, broiled in the Kalahari, been poisoned

in India and generally enjoyed the doubtful benefits of being a wildlife photographer's partner.

First published 2002 by
Guild of Master Craftsman Publications Ltd,
166 High Street, Lewes, East Sussex, BN7 1XU

Copyright in the work © Guild of Master Craftsman Publications Ltd
Text and photographs copyright © Peter Evans
Author photograph by J. E. Knight

ISBN 1 86108 224 X
A catalogue record of this book is available from the British Library

Designed by Joyce Chester
Cover design by Fineline Studios
Typeface: Baskerville and Formata

Colour origination by Viscan Graphics (Singapore)
Printed and bound by Kyodo Printing (Singapore)

Contents

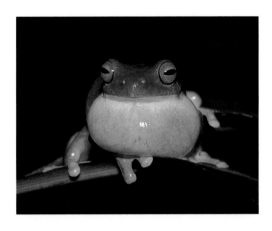

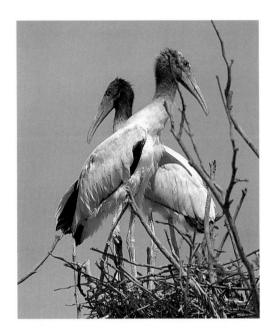

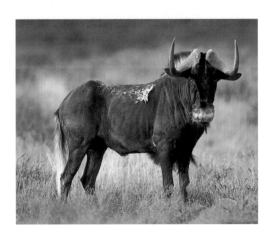

Foreword

During the last 20 years or so, many of us have been captivated by the wonderful wildlife and breathtaking locations that have graced our television screens courtesy of the world's natural history film units. Having had our appetites whetted, many travellers, like myself, acquired the urge to see the world and its wildlife at first hand. In recent years such journeys have been made easier as worldwide travel has become both more affordable and more accessible than ever before.

During the same period, as our daily lives have become more and more visually orientated, interest in photography has flourished. The travel industry reacted rapidly to the general public's sudden interest in the world's wildlife and, to a lesser degree, to its interest in photography. Many popular nature magazines now boast page after page of travel company advertisements, offering tours to see everything from polar bears to penguins.

This book offers sound advice on where, when and how to organize visits to many of the top wildlife destinations of the world, as well as providing useful tips on camera equipment and photographic techniques. This advice will be equally beneficial should your journeys of discovery be with ready-made group tours, or as an independent traveller.

Whether your interests centre on the big game animals of East Africa, the unique animals of the Galapagos Islands, the forest creatures of South America, the birds of Florida or the Falkland Islands, the bizarre wildlife of Australia or other prime wildlife locations, this book caters for them all. You hold in your hands an invaluable companion should you wish to discover the abundant riches of the natural world.

Martin B. Withers FRPS
Chairman, Nature Group, Royal Photographic Society

Introduction

This book describes how to photograph wildlife and the best places outside Europe to take top-class pictures. It is concerned with wild life; not flowers or trees, just creatures that move. It concentrates on the wildlife that most travellers want to photograph – the mammals and birds – with a bit about the frogs, lizards, snakes, crocodilians and insects. It describes the equipment to use, how to organize your trip (or to let someone do it for you) and where to go for the best results. It is aimed at the many travellers who would like to take wildlife pictures, but believe it to be too difficult, and the ones who have been content to build up lists of what they have seen, but are now ready for something more. The fact is that although wildlife photography used to be difficult, it is now pretty easy, provided you go to the right places with modern equipment.

The advantage of going abroad arises from the relatively small number of species that can be found in Europe and the generally more helpful conditions in warmer parts of the world. The light in these places is better and the wildlife more varied, bigger, brighter and generally more approachable. However, you must know where to go for the best opportunities. Wildlife photography is quite distinct from birdwatching and the best pictures will not come from a trip designed to see the maximum number of species. If photography is your aim, you can drive straight past those nondescript specimens that are used to build up a big species list. You don't want to spend time on birds or animals that are in thick bush or are far away. Anything that you cannot see clearly is unlikely to make a satisfactory subject for your lens and you have no need to hunt it out. Photography demands time and you should use it where your prospects are good, not waste it on forlorn hopes.

When you return home with some really superb images, as you will, you will be much more satisfied than you could ever be with a list, however many rarities it may contain. Your pictures will last a lifetime, whereas memories are unreliable and fade all too quickly. When you want to give a talk about your travels, the slides will provide all the cues you need, and give pleasure to the audience.

Although I specify the places that I believe offer the best prospects, there are other possibilities and everyone has their favourites. The ones I describe in this book are simply those I have found to be the best in my last 30 years of photographing wildlife.

Peter Evans

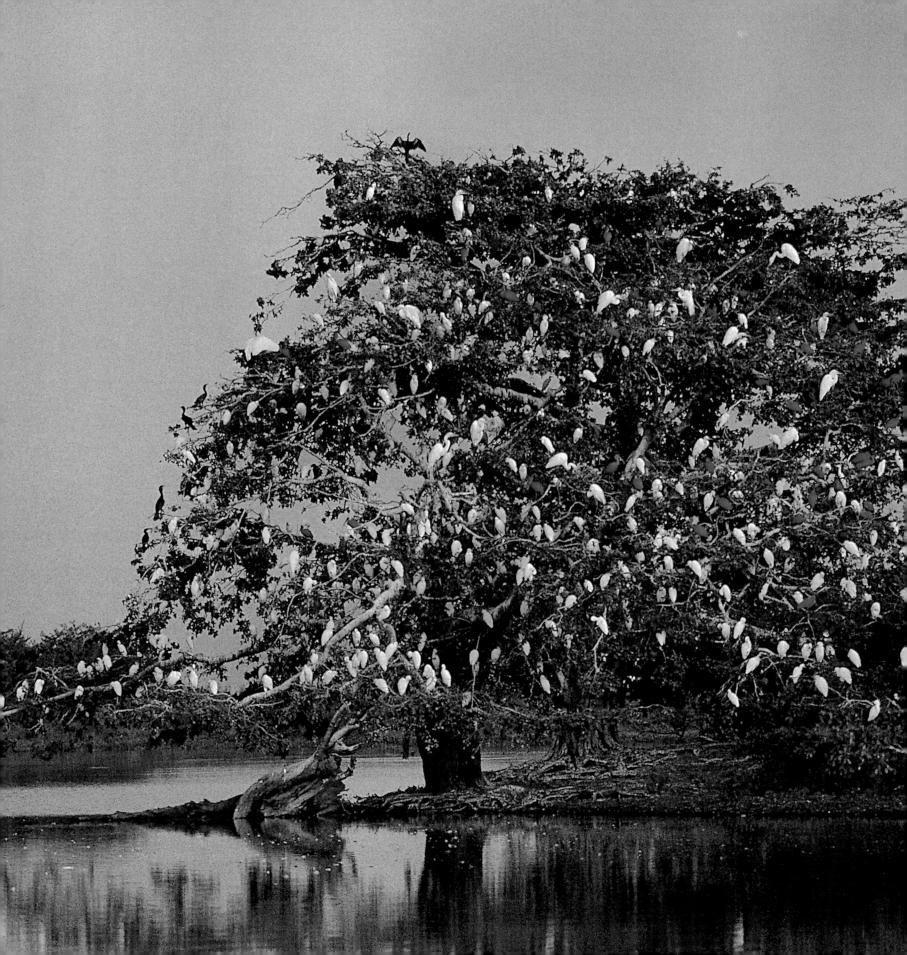

WHAT TO CONSIDER

Planning the trip

Once you arrive at your destination, your main choices have already been made. The secret of a good trip is in the preparation that has gone into it before you leave home. Whether you do your own planning or delegate it to someone else, this principle still holds.

ORGANIZED TOURS

A common approach is to join one of the many trips now offered by wildlife tourism firms. These advertise in birding and similar journals. You simply choose your destination and the organization to travel with. Most of these tours are designed for birdwatchers and although they are tolerant of photographers, their priorities do lie elsewhere. A small number of companies run tours specifically for wildlife photographers. These are much preferable, but at present only cover the most popular countries. Once you have picked your tour, they will do the hard work for you, sorting flights and other transport, set an itinerary based on extensive experience, and provide guides. You will almost certainly enjoy the sociability of such a trip, get plenty of decent pictures and return highly satisfied.

When you have a few trips under your belt, however, you may hanker for something more. The reason is that, even with a party ostensibly sharing the same aims, there will actually be significant differences in approach and equipment. Inevitably you will be working from a vehicle which cannot always offer you the optimum viewpoint at the time you want it, because others want it too. Some people will have longer lenses than others and will be content to operate further from the subject; others will need to work closer, making the image too big in the frame for the first group (assuming the subject will accept the closer approach). Vehicle hire is expensive, so commercial operators tend to allow insufficient space for comfortable working, especially as photographers need more room than birdwatchers. Nonetheless, if this is your first trip to a country, or there are language barriers or difficulties with the formalities, travelling with a tour group will probably be the best option. However, if you aim to get the very best pictures, you must be prepared to put in much more work, both before and during the trip, and organize a do-it-yourself tour.

PLANNING YOUR OWN TRIP

Start by settling where you are going and who is coming with you. There are dozens of books detailing the reserves and other good places in almost any country you fancy. If you really don't know where to start, get brochures from the wildlife tour companies and join a tour. That will give you a look at the country and you can plan your own trip another year, using just the best bases for photography. Once you have chosen your destination in broad terms, check the best time to go and the most promising areas of the country.

The later chapters will cover most of this. Do not move around too much, as you need time to find the best opportunities and exploit them. Each move will cost the best part of a day's photography.

Flights

Next, check the choice and cost of flights. Any travel agent will do this, though some are better than others. A phone call to one or two who advertise in the newspapers and on television will give you a start. Using the Internet is fine in theory, but the telephone is better in practice. Using the Internet to find flights is a surprisingly clumsy affair. Even using the sites of the same companies that you would phone, the flights you want tend to be shown as not available, nor can you readily get flight timings and other details. Telephone staff can quickly give alternative flights and prices, timings, and most other details. Internal flights in overseas countries are generally not available on the Internet, but can easily be arranged by phone.

Accommodation

It is best to book in advance, because it avoids wasting precious time in the field and guarantees a bed at the end of the day. If you aim to use the pick of the places, such as the huts in the South African national parks, you will need to book early. Try to avoid peak holiday times, which usually means the school holidays, in the country you are visiting. The actual

booking can be done by post, fax, telephone or email, but if you have the fax number, this is the best way. There are many parts of the world in which the person at the other end of the phone does not speak English. Consequently, there can easily be differences between what you think has been agreed and what has actually been booked. A fax gives time for both parties to get translations into their own language and provides a hard copy, which can be produced in the event of disagreements. Letters do the same, but post can take a long time. Remote lodges do not have mail deliveries, so post will be dealt with, if at all, by some remote office. Emails tend to be ignored. Most places will require a deposit before they reserve your accommodation, but a credit card number will usually suffice.

Car hire

The major car hire companies cover most of the world and will be delighted to take a booking, direct or via whatever agency you are using. It is usually cheaper to book from your home country rather than when you arrive. In a large country, you can save time and energy by flying the big hops, though it costs more than driving. Do not be mean about the size of your hire car if you are intending to photograph from it. A camera with a big lens needs as much space as a person and you need room for ready access to the rest of the gear. Occasionally there will be a package deal that can be utilized for part of the trip and there are cheap charter flights to popular holiday destinations, such as Florida and The Gambia. If you want to go somewhere remote, where camping is the only way, consider using the services of one of the local companies. You need a big enough party to make it economic to take a vehicle; eight would be about right for a truck, but the more of you there are, the cheaper it becomes. You then provide the itinerary and the company provides the driver, vehicle and camping gear. It is well worth paying for a cook, too, because safari cooks are far more expert at providing good meals under restrictive conditions than any member of the party is likely to be. It also avoids having to spend time preparing food when you really just want to be fed and roll into bed. Whatever the trip, recognize that it will not always run smoothly, due to weather or other reasons, so allow some latitude. A do-it-yourself trip should be cheaper than a commercial one: you are not paying for staff time and profit. However, it does mean putting in much more effort and managing without the comforting presence of a tour leader.

BAGGAGE

However you travel, there is no escaping the problem of baggage. Clothes are the least of your problems in warm climates. Lightweight gear is easily washed and dried and many companies offer clothing specially designed for this purpose. You need to protect yourself against thorny trees and fierce sunshine, so long trousers and long sleeves make sense. Even in the Tropics, you may need some warm clothing. A night or early morning drive in an open vehicle can be freezing.

Your suitcase will take up a significant part of your luggage allowance, so take the smallest that will accommodate all the things you really need. It should be big enough to take your tripod and its head (packed separately), a pair of shoes and any other rigid articles. Clothing can then go in as packing. I like to line the case bottom and sides with clothes, put in the hard stuff, then fill in the rest with the soft things. You may have to move your case a considerable distance, so make sure it has wheels and a handle. Electrical equipment is forbidden in the hold, so put it in your hand baggage. Many countries, among them Australia, have rigid rules against the importation of foodstuffs, including food from the plane. Don't imagine you will get away with it, because sniffer dogs survey all the baggage. Duty-free drink is hardly worth the bother – it will often be cheaper where you are going. Many Muslim countries forbid importing alcohol.

You shouldn't have much difficulty in meeting the 44lb (20kg) limit for hold baggage and airlines will not usually fuss about a little extra, especially if you check in early. Hand baggage is trickier, as the airlines differ hugely in what they will tolerate. This may be printed on the ticket or can be checked with your travel agent; there will probably be both weight and dimension limits. I use a small LowePro bag, which meets the size requirement but, when full, is still heavier than the maximum weight allowed, which can be as low as 11lb (5kg). Bigger bags may be rejected and will have to go in the hold and be X-rayed accordingly. You can eke out the allowance by carrying a substantial 'handbag' – in my case a waist bag – to hold tickets and valuables, plus a small camera body and other useful bits and pieces. The film can go in your jacket (see p 10). These problems disappear if you can afford to travel Business Class, which brings a larger luggage allowance and greater tolerance of cabin baggage.

Staying fit

EFFECTS OF TRAVEL

Travel in crowded conditions provides an increased risk of illness, usually minor. Air travel may encourage thrombosis, so take off your shoes, move around when you can and twiddle your toes when you can't. Some people suffer badly from jet lag after a long journey. Various aromatherapy oils are marketed as a means of combatting jet lag, and there are several prescription drugs believed to reduce its effects; your GP may have something to offer. Generally, a good night's sleep, followed by a keen search for pictures, will leave you restored. I have been less affected with advancing years, so that may be something for you to look forward to.

DISEASES

Although the Tropics harbour all sorts of dread diseases and risks from snakes and other creatures, by far the greatest hazards are the ones you also meet at home – car accidents and falls. Of course, it is sensible to take precautions against the usual diseases and your GP can advise on that. Malaria is more of a problem and there is no complete answer. Your GP can advise what to take in relation to the countries you will be visiting, but minimizing the number of mosquito bites you receive is also important. Keep covered in the evening and early morning and use repellent generously.

Avoid overdosing on sun, apply plenty of sun cream and wear a hat, especially if you are a bit thin on top. Avoid dehydration by drinking plenty of non-alcoholic liquid and don't overestimate the amount of exertion that you can undertake. When you feel you've had enough, be ruthless about calling it a day, otherwise you can be out of action for a long time.

Take your preferred antiseptic for treating cuts and scratches and don't hesitate to use it. If you need regular medication, take one lot in your hand baggage and the rest in your hold baggage. After incurring a nasty infection in Senegal, which nearly did for me, I always carry a wide spectrum antibiotic. Your GP can give you a prescription, if he is convinced you need one.

FOOD

Stomach upsets are common in some parts of the world. Freshly cooked hot food is usually safe, even from doubtful premises, but cold food and salads can be risky. Where high standards of hygiene are enforced, certainly in most of south and east Africa, the United States and Australia there is unlikely to be a problem. Some water in east Africa contains rather a lot of magnesium salts. It won't poison you, but may give you the trots. Hotels may provide filtered water free of charge; failing that buy bottled water. Although expensive, this may prevent a ruined trip. Check that the seal is intact. Where the water is suspect, don't even use it for cleaning your teeth.

SPIDERS AND SNAKES

Your chance of being bitten by a snake is tiny, but don't push your luck, even with non-venomous ones, as they can give you an infected wound. Scorpions and spiders should be avoided – shake your shoes before you put them on. I once found a large toad in mine.

Hardware and technique

THE CAMERA

The choice of type is easy: only the modern 35mm reflex provides the quality and compactness that is needed. Larger format gear is too cumbersome and the compact camera, although fine for family snaps, is almost useless for wildlife. The advantage of advanced photo system (APS) cameras is that they are slightly easier to put the film in, but for wildlife photography, the quality of film they use and their smaller image size combine to make it very difficult to obtain pictures of the standard required. Digital cameras are not yet capable of giving the very high definition required and they have other drawbacks, but their day is not far off.

There is a huge choice of 35mm reflex cameras and it is worth taking great care over your initial choice of make, because changing later is expensive. Most people go on to want better gear, so avoid makes which are too limited to allow this. Your choice then becomes a question of the depth of your purse.

It is sometimes said that equipment is unimportant, that it is the person behind the camera who is decisive. Of course, a skilled photographer will take good pictures even with poor gear, but he will take better ones with better equipment. Moreover, sophisticated cameras reduce the likelihood of error, and you will save yourself a great deal of bad temper, wasted effort and film by buying the best you can. If you can't afford top dollar, the second or

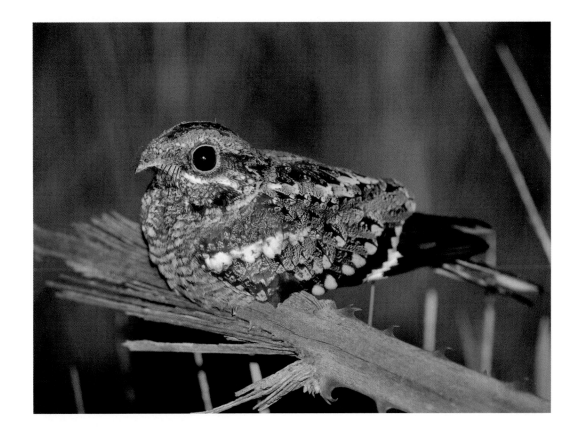

third models in the range of the top manufacturers' offerings are good value for money. Or you can buy second-hand.

With long lenses it is much easier to focus if you have an appropriate focusing screen. Some cameras have central split-screen sections designed for use with wide aperture, short focal length lenses. These are of no value with longer lenses and make focusing difficult because the central portion, where focusing normally takes place, is obscured. If such a screen is fitted as standard, check that it can be replaced

Square-tailed nightjar, Botswana
Nikon F5 with 300mm lens, Fuji Sensia 100, 1/250sec at f/5.6, SB24 flash gun

and failing that, choose another camera. Cameras are expensive, but are only a minor part of your total costs, so beware of false economy. If you get round to buying a second body to cover against loss or breakdown when you are abroad (though this is a rare event), it is best to get a repeat of your existing model. It is extraordinarily

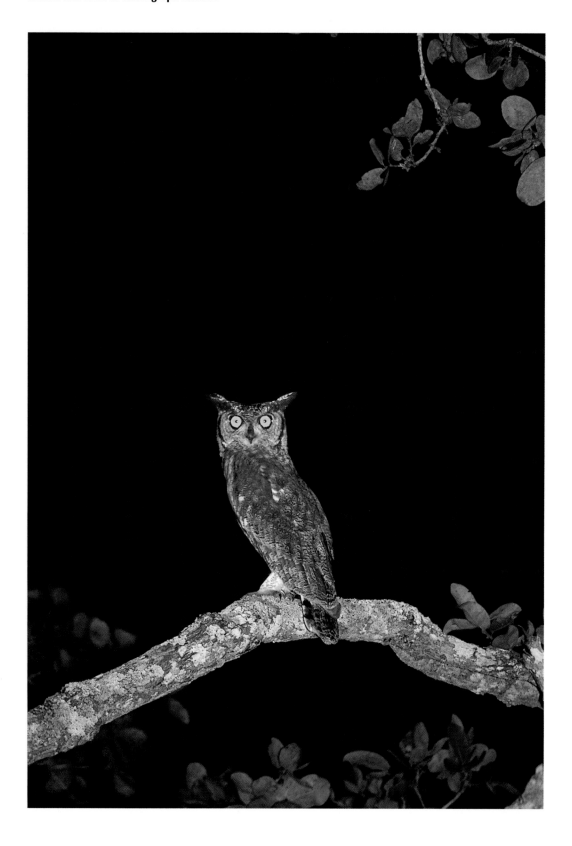

confusing to work with two different cameras: their major controls will be in different places and work in different fashions. Time is always at a premium with wildlife and you need to be able to drop your fingers on to the controls and operate them without having to check where the knobs and buttons are and which way they turn.

Automatic exposure systems come with the camera. They do vary a bit, but are always pretty good. When you get a new camera, shoot a roll of film on an assortment of subjects just to be sure; thereafter leave the camera to do its job. Only when you have a lot of experience will you think you might do better manually – and even then you will often be wrong.

Many modern cameras come with a choice of wind-on speeds. You can, and often will, shoot only one frame at a time, but you may want to shoot a burst of shots during a peak of activity and a camera that permits this is a bonus. Birds always, and mammals sometimes, think and react much more quickly than we do. Especially when your subjects are fighting or bathing, you can give yourself the best chance of hitting the crucial moment by shooting continuously, and the faster the better. This is expensive on film – at six frames a second a roll would last just six seconds – but you will usually only get a few exposures and these occasions are so rare it is vital to cash in on them.

Spotted eagle owl, Zimbabwe
Nikon F5 with 70–210mm lens, Fuji Sensia 100, 1/250sec at f/5.6, SB24 flash gun

LENSES

Most pictures of big mammals require a lens of between 135 and 300mm; herds need between 28 and 135mm. With a 28–70mm and a 75–300mm, you can cover the whole range. For birds and small mammals, you really need at least 400mm. If funds run to it and you can stand the weight, either a wide aperture 300mm with an extender, or a 500 or 600mm will be better still. A light alternative – and a possible choice for the less devoted photographer – is a mirror lens. A 500mm mirror will be cheap, light and compact, but it will have a modest aperture and need manual focusing. Sometimes it will also show out-of-focus highlights in a rather ugly way and this rules them out for most serious photographers. However, it is better to spend your money on a lens that you are actually going to take and use rather than one which is a beautiful example of optical craftmanship, but too cumbersome for you to bother carrying.

Short focal length lenses are useful for shots of habitats, hides and personnel. Often your short focus zoom will serve. In woodland, habitat shots will sometimes be better with a 24mm. The difficulty here is getting all the tree in the frame: as soon as you retreat, other trees get in the way. The shorter the focal length, the more you get in the picture at any given distance. A 24mm will encompass twice as much linearly as the standard 50mm. The drawback is that short focal length (wideangle) lenses distort the picture, unless used carefully. For frogs, lizards, and large insects you need a lens that can focus at short range. Some zooms will suffice at a pinch, but if you plan to do much with this sort of subject a macro lens of 90–105mm will be worthwhile.

It is possible to increase the focal length of a lens, and thus the size of the image, by adding an extender between the lens and the camera body. A 1.4× model will turn a 300mm lens into a 420mm and a 2× will make it a 600mm. The light entering the lens will be spread over a larger area, so more exposure will be required. The best extenders, which are matched to the lens, are very good, but cheaper ones may cost you some image quality. An f/2.8 300mm lens with a 2× extender provides an f/5.6 600mm which is lighter and more compact than a 600mm telephoto. When your baggage has to be reduced, an f/2.8 80–200mm zoom with a 2× converter makes a very serviceable combination. It is possible to use two extenders together at the expense of some image quality.

Many lenses now have automatic focusing (AF) and this is quicker and more accurate than manual focusing, provided you place one of the focusing spots in exactly the right place. Once you have focused, you can hold the focus if you want to re-frame the picture to improve the composition.

Camera bodies and lenses gather a great deal of dust in dry, tropical climates. It gets into everything and scrupulous cleaning every day is needed to keep camera-lens contacts free of dirt and lens surfaces clear. The camera interior needs brushing out at every film change, if time permits, but keep clear of the shutter blinds. There are two other hazards: sun cream and the DEET in your insect repellent. I prefer to apply sun block in the morning before setting out, wash my hands well, and leave it at that. Similarly, repellent must be removed from your hands before you touch anything, as it can destroy plastic.

TRIPODS

For work in the studio or adjacent to the car, the heavier the tripod the better, but for travel by air, you have to compromise. Pick a medium tripod that will fit into your suitcase or whatever else you use for baggage. Such a tripod may be made of light alloy, though I have had these smashed in my case. Carbon fibre is stronger, lighter and stiffer, but much more expensive. A separate tripod for the flash gun can be as small and light as you can find, providing it will extend to a sufficient height.

The tripod head is as important as the tripod itself. A medium ball-and-socket head, or a pan-and-tilt, will serve for lenses up to 300mm, but bigger lenses demand bigger heads, or it will be impossible to set them up accurately. The Manfrotto 3D head works well and is what I usually take abroad. With a really big lens I prefer to use a large ball-and-socket, but it is expensive and heavy.

Whatever you use, you will have to carry it over all sorts of terrain, sometimes in oppressive heat, so be realistic about your stamina. Working from a vehicle, a beanbag is the best support. It is extremely difficult to set up a tripod in a vehicle, except in the back of a utility, and even then it demands more space than you are likely to have. You can rest the lens on a window sill, but it is better to have a bigger, softer pad to sit it on as this gives greater steadiness. A beanbag can be taken empty and filled with dried peas, lentils or rice at your destination. Sometimes you have to work without a tripod or a beanbag. In a rocking boat, you must hold the camera yourself, and this is usually the best way for flight shots. There may also

be times when the extra physical demand of carrying a tripod is going to prevent you from reaching the subject – I find these times get more frequent as I get older. I have known some photographers who are able to hand hold a 500mm briefly, but in these circumstances I settle for an f/4 300mm or an f/2.8 80–200mm with a converter.

FLASH

A flash is an indispensable part of the equipment, in daylight as well as in the dark. A powerful gun is an advantage, especially at night, as it permits working at a greater distance. The flash gun should be dedicated to the camera because this greatly simplifies its use. The camera will decide how much flash it needs and you don't have to bother with complicated calculations. You can use the flash fitting on the camera, set the exposure to Programme or Aperture Priority, and shoot. At night, provided your equipment permits, it is better to set the shutter to Manual at the highest speed at which it will synchronize (usually 1/125 or 1/250sec) with the flash on its through-the-lens metering (TTL) setting. This gives the same result as the first method, but with less camera shake and less local overexposure, if your guide shines a spotlight on the subject.

Better modelling may be obtained with the flash off the camera and there are brackets to enable this. Alternatively, you can hold the camera in one hand and the flash, connected by a dedicated cord, in the other. Better still, get someone to hold it for you.

There is a special technique that can be used for photographing birds at night.

They commonly sit on the roadside where they can be picked up in your headlights. Stop the vehicle about 20yds (20m) away and have someone hold the subject in a spotlight. Get down from the vehicle and walk quietly towards the bird, taking care to keep out of the spotlight beam. You can then photograph from a convenient distance – sometimes you can get very close. This works with owls, nightjars, coursers and dikkops, though not every time. No harm is done to the bird; as it flies away, you will see it has no problem in steering through the trees. Of course, you have to take your chance with whatever predators may be around.

It is sometimes helpful to combine flash and daylight. In flat light, flash can put a bit of sparkle into otherwise boring pictures and can provide a highlight in the eye of the subject, which brings it to life. Birds which have a black head or crown, like terns, and mammals with deep-set eyes, like baboons, look dead without some light on them. If you can't have low sun, a little flash can save the day, though it is second best.

If you have a subject in poor light against a relatively bright background, the best thing is to leave it alone. If you really must have a picture, flash it, though don't expect a great shot.

In excessively contrasting light, using some flash on the camera may help to reduce the contrast. In daylight you need not settle for the amount of flash the camera will choose – you can instruct the flash gun to issue just a fraction. Setting it on -1 will give half as much fill-in, which is often about right. If you only want a highlight in the eye, or a touch of fill-in, try -2.

CAMERA BAGS

Air travel, followed by hard work in the field and transport over rough country, demands a properly padded camera bag. This needs to accommodate as much as possible of the equipment, so that it can travel with you as cabin baggage. However, airlines are less tolerant of overlarge cabin baggage than they used to be, so a compromise is needed.

You definitely need a bag with two shoulder straps: bags slung over one shoulder can swing as you are jumping ashore or teetering along a ledge. Additional equipment can be carried in the pockets of your photographic waistcoat or a suitable anorak. I have one that can accommodate 60 rolls of film, a camera body, a flash gun, and a small lens, though if I did carry all that it would be pretty uncomfortable to wear.

To reduce the volume of film, it is common practice to remove the cassettes from their plastic containers and put several in one of the boxes in which slides are returned by the processor.

FILM

Only the best film is good enough, but that still leaves some difficult choices. For most purposes, colour positive (transparencies) will be best, and for giving talks there is no alternative. A speed of ASA 100 is a good starting point. If you must have something faster, uprating an ASA 100 film to ASA 200, and having the film processed accordingly, is a possibility and saves carrying an extra kind of film stock. You must then have a foolproof way of distinguishing films that have been uprated.

Picture quality falls off with higher film speed, but if getting a record is all-

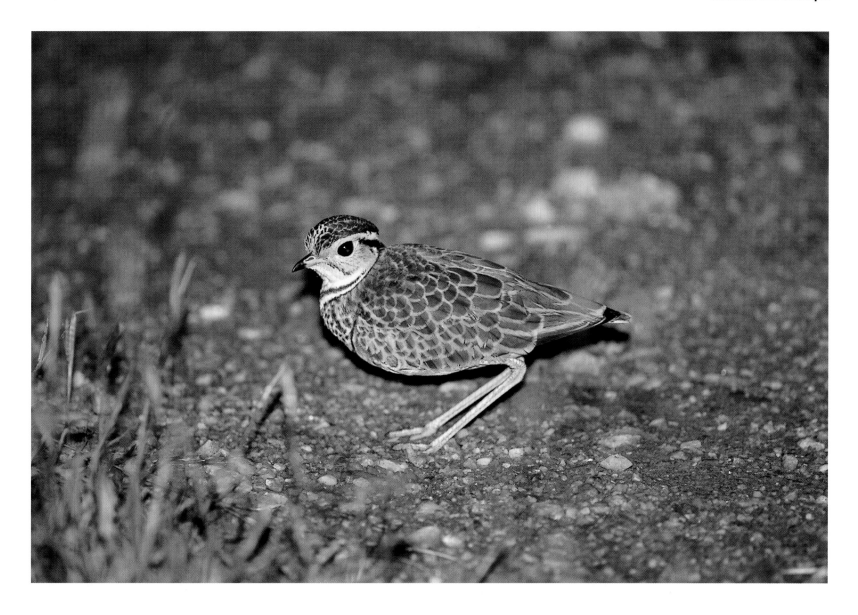

Three-banded courser, Zimbabwe
Nikon F5 with 300mm lens, Fuji Sensia 100, 1/250sec at f/5.6, SB24 flash gun

important, there are films of ASA 1600, and you can uprate these too. However, I do not normally exceed ASA 200.

You could use negative film if you only want prints; although you can make perfect prints from transparencies, it is not very practical to make transparencies from negatives. Running out of film is silly, so take plenty. For a two-week trip, I suggest at least 50. If any film is left you can use it later, and a dozen extra rolls take little space.

To avoid any degradation, it is as well to keep all your film as cool as you can, but this is not usually a major problem.

FILTERS

Protect the front element of your lenses against dust, spray and impact damage by using a 1A or similar filter. If the filter gets dirty, it can be gently cleaned. Normally, dusting with a lens brush will suffice. More serious dirt can be washed off with water. Sun cream and other greases need a solvent and there are lens cleaning fluids available commercially. Finish off with a

lens tissue. Ordinary tissues, like Kleenex, are said to scratch the soft lens coating, but I have never noticed this and I use them a lot. If the worst happens, it is much cheaper to replace a filter than a lens.

Polarizing and graduated grey filters can be useful for habitat shots. Polarizers are also good at reducing unwanted reflections from a water surface, or from an animal with shiny skin.

Flash guns tend to produce images which appear a bit on the 'cold' side, but this is easily remedied by using an 81A or 81B filter. There is no need for a filter when flash is being used to fill in on a daylight shot.

HIDES

The older generation used hides as a matter of course: you cannot reasonably march around the countryside bearing a 5 × 4 plate camera on a tripod. Now the pendulum has swung to the opposite extreme and many photographers never use hides at all. The opportunities on a commercial safari are limited, because too often you are shooting on the hoof but, where you have a static situation, a hide can be very useful. For travelling, hides have to be skimpy to save on weight and may amount to nothing more than some fabric with a hole in it. This can be anchored between trees or whatever is handy. Alternatively, you can buy a camouflaged bag to take you and your tripod. You must take a stool to sit on, preferably an aluminium one, as they are the lightest.

Drinking places are ideal locations for hides, because you can get a wide range of species in a relatively short time. A carcass may attract vultures, crows and kites. If

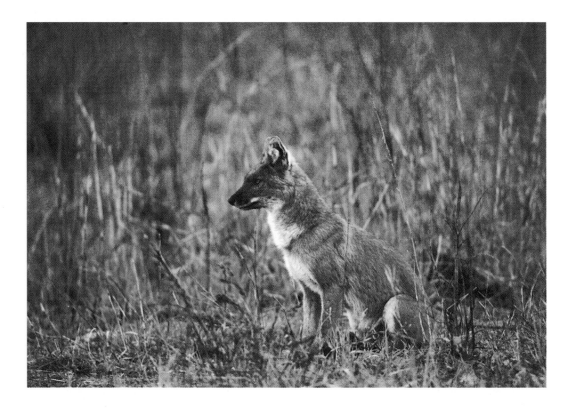

you have time, you can bait a place with suitable food before you enter the hide. Be ready to spend a few hours and be prepared for heat – it will be hotter in the hide than out.

Permanent hides are even better. The wildlife is used to them and they provide more space, though you may have to share with others who are not as dedicated as you. Relax. They have little patience and will soon move on. Having time to use hides is one of the bonuses of organizing your own tour.

Mostly, you will use a mobile hide; a vehicle or a boat. A vehicle provides a seat, shade and support for the beanbag, on which you will have your lens. You can stop at a water hole or a carcass, but most of the time you'll be touring around hunting for subjects, moving on when

Dhole, India, 6am
Nikon F4 with 300mm lens, Fuji Provia 1600 uprated to ISO 3200, 1/1000sec at f/8

you've had your fill or when the subject moves away. From a car, the wing mirrors get in the way, unless you can fold them back, so you must draw up almost level with the subject. Have the engine switched off before you shoot, unless you are dealing with a beast which is both dangerous and close. If you are hiring a car, make sure it doesn't have a security device that takes several movements to deactivate. You could be sat on by an elephant while you are fiddling. Make sure, too, that all the windows retract fully. Four-wheel drive is not generally a requirement; the later sections, on specific destinations, will spell out where it is.

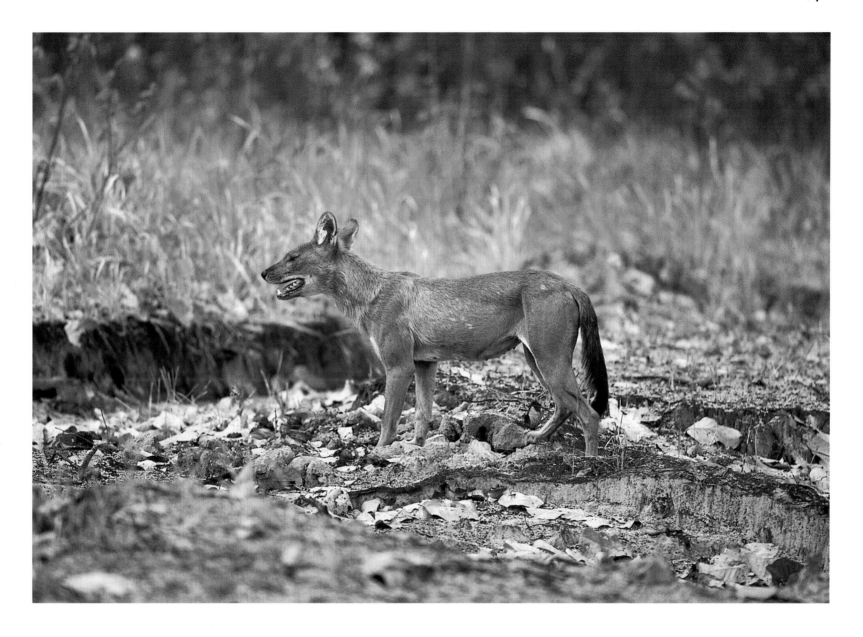

Dhole, India, mid-morning
Nikon F4 with 300mm lens, Fuji Sensia 100 uprated to ISO 200, 1/45sec at f/5.6 (The better quality with the slower film is obvious)

Photographing from boats is delightful and infuriating. You shoot as you go, using the AF, or prefocusing and shooting just before the subject looks sharp: the shutter is released a moment after the button is pressed. A skilled boatman may be able to drive the boat against the current, so that it is still for a moment at the right distance from the subject, but this depends both on the speed of the river and on his or her skill. In some habitats, boats offer the only realistic option of getting close, but expect a very high proportion of dud shots and prize the good ones. On the open sea, the problems are essentially the same but worse. A tripod will only be a hindrance, but a lens with a mechanism for reducing the effects of movement should help.

What makes a good wildlife picture

The key to getting quality pictures is finding the occasions when things are in your favour – the light is right, the animal looks good, it is doing something, and it will let you get close to it. When this happens, take plenty of exposures with different angles, different sizes of image, different backgrounds and so on. Such occasions are rare and you must make the most of them. Expect to reject a lot of what you take. Animals move at the wrong moment, get themselves into awkward poses, generate shadows which you don't spot until the pictures come back, and so on. Of course, you will learn to watch for these things before you shoot, but in this business, those who hesitate really are lost. The perfect shot is often only offered for a fraction of a second. Get used to the idea that film is expendable. I know it seems expensive when you buy it, but the cost of film is only a small part of the cost of your trip. Shoot plenty and bin all but the best.

The most important thing is that the picture please the photographer; everything else is secondary. However, if you want to satisfy others as well, the following guidelines are worth thinking about.

IDENTIFYING THE SUBJECT

The first rule is that the subject be identified. This can be bent for some 'minibeasts', where identification is genuinely difficult, but normal practice is that a wildlife subject must have a species name. There are plenty of books to help and tour company guides are generally very good. The bigger, more clearly marked species, on which I suggest you concentrate, are not usually much of a problem. Bear in mind that the same name may be used for more than one creature – a black vulture in America is not the same as a black vulture in India. If you are in any doubt, check the scientific (Latin) names.

SHARPNESS

The image should be really sharp. In some other branches of photography perfect definition may be unimportant, or even undesirable, but for wildlife photography it is vital. The aim is to show individual feathers and hairs. If the subject is standing parallel to the plane of focus, the whole animal should be sharp but at other angles this may not be possible. If you shoot a big close-up of a head, the eyes, nose and ears should all be sharp. The importance of eyes can hardly be overstated – they are what bring a portrait to life. A highlight in the eye is helpful and a shadow over it is bad news.

SUBJECT SIZE

The size of the animal in the format needs to be appropriate. A substantial creature should extend about halfway across the frame, two-thirds at most, but a little one should be smaller. It is possible to make fine images in which the subject is quite tiny, provided the rest of the picture is attractive in its own right, or sets the scene in a special way. Abnormally thin subjects, like snakes, can use more of the picture width, though they are better coiled up.

COMPOSITION

The composition should be comfortable. Whole books have been written on the art of composition, but start from the basis that the animal should look into the picture; there should be more space in front of it than behind. The light should be coming from a direction which illuminates its main features; not directly in front, but somewhat to the side. Extreme side-lighting, or even backlighting, can be used to highlight edge detail. This can work well if the film can handle the high contrast.

Shooting against a pale grey sky is usually hopeless, but a blue one or a really dark grey one is fine. Shadows are important to give shape, but they need to be soft and have some detail in them. Birds in flight need some light on the underwing.

COLOUR AND CONTRAST

Colour and contrast are crucial. These are influenced by the film you use, as well as by the lighting conditions. You will want to avoid garish colours and excessive contrast, but the rest is up to you.

As a rule, you want the background to be as unobtrusive as possible, with the subject standing out clearly against it. Where you can, you should adjust your viewpoint to achieve this, though in

reality, you often don't have much choice. However, you can still exercise some control through the aperture you select. A wide one will blur the background, but it may also blur part of the subject; this is a trade-off you must manage.

Shooting with big lenses at full aperture can lead to striking pictures, but it can also lose definition in a vital part, like the nose or bill. Good technique is to stop down just enough to keep the vital features sharp, while keeping the background diffuse.

ACTION SHOTS

Taking good pictures of stationary animals in a nice pose, sharp, and correctly exposed, will soon become second nature. Then you are ready to move on to action shots. These are more difficult, as all the preceding conditions have to be met and you also have the problems of framing the moving animal – quite a challenge if it is travelling at speed – and selecting a shutter speed to stop the movement of most of its parts. A little blurring of the extremities can help to convey the sense of speed.

ANIMAL WELFARE

There is one other rule which must not be broken. The welfare of the subject must not be put at risk. This does not mean that it may not be put to flight – wild creatures are used to disturbance of many kinds – but once it goes, let it be.

THE RESULTS

This may seem a formidable set of criteria, but none of us manages to satisfy them totally, even most of the time. In a two-week trip to the easier destinations, you can expect to take at least 100 very fine pictures, the sort you can show with pride, but if you take a couple of virtually perfect action shots, you are doing very well. In any event, if the pictures give you pleasure, you have made a good start.

It helps to be able to see your work in relation to what other photographers are doing. Visit exhibitions of wildlife work and join an appropriate club. General photographic societies will be of little assistance, unless they have a wildlife section, but there are clubs which circulate members' wildlife pictures for constructive comment and if you are keen, you should join one. It will speed up your learning process no end. If you are really keen and want to test how you are doing, go for one of the Distinctions of the Royal Photographic Society. Expect to fail the first time, but there is no better stimulus for learning quickly.

SORTING AND CATALOGUING

You've had the fun, but the work begins once the slides come back from processing. Unless you deal firmly with them, you will quickly amass so many that you will never find the ones you want. Ruthless pruning is essential and it needs to be done straight away. Examine each slide with a magnifier and cast out any with obvious faults. Group together all the pictures of one species and select the best few. The rest can be binned – you will never use them and they will clutter up your system.

Next, these best ones must be catalogued so that you can locate what you want. There are computer-based systems, but a simple manual one based on species works well for wildlife. As your collection will expand rapidly, the system must allow for this from the start. Buy world lists of birds (about 10,000) and mammals (about 4,000). If they are not numbered, you must do it for yourself. This is tedious, but it only has to be done once. Write the species number on each slide, together with any other data you require, like place and date taken. File your slides in sequence in slide pockets or a slide cabinet.

Habitats and other general shots can be filed by trip or by country. Reckon to take as long sorting and filing your slides as you spent producing them. Over the years you will acquire better pictures, so use the winter evenings to go through your files and keep them weeded out.

Laptev Sea

NOVOSIBIRSKIVE
OSTROVO

East
Siberian
Sea

Sea of
Okhotsk

Sea of
Japan

Yellow
Sea

East
China Sea

PACIFIC

OCEAN

ND

South
China
Sea

Celebes
Sea

Philippine Sea

MELANESIA

INDIES

Coral Sea

AUSTRALIA

North I.

Tasman Sea

South I. NEW
ZEALAND

WHERE TO GO

Apart from Europe and North America, there are three areas of the world that are straightforward to reach, have a good infrastructure for tourists, where English is widely spoken, and there are abundant opportunities for high-quality wildlife photography. They are south and east Africa, and Australia. The following chapters provide a brief description of each area and the factors you should keep in mind when planning your trip. There is not the space here to be comprehensive, but there are many books, magazines, videos, websites and tourist bureaux which can give you the fine detail.

Each area holds enough hotspots to keep you busy for a lifetime, but when you decide you want something else, try some of those described in the later sections. These generally require more complicated travel arrangements, both internationally and within the country. In South America, some knowledge of Spanish or Portuguese is helpful as in the country areas English is hardly spoken at all.

Australia

When Gondwanaland broke up into the continents we recognize today, Australia was the piece that drifted furthest away and its wildlife evolved very differently from that of its original neighbours, India and Africa. Most of its mammals are marsupials (whose young, born at a very early stage, finish their development in the mother's pouch), though some species that superficially resemble groups found on other continents have developed.

Most of the human population of Australia is concentrated in a thin strip of land around the periphery, especially along the eastern side, where living conditions are easy. Many of the birds follow suit, not because they are helped by the people, though nowadays they may be, but because they need the same benefits as humans, especially access to water.

Much of Australia is very hot for at least part of the year and the residents have become very sensitive to the need to protect themselves against excessive exposure to sun. Visitors should do the same.

Australia has a good internal air service and an excellent main road system. Minor roads are often dirt, but present no problem when dry. Long-distance travel into the almost unpopulated interior demands care and planning. Unless you are experienced, it would be wise to use the services of one of the local travel companies. The populated areas have an abundance of motel and other accommodation. On the other hand, getting to Australia demands a long flight from Europe or America. It is a huge country with vastly differing conditions, so I will deal with it in three sections, Western Australia and the Northern Territory, eastern Australia and Christmas Island.

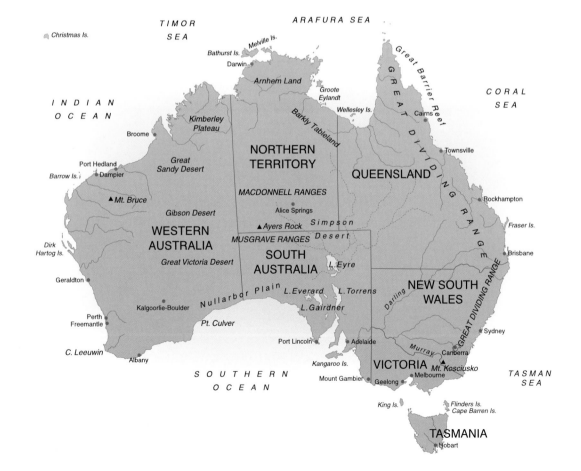

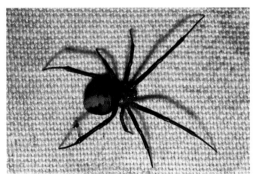

Redback spider. Treat spiders with respect. Redbacks give a painful and venomous bite
Nikon F80 with 105mm lens, Fuji Sensia 100 uprated to ISO 200, 1/250sec at f/16, SB24 flash gun

WESTERN AUSTRALIA AND THE NORTHERN TERRITORY

South-west Western Australia

The south-west corner of Australia is relatively cool and wet. It receives most of its rainfall in the winter, together with winds coming from the Antarctic. In spring, it is a garden of wild flowers, including orchid species by the hundred. Year-round it is notable for magnificent forests. As in the rest of the country, the mammals are marsupial and nocturnal; pass through the forest in daylight and, apart from kangaroos, their absence is remarkable; even birds are thin on the ground. The wandoo forest, Dryandra, has numbats. You can stay in the Lions Club bungalows in the forest, or in motels not far away. At night, mammals like the brush-tailed bettong and the arboreal brushtail possum are abroad. There are birds to be photographed, including the magnificent black cockatoos, but the variety is less than it is in the east.

Going north along the west coast, there are many good places for wintering waders, starting with the Vasse Estuary and Peel Inlet. There are parks, pleasant enough, but their purpose is more for human recreation than for the benefit of the wildlife. They are still worth a visit, because some of the birds become quite used to people.

Kings Park, in the centre of Perth, has many parrots and honey-eaters. A walk along the shore of Herdsman Lake should provide Pacific black duck, Australian shelduck, purple swamphen and black swan within comfortable camera range. Corellas and kookaburras often sit around in the trees, especially in the early morning.

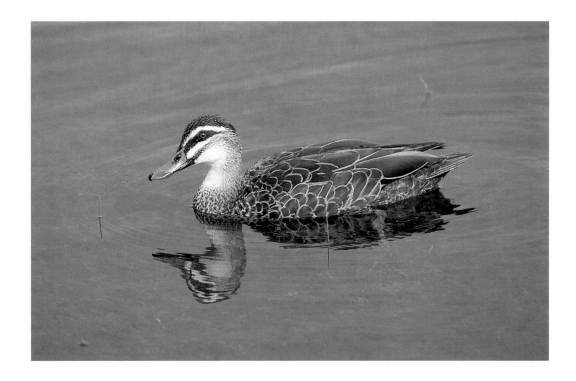

Pacific black duck ▲
Nikon F5 with 80–200mm lens and 2✗ extender, Fuji Sensia 100, 1/250sec at f/5.6

Australian shelduck ▼
Nikon F3 with 300mm lens, Kodachrome 64, 1/250sec at f/5.6

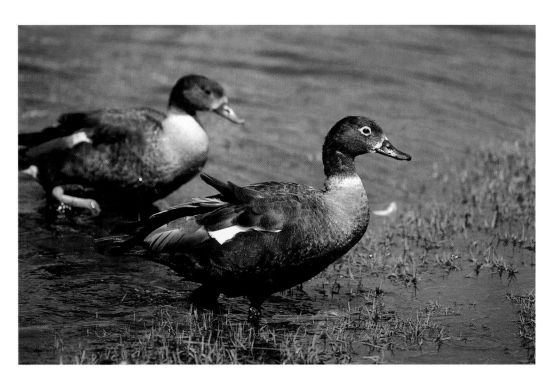

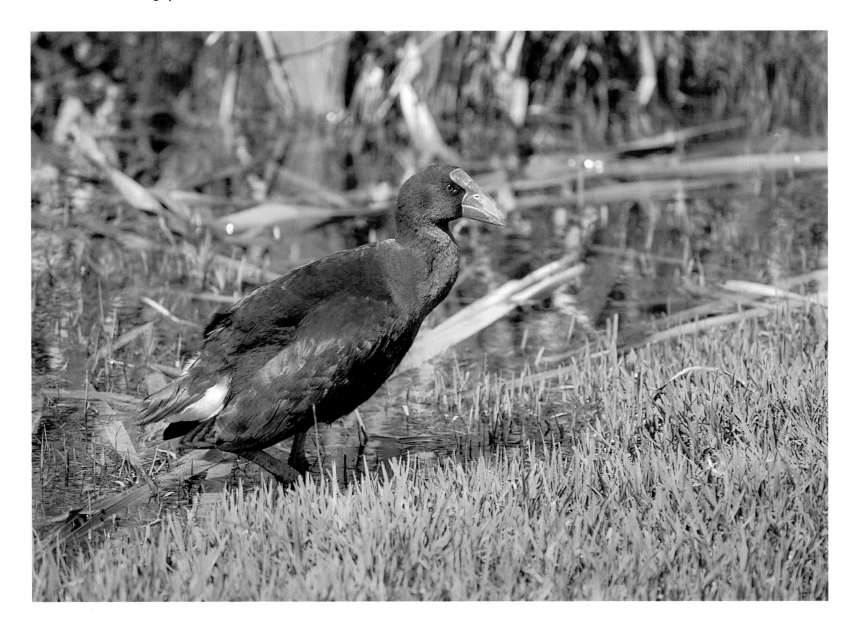

Purple swamphen
Nikon F3 with 300mm lens, Kodachrome 64, 1/200sec at f/5.6

If the birds there are not behaving, Lake Monger will probably provide them. Take care if you walk in the vegetation by the water as there may be taipans, one of Australia's most dangerous snakes. The country has a wide variety of snakes, but no dangerous mammals.

While in Perth, a visit to Rottnest Island is worthwhile for the terns and other sea birds and for the special species of the island, a little marsupial called the quokka. The island is a very short hop by air, or a couple of hours on the ferry from Fremantle. There is plenty of accommodation as it is a tourist resort, which means it is best avoided at weekends. Bicycles can be hired when you land and are the usual means of getting around.

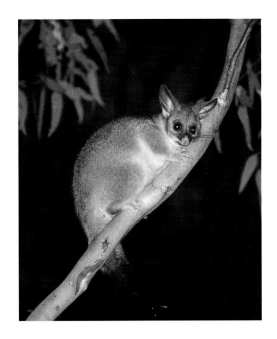

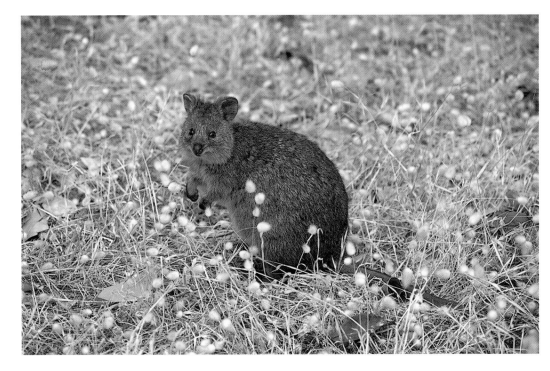

Brushtail possums can be photographed at night in Dryandra forest
Nikon F3 with 300mm lens, Fuji Sensia 100, 1/250sec at f/4, SB24 flash gun

Quokka on Rottnest Island; a hands-and-knees job ▲
Nikon F3 with 70–210mm lens, Kodachrome 64, 1/60sec at f/11

Common sand monitor. Australia has numerous species of lizard, including several big ones ▼
Nikon F5 with 80–200mm lens and 2✕ extender, Fuji Sensia 100, 1/60sec at f/16

North-west Western Australia

Once north of Perth, be prepared for serious heat in summer. Road journeys can be lengthy, and frequent stops at the roadhouses for cool soft drinks are very much in order. The whole of this west coast, right up to the Top End, over 2,000 miles (3,200km) away, is good for waders and for flowers, in season. Most of the reserves are floral and the roadside verges are often wide and thick with flowers. Near Karratha and Port Hedland are large solar saltworks which take in seawater and allow the powerful sun and drying winds to evaporate the water and leave common salt. Near the inlet, where the salt concentration is not much greater than in the sea, all the marine species can flourish.

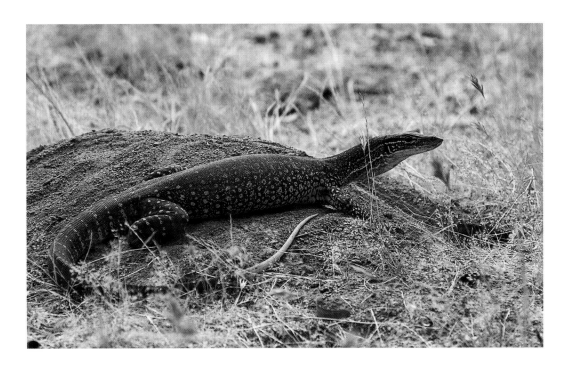

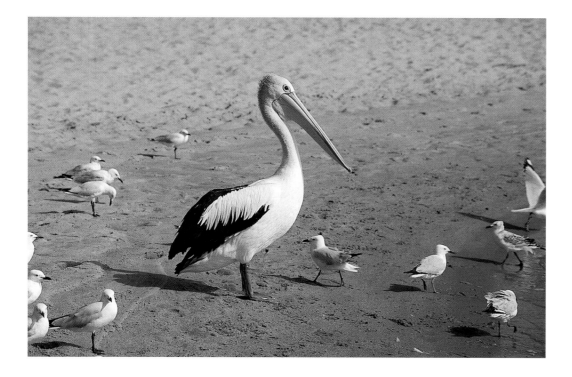

Australian pelicans are easy to photograph in many places along the coast. Here they are with silver gulls
Nikon F3 with 300mm lens, Kodachrome 64, 1/125sec at f/11

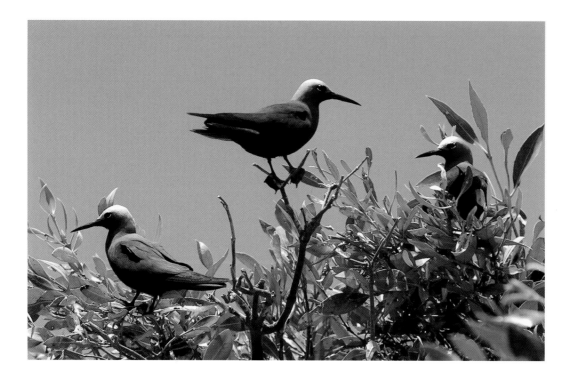

Lesser noddies nest in the mangroves on Pelsart Island
Nikon F5 with 80–200mm lens and 2✕ extender, Fuji Sensia 100, 1/125sec at f/8

Wading birds feed on the worms and molluscs and bigger birds move in to feed on the abundance of fish. Herons, egrets, pelicans, gulls and terns provide a host of photographic opportunities. The saltworks are private, but at Useless Loop, it may be possible to arrange access to the area with the park ranger.

On the way up, the harbour and pier at Carnarvon are worth checking – there is a chance of green turtles and dugongs. Near Shark Bay there are two specialities: Hamlin Bay has outstanding growths of stromatolites (algae similar to those growing many millions of years ago), and at Monkey Mia there is a beach much frequented by bottle-nosed dolphins, which used to be happy for you to swim with them and even touch them gently. Now, the place has become a major tourist attraction and such free access cannot be allowed, though at quiet times you may still be able to get pictures.

There are many islands off the west coast, some with big colonies of sea birds for which the mainland is too disturbed. Pelsart Island, accessible from Geraldton, has crested, common and lesser noddy terns and the large king skink. Further north you can find bridled terns and lesser frigates. All these west coast islands are protected and to visit them, permission is required. They are honeycombed with shearwater burrows, so you must keep to the shoreline. Given permission, you hire one of the cray fishing boats to take you out, but this is not cheap.

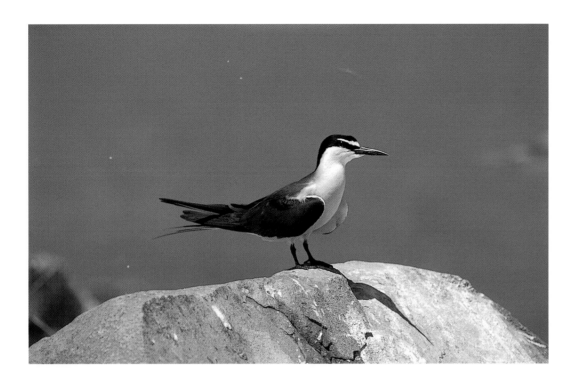

The Northern Territory

Continuing along the west coast, then travelling north and east into the Northern Territory, there are magnificent tropical habitats full of wildlife. The north is cyclone territory and is mostly impassable off the tarmac without a 4WD once the summer rains begin in earnest. It is best visited in the austral winter, when it is dry, but still pretty warm. Watch out for saltwater crocodiles, as they are aggressive and lethal. In places like Kakadu there are tourist boats which will carry you in safety to photographic range.

Bridled tern ▲
Nikon F3 with 400mm lens, Kodachrome 64, 1/500sec at f/5.6

Caspian terns ▼
Nikon F3 with 400mm lens, Kodachrome 64, 1/250sec at f/8

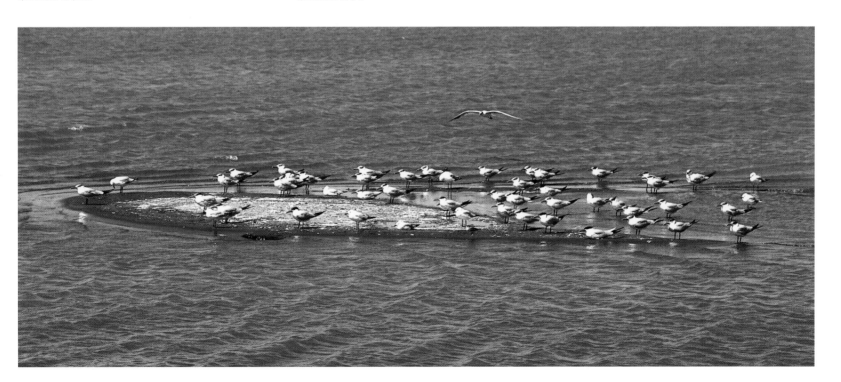

EASTERN AUSTRALIA

North-east Queensland

Travel east along the north coast and by the time you get to the corner you are in Queensland, probably the pick of the states for the wildlife photographer. Cairns has an international airport, a wide variety of accommodation and tarmac roads to many good wildlife spots. Before you head off, give the seafront and the parks a day or two. In season, with the right tide and a

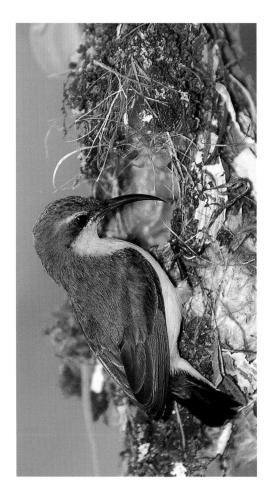

Yellow-bellied sunbird at its nest, Daintree
Nikon F5 with 80–200mm lens and 2× extender, Fuji Sensia 100, 1/125sec at f/8, fill-in flash

big lens, you can photograph many wader species from the promenade. There will be loads of red-necked stints and sharp-tailed sandpipers, and most of the northern breeding species pass through. The parks in Cairns have lakes, which host the usual water birds and some of the land birds are not too shy.

To the north, a short run leads to Daintree, which has plenty of birds, and from boats on the Daintree River you may get Papuan frogmouth, shining flycatcher and great-billed heron. The usual problems involved when photographing from boats apply, and do not imagine that the light is always good. Not far away is the Daintree Forest Habitat Enclosure. If you are not too proud to take birds in captivity,

Papuan frogmouth. These highly cryptic birds build their nests on a branch. This one was over the Daintree River and was photographed from a boat
Nikon F5 with 80–200mm lens and 2× extender, Fuji Sensia 100, 1/125sec at f/5.6, flash

this is about as good as it gets, with lots of species in natural surroundings. It is dark, though, like any other rainforest.

From Cairns it is easy to board a catamaran to Michaelmas Cay, a sandy islet which is home to colonies of common noddy, sooty and crested terns. The timing is far from ideal, as you land around midday when, in addition to being boiling hot, the sun is too high in the sky to give anything but very harsh lighting. This is another place that sees too many tourists,

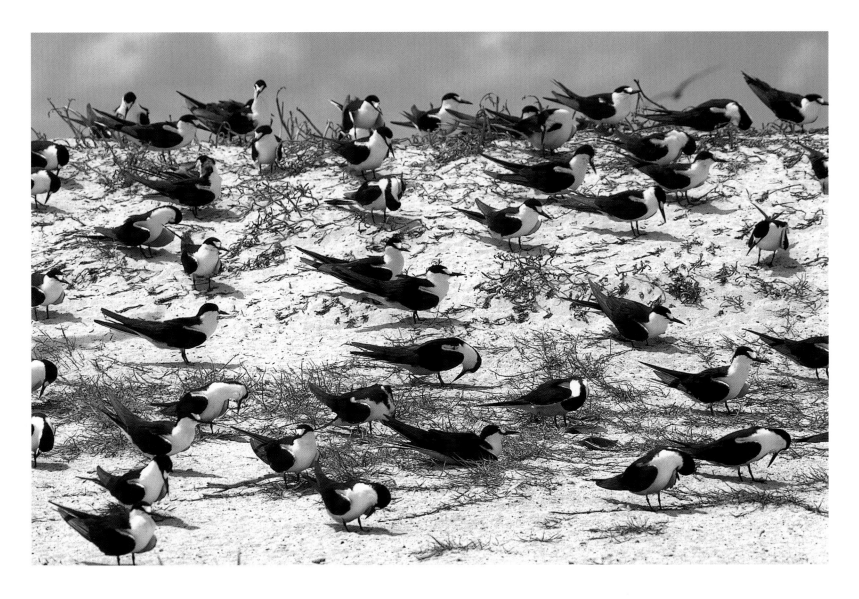

so access has had to be limited to a small section of the beach, from which you can shoot into the nesting colonies.

Many islands on the Great Barrier Reef have good birds and are well worth time, if your pocket can stand the strain – the best ones tend to be seriously expensive.

Some of the best remnants of rainforest are on the Atherton Tableland, which lies inland from Cairns. Among extinct volcanoes and lakes like Barrine and Eacham, are areas of rainforest alive with the calls of bowerbirds and the scufflings of birds and marsupials on the forest floor. By all means take a boat ride and walk the trails to the spectacular viewpoints, but some of the best opportunities occur in the car parks where birds and beasts come to glean unconsidered trifles left accidentally or deliberately by the tourists. Crater is one such car park, and has birds by day and possums by night. There is no need to

Sooty terns on Michaelmas Cay
Nikon F3 with 300mm lens, Kodachrome 64, 1/80sec at f/16

get there at nightfall – 9pm will do nicely – but do bring a spotlight. Brushtail and ringtail possums will be the most frequent visitors, but there is also a chance of lemur-like possum and the strangely coloured green ringtail possum.

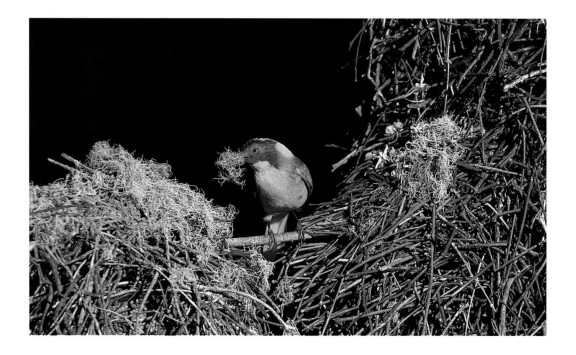

Golden bowerbirds live in the remnants of the rainforest on the Atherton Tableland and on Mount Lewis. This one is a male attending his bower. Using flash is unavoidable in the dark forest ▲
Nikon F3 with 400mm lens, Kodachrome 64, 1/60sec at f/5.6, flash gun by perch triggered by small flash near hide

Mareeba wallaby, Granite Gorge ▼
Nikon F5 with 28–105mm lens, Fuji Sensia 100, 1/200sec at f/8

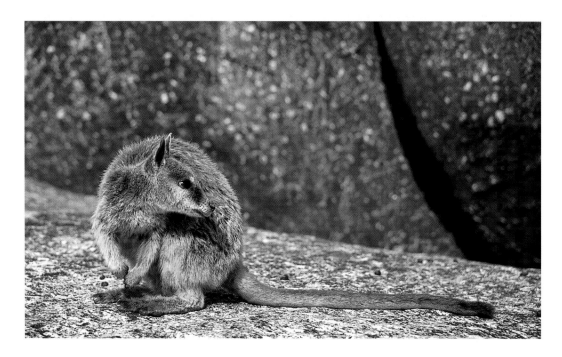

The forest carries a number of tree frogs. The best way to find them is to go out in the car one evening after rain, pick them out in the headlamps and pop them into jars, together with something to keep them moist. They can then be photographed at leisure, either with torch and flash the same night or in the morning, before you put them back in the forest, adjacent to where you found them.

In the very harsh, rocky country at Granite Gorge, there is a localized species of wallaby, which is easily photographed early in the morning.

Queensland/New South Wales border

Continuing south to the border with New South Wales, inland from Brisbane and the Gold Coast, you will reach one of the best places for wildlife anywhere in the world. This is Lamington National Park and it has a guest house on each side, one called Binna Burra, the other O'Reilly's, and plenty of cheaper accommodation. There are long, hilly trails here to satisfy the most energetic, and they offer chances of Albert lyrebird, Australian ground thrush, logrunner and eastern whip bird. Many fine birds are on view within a few hundred metres of the lodges – satin and regent bowerbirds will come to hand and wonga pigeon, king parrot, crimson rosella, pied currawong and brush turkey feed in the grounds. The 'turkey', one of the megapodes (birds that deposit their eggs in piles of fermenting vegetation), will probably have a nest not far away. There will certainly be at least one bower of the satin bowerbird. You don't need a hide, just sit quietly for a while on your stool. While you are sitting at the bower,

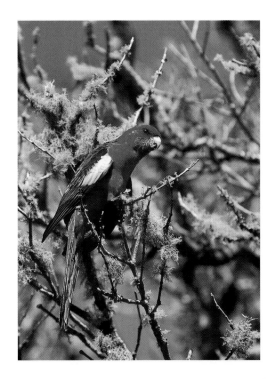

Crimson rosella
Nikon F5 with 80–200mm lens and 2✕ extender, Fuji Sensia 100 uprated to ISO 200, 1/125sec at f/8

King parrot ▲
Nikon F5 with 80–200mm lens and 2✕ extender, Fuji Sensia 100 uprated to ISO 200, 1/125sec at f/8

Brush turkey ▼
Nikon F5 with 80–200mm lens and 2✕ extender, Fuji Sensia 100, 1/250sec at f/8

there will be a procession of other birds passing through. In the late afternoon red-necked pademelons (small wallabies) come out to graze and at night there are sugar gliders and mountain possums.

O'Reilly's is a good place for frogs, so good they hold a special Frog Week once a year for frog enthusiasts. Orange-eyed and Fletcher's black-soled frogs can be found in the pools adjacent to the accommodation and there are plenty of other species in the forest. Not all frogs are easy to identify, so having some experts around could be handy. There are lizards too, of which the rainforest dragon is the most dramatic. You might find one in the botanic garden at O'Reilly's.

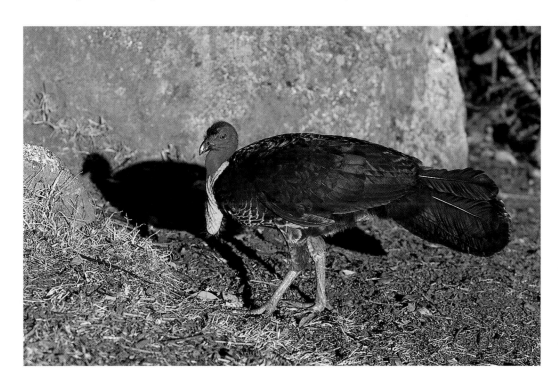

The male regent bowerbird is one of the most gorgeous birds in the world. It needs a little extra exposure to record the detail in its jet black plumage, without burning out the bright gold
Nikon F5 with 80–200mm lens and 2✕ extender, Fuji Sensia 100, 1/250sec at f/8, SB24 flash gun

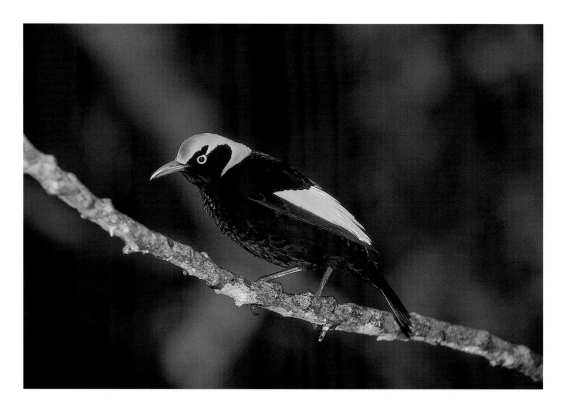

Pied currawong
Nikon F5 with 80–200mm lens and 2✕ extender, Fuji Sensia 100 uprated to ISO 200, 1/250sec at f/8

The satin bowerbird displays by his bower, where he may be visited by a female. This male is Sir Jock Aloysius McSatin, a well-known character at O'Reilly's. Filmed many times over many years, he is reckoned to be at least 27 years old. His deep blue plumage needs generous exposure; three flash guns were used
Nikon F5 with 80–200mm lens, Fuji Sensia 100, 1/60sec at f/8, flash

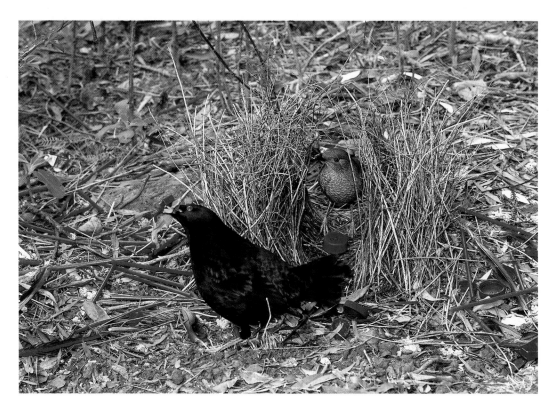

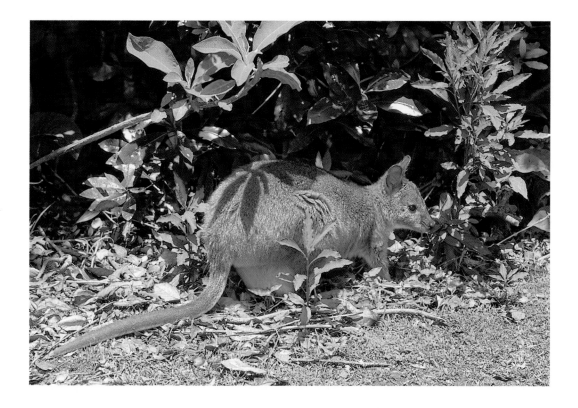

Red-necked pademelon
*Nikon F5 with 80–200mm lens, Fuji Sensia 100,
1/60sec at f/11*

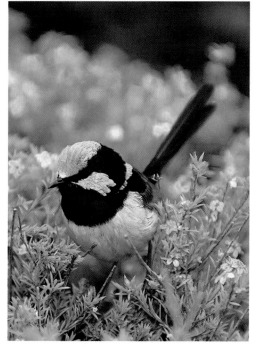

Superb fairy wren
*Nikon F5 with 80–200mm lens and 2✕ extender,
Fuji Sensia 100 uprated to ISO 200, 1/250sec at f/5.6,
SB24 flash gun*

Golden-crowned snake
*Nikon F5 with 80–200mm lens, Fuji Sensia 100,
1/250sec at f/11, SB24 flash gun*

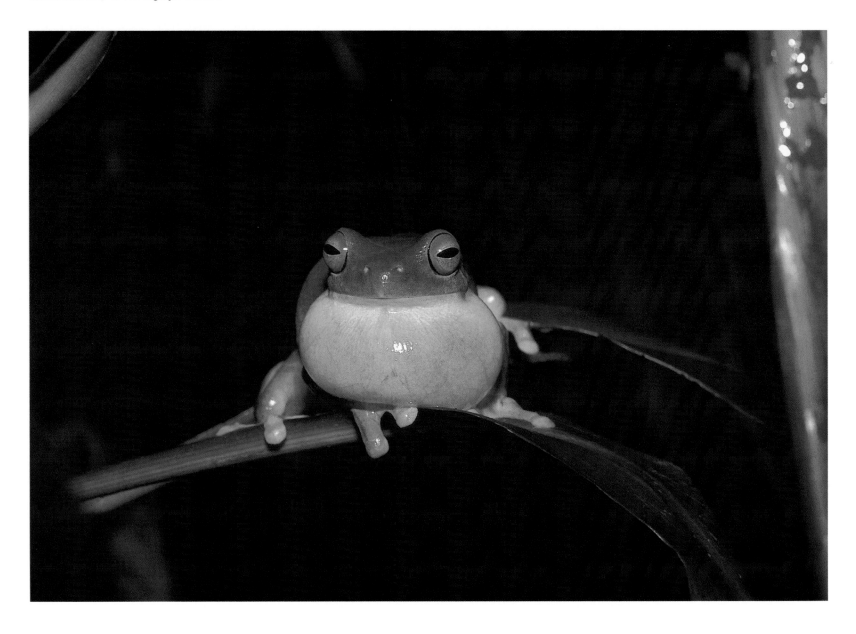

Orange-eyed frogs move in to O'Reilly's with the summer rain. This one and his mates called from a little pool by my room
Nikon F5 with 105mm macro lens, Fuji Sensia 100, 1/250sec at f/11, SB24 flash gun

Victoria

Near Melbourne there are offshore trips for sea birds – provided you have good sea legs – but you will need to talk to the local birders to see what is available. You can visit Phillip Island, a couple of hours run from Melbourne, providing you start on the right side of the city (the south east). The island is a great tourist attraction because of its little penguins; the track they follow to visit their nests each night is lined with hundreds of sightseers. The birds only dare to come in at night, because they are too vulnerable to predators in the daytime. A whole tourist industry has been built around the penguins and you may not care for the artificiality of it all, but it is certainly spectacular.

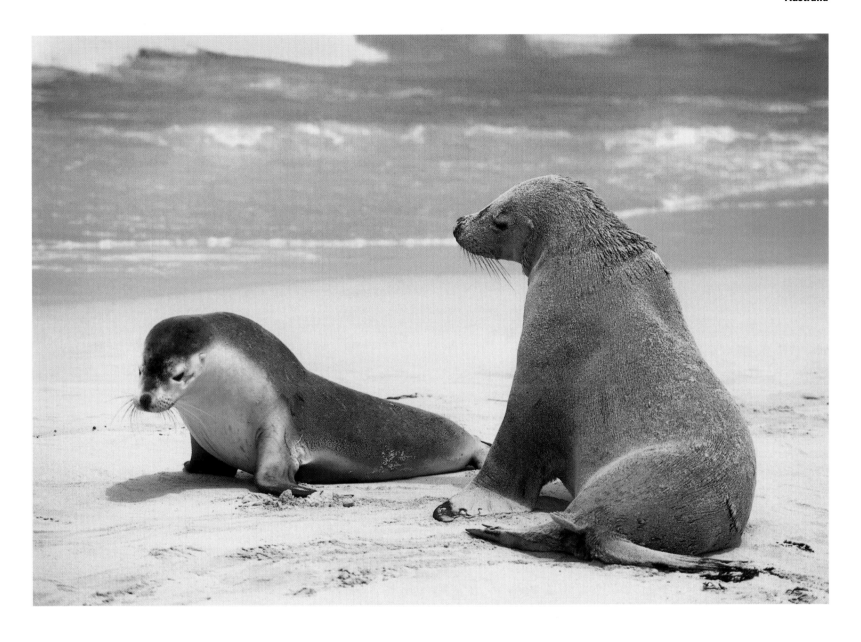

South Australia

Off Adelaide, on the south coast, lies Kangaroo Island, easily reached by a short flight or on the car ferry. At its western end, in the Flinders Chase National Park, there are cereopsis geese. There are also koalas and black-faced kangaroos. In the south, at Seal Bay Conservation Park, there are Australian sea lions. These are not shy and should provide good pictures, but the place has become too popular, so you can no longer walk among the animals. In any case, a little care is called for as they pack a powerful bite.

The salt marshes near Adelaide are open to birders. They hold large numbers of waders, including both stilts and red-necked avocets.

Australian sea lions courting
Nikon F3 with 70–210mm lens, Kodachrome 64, 1/125 sec at f/11

CHRISTMAS ISLAND

Christmas Island, in the Indian Ocean, although much closer to Indonesia than to Australia, is part of Western Australia. It can be reached by air from Perth, Singapore or Jakarta. There is good-quality accommodation and a choice of modest eating places, including Australian, Malaysian and Chinese. You need a 4WD for the steep and rough roads, but hire charges are very reasonable.

Mining of phosphate rock, which was the mainstay of the island, is ceasing and much of the island is now a reserve, protecting several endangered species. When the rains start in earnest, around

Red crabs pour down to the beaches by the million
Nikon F5 with 28–105mm lens, Fuji Sensia 100 uprated to ISO 200, 1/125sec at f/11

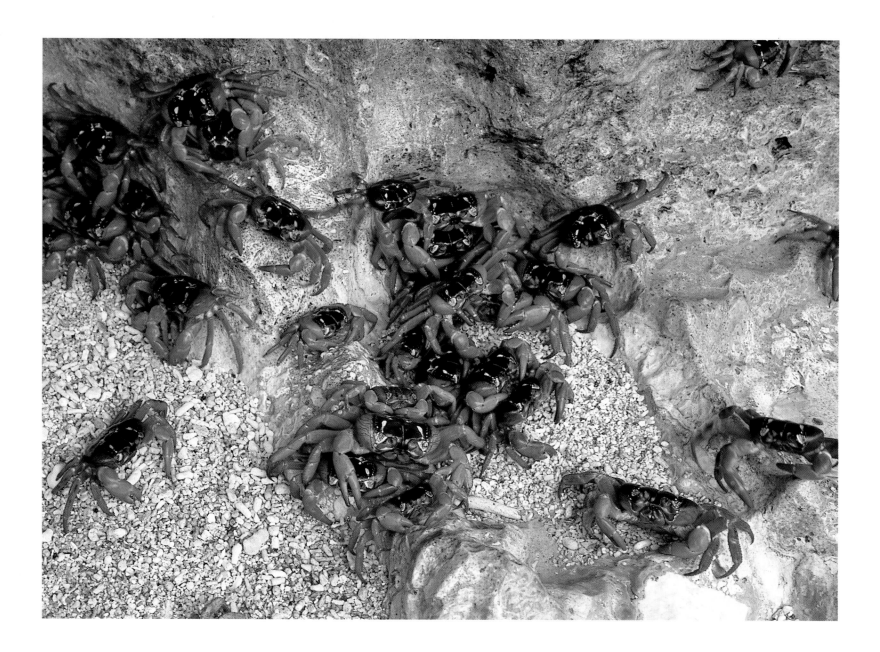

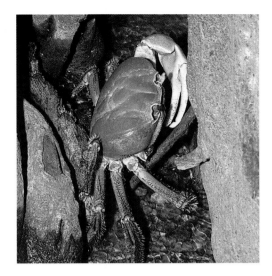

Blue crabs live around the few places where there is fresh water
Nikon F80 with 105mm macro lens, Fuji Sensia 100 uprated to ISO 200, 1/125sec at f/11, SB24 flash gun

November, millions of red crabs move towards the sea from their inland quarters in the rainforest. They 'dip' in the sea water to recover from the long journey and later, mate. Whole areas of the island can be carpeted with crabs and some roads are closed for a while to reduce casualties.

Christmas Island has many other species of crab, including the robber crab, which is reputed to crack coconuts, and the attractive blue crab. Your macro lens is ideal for them and, except when they are on the beach, you will need flash. Take care with robber crabs or they will amputate your fingers.

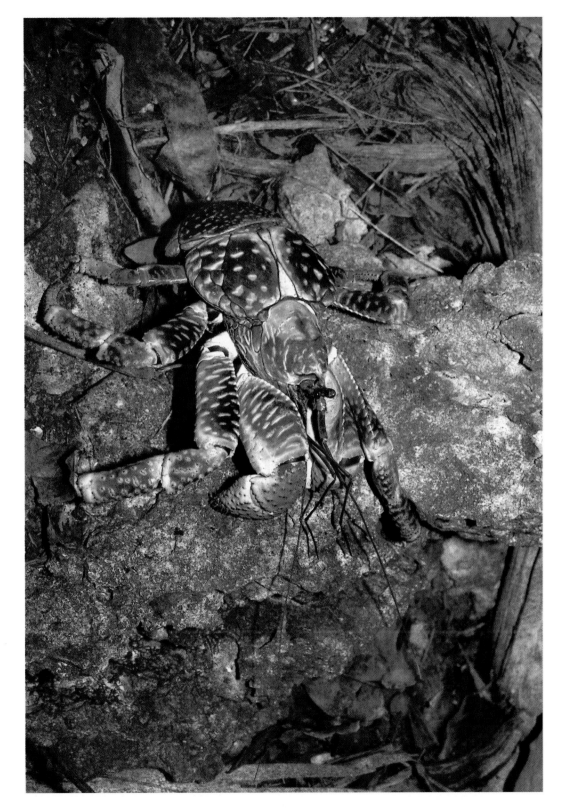

Robber crab
Nikon F80 with 105mm macro lens, Fuji Sensia 100 uprated to ISO 200, 1/125sec at f/11, SB24 flash gun

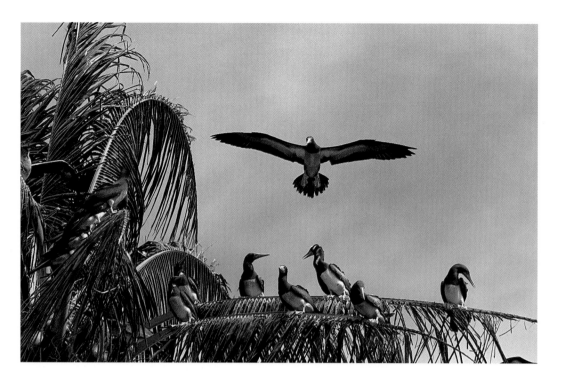

Brown boobies ▲

Nikon F5 with 80–200mm lens and 1.4X extender, Fuji Sensia 100 uprated to ISO 200, 1/750sec at f/5.6

Immature Christmas Island frigates fly around below the nesting colonies ▼

Nikon F5 with 80–200mm lens and 2X extender, Fuji Sensia 100 uprated to ISO 200, 1/500sec at f/5.6

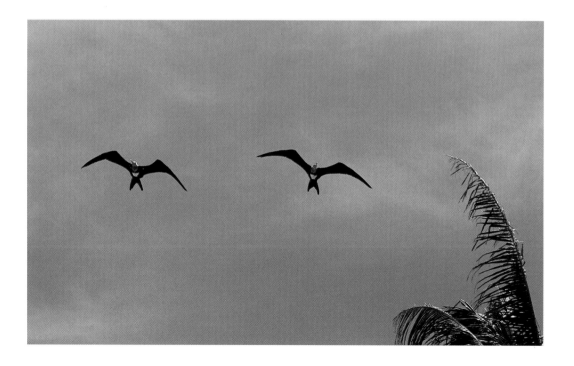

The birds of the island are very special, with several endemic species having only small populations. The biggest forest trees provide nesting places for Abbott's booby, the largest and scarcest of the gannet tribe. They are difficult to photograph without a 150ft (45m) high pylon hide. The red-footed boobies use smaller trees and the brown boobies nest on rocky ground just above the sea.

Christmas Island frigate birds, which, like the Abbott's boobies, nest nowhere else in the world, can be found in the trees above the golf course and the Chinese cemetery. The trees are a bit of a tangle and getting clear views is very difficult. Both Christmas Island and great frigates can be seen soaring around and this is where the best opportunities lie. Try the palm tree across the road from the golf course for frigates and boobies. A 300mm lens will suffice there. The plumage of different species of frigate bird can be confusing, so be careful about identification.

The forest holds a couple of other endemic species: the Christmas Island imperial pigeon and the Christmas Island white-eye, and endemic races (subspecies) of the brown goshawk, glossy swiftlet, moluccan hawk owl, emerald dove and island thrush. A week here will suffice for photographing the bigger crabs and all the birds, except the owl, the swift and Abbott's booby.

Two of the most attractive birds are the tropic birds, red-tailed and white-tailed. Both have a wide distribution, but the Christmas Island white-tailed is an endemic race, distinguished by its golden, instead of white, plumage. Flight shots are possible from the viewing point near the Park Information Centre and from a point

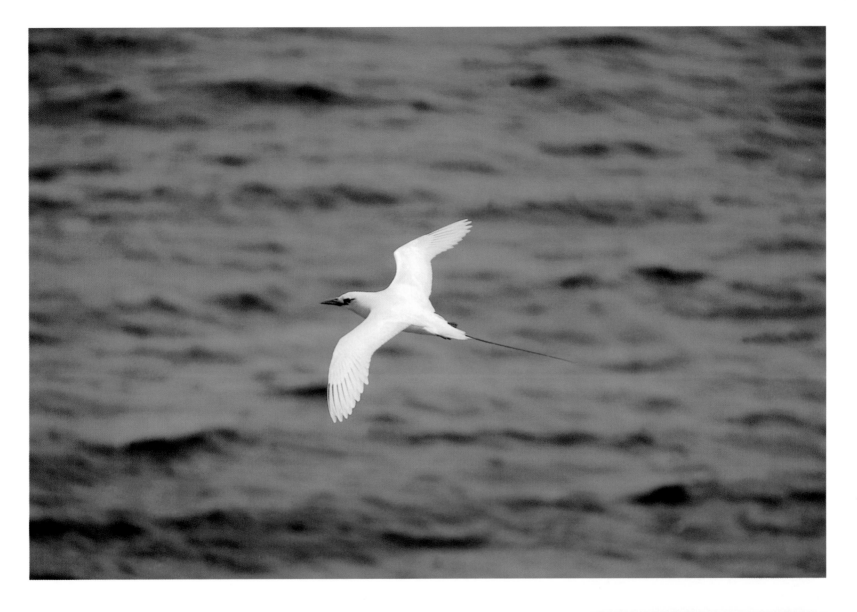

Red-tailed tropic bird ▲
Nikon F5 with 80–200mm lens and 2✕ extender, Fuji Sensia 100 uprated to ISO 200, 1/500sec at f/5.6

Fully fledged red-tailed tropic bird chick ready to leave the nest ▶
Nikon F5 with 28–105mm lens, Fuji Sensia 100 uprated to ISO 200, 1/100sec at f/11

below there at Flying Fish Cove. Both tropic birds nest in holes in trees or in any other recess. By Settlement, you can find red-tailed tropic birds nesting under vegetation on the raised beach.

East Africa

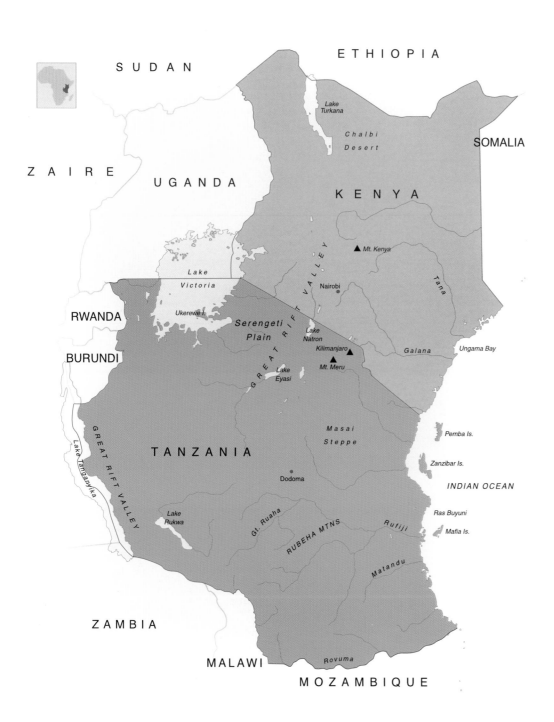

East Africa is classic safari country, with dozens of specialist wildlife tours, and quite a few for wildlife photography, on offer. No part of the world is as closely identified with wildlife photography as east Africa, particularly Kenya, not least because of the frequency with which it appears on television. The attraction is not so much the abundance of birds, though there are many, but the presence of large mammals in circumstances which make them easily accessible to the photographer. Not only have many large species survived, but most of them live in open habitats that readily permit good pictures to be obtained. There is a huge tourist industry geared around the wildlife. This is both a blessing and a curse; on the one hand it gives the animals and their habitats a commercial value, which encourages their conservation and has promoted an infrastructure of roads and lodges. On the other, it brings in many people and vehicles and causes damage to the very things that they have come to see.

In the urban areas, as in so many other countries, mugging and general thieving have become more prevalent than they used to be. There are also spasmodic incidents of attacks in more remote areas so, if you are of a nervous disposition, stick with a tour party. However you travel, precautions against malaria must be taken.

If you go on one of the remarkably cheap, non-specialist packages, you will certainly cover a lot of miles and see many

animals, but will struggle to take good pictures. It is better to tour with a wildlife company and better still with a wildlife photography party. Ideally, go in your own small party and drive yourself. There is no difficulty in making your own bookings, though it does take more effort than buying a package.

Navigation is not a big problem in Kenya, except occasionally in the reserves, but Tanzania can be difficult. Vehicle hire is fairly expensive, especially if you want 4WD. This is not essential in dry weather, but the extra ground clearance is useful. Many of the roads are pretty rough and on the main ones there can be a lot of heavy traffic. Whether you organize or are organized, you will go to many of the same places. The lodges are of a high standard, providing good food and a pleasant atmosphere. They are used to people setting out in the early morning – when the animals are at their best and the light is not too harsh – and returning for lunch and a swim or siesta before going out again after a cup of tea. East African bottled beer and soft drinks are cheap, good and wholesome.

Any one of the major parks has so much material that even a week will do no more than enable you to skim the surface; you could spend years and still be turning up new opportunities.

KENYA

Amboseli National Park

This park is immensely popular with the tourist companies – perhaps too popular. Most of Amboseli is dry and dusty, and this is made worse by the large number of vehicles traversing it. It does, however,

African spoonbills at dusk ▲
Nikon F2 with 300mm lens, Kodachrome 64, 1/30sec at f/11

On the shore of Lake Nakuru a marabou found a baby zebra that had died overnight ▼
Nikon F4 with 300mm lens, Fuji Sensia 100, 1/125sec at f/8

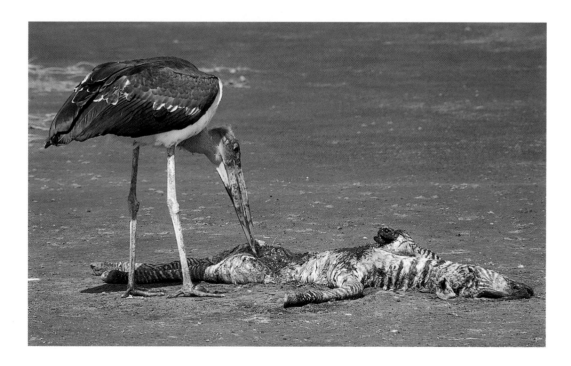

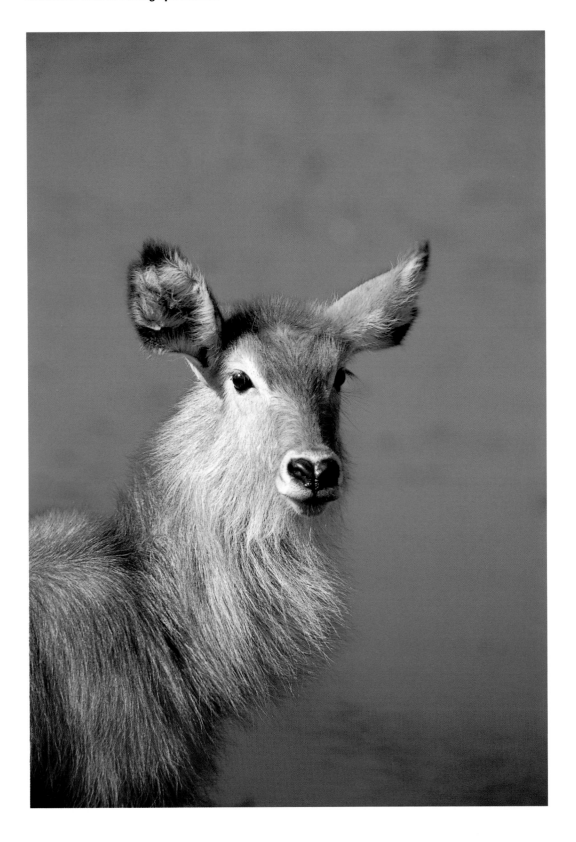

boast some large pools. These are the key to the place and, as they are fed by underground streams from the mountains, they never dry out.

After the rains, the land outside the park becomes green and the animals move out to crop it while they can still find water to drink. There are plenty of Grant's and Thomson's gazelle, common zebra, blue wildebeest and giraffe. It is a good place for yellow baboons, which replace the olive baboons found elsewhere in Africa. The less frequented dry areas give the best chance of finding gerenuk, though they are more easily found in Samburu.

You will also come upon elephants, some of which spend a lot of time in the wet areas. Fortunately, Amboseli elephants are normally very placid and can be watched quietly at close quarters without any obvious reaction. Just watch out for females with small calves, which are naturally more touchy than the others.

There are birds all over the park; the drier areas have ostrich, plovers, several bustards and double-banded courser, among others. Red-billed and hottentot teal, goliath and other herons are just a few of the species on offer near the pools.

Some of the best birds can be found right by the lodges. On the feeding tables there will be starlings, parrot-billed sparrows, weavers and hornbills. These places are not very attractive and you will obtain better pictures by photographing the birds on adjacent perches, as they

Waterbuck have shaggy coats that enable them to live in the cool climates of the hills, but they manage very well in hot areas too
Nikon F5 with 300mm lens and 2✕ extender, Kodak Elite 100, 1/250sec at f/5.6, flash

queue for the food. If you don't like the perches on offer, set up one of your own. The Taveta weaver is a scarce bird generally, but is common by some lodges. Use flash if necessary. Rubbish tips nearby attract marabou storks and baboons, which scavenge on the waste from the lodge.

Tsavo National Park

This is easily reached from the main road between Nairobi and Mombasa. It is in two sections, separated by this road. In Tsavo East, you may leave your vehicle at the river and cross by boat to a camp on the other side. This leaves you dependent on the camp transport.

Tsavo West is enormous and takes several hours to cross. There are big herds of elephant, most of the usual wildlife, and some good places to stay, but you may find more photographic opportunities in some of the other reserves.

In a prolonged dry spell, Lake Nakuru dried up and most of it was covered in grass. Animals moved in to utilize this additional feed, even though the area was subject to gusts of soda blown in the wind
Nikon F2 with 50mm lens, Kodachrome 25, 1/60sec at f/8

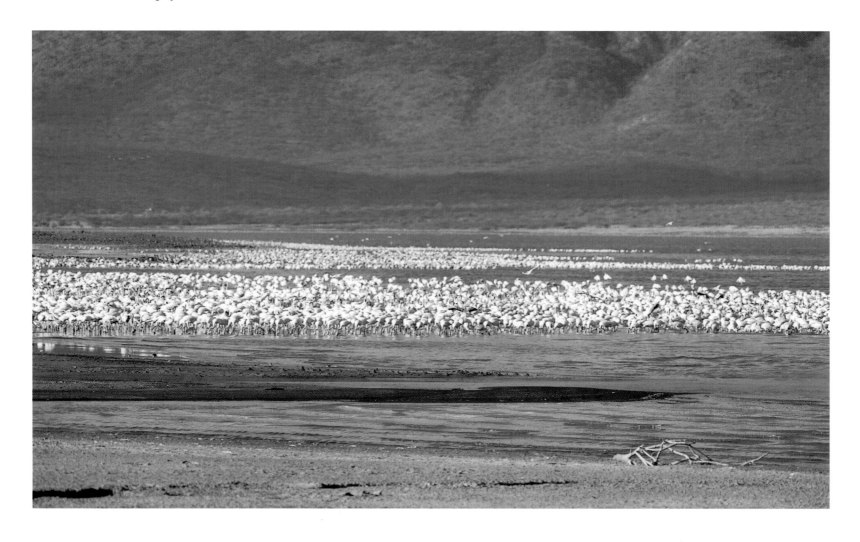

The soda lakes

During the wet season, heavy rain percolates into the volcanic rock and dissolves salts from it. The solution travels underground for considerable distances and finally emerges into one or other of the soda lakes at the bottom of the Rift Valley. Once in the open, this weak solution becomes more concentrated under the action of the hot sun and drying wind and the salts crystallize.

Lake Nakuru is the best known of the soda lakes and pictures of it with huge flocks of flamingos are common. There is

a choice of accommodation only minutes away by car. The birds here are spectacular. Apart from huge numbers of lesser flamingos and smaller ones of greater flamingos, there are great and long-tailed cormorants, pink-backed and white pelicans, African spoonbills and yellow-billed storks, little and great-crested grebes, as well as a good variety of ducks, herons, waders and small passerines.

The land around the lake is excellent for mammals. Defassa waterbuck are everywhere and there are lots of impala. It is a good place for Bohor reedbuck,

Lake Bogoria presents an impressive sight with its thousands of flamingos, and boiling springs
Nikon F2 with 70–210mm lens, Kodachrome 64, 1/250sec at f/8

which are elusive elsewhere. There are leopards and lions in the woodland, but they are not easy to find nor to photograph when you have found them. Giant (milky) eagle owls may be seen roosting in the trees, sometimes quite low down.

There is a road all the way round the lake and an offshoot provides access to Baboon Cliffs. Near the shelter at the top

there are rock hyraxes, which are not averse to small pieces of biscuit dropped on to a suitable site, though the cliff chats may get in first. Black eagles and augur buzzards appear from time to time. The small birds at the top of the hill include Schalow's wheatear.

Lake Bogoria is more dramatic than Nakuru. It has the same masses of flamingos, but is set among cliffs and boiling volcanic springs. There is no accommodation here, though you may be allowed to camp on the lake shore, giving you easy access to an unlimited supply of hot water for the washing up. Drinking water you should take because the lake water tastes revolting. If you stop to picnic, birds such as D'Arnaud's barbet and white-browed sparrow-weaver will be delighted to help out with anything spare. This is the only area where I have found lesser kudu, and then only once.

At the lowest part of the Rift Valley lies Lake Magadi, which has huge deposits of soda. These are worked commercially and are an important item in Kenya's balance of trade. The Masai and their animals make their way through as they have always done and even the flamingos take little notice and feed in the soda liquor at the side of the factory road. The biggest ever colony of lesser flamingos nested here one year when the water level at their normal site, just across the border in Tanzania, was too high.

There is no commercial accommodation at Magadi, but the road from Nairobi is good and a day trip can be made. Most of the water birds are found and there are often good opportunities to photograph them, especially around the western arm and near Bird Rock –

wherever relatively fresh water seeps into the lake. The speciality here is the tiny chestnut-banded plover, for which Magadi is the best place in Kenya.

The roads around Lake Magadi are very rough so a vehicle with plenty of ground clearance is advisable. Common zebra, Grant's gazelle, giraffe and wildebeest are likely to be seen. Several cats still occur, though it is some years since a leopard had to be chased out of the ladies' changing room at the Magadi Club. Magadi is the lowest point of the Rift Valley and can be very hot.

The freshwater lakes

There are two large freshwater lakes: Naivasha and Baringo. Lake Naivasha is only 50 miles (80km) along a tarred road from Nairobi, though heavy trucks sometimes make for slow going. There is plenty of accommodation. The whole range of east African wetland birds can be found on or around the lake, including white-breasted cormorants. These nest on dead trees in the lake and are accessible using one of the boats that are available for hire. There are many ducks, including migrants from the north during the northern winter, with garganey, shoveler and pintail quite numerous. The resident birds include yellowbills, African pochard and Egyptian geese. There is a good variety of herons, egrets, ibises, pelicans, and so on and a tremendous variety of waders. From a boat there is a chance of fish eagle, several of the duck species and herons. You will also find other species along the shore and hippos in the water. The boat can land you on Crescent Island, which is a pleasant place and offers chances for waterbuck and other mammals.

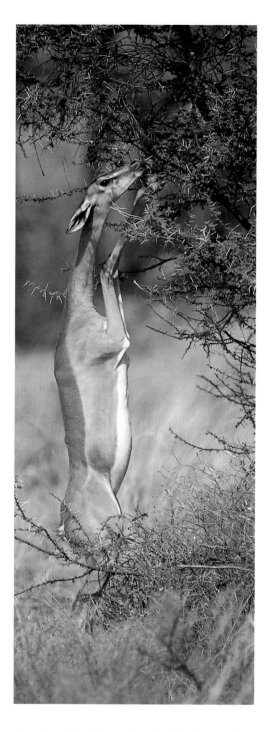

Gerenuks habitually stand on their hind legs so that they can reach vegetation that the other antelopes cannot; use a vertical format
Nikon F4 with 400mm lens, Fuji Sensia 100, 1/250sec at f/8

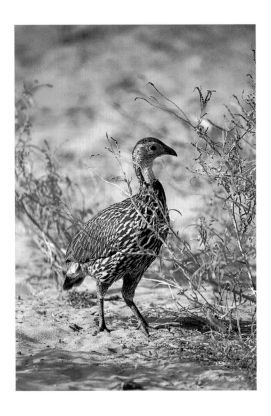

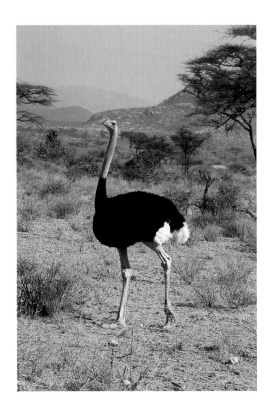

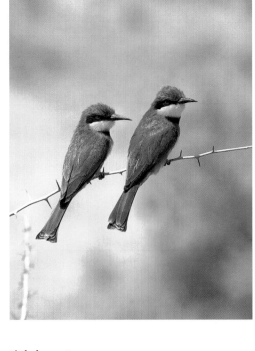

Yellow-necked spurfowl
Nikon F4 with 400mm lens, Fuji Sensia 100,
1/250sec at f/5.6

The ostriches in Samburu are of the northern form,
with grey rather than white necks
Nikon F4 with 300mm lens, Fuji Sensia 100,
1/250sec at f/8

Little bee-eaters
Nikon F4 with 400mm lens, Fuji Sensia 100, 1/250 at f/8

Lake Baringo lies just north of Lake Bogoria. There is a lodge and a campsite here. Many small birds, including a fine variety of weavers, can be found in the garden. There are heavyweights too, like the spotted eagle owl and white-bellied go-away bird. You can relax here over a meal and a drink, watching the birds out in the lake, then take a boat out and see if you can photograph them. There are hippos by the dozen, though when they are in the water they don't generally make much of a picture.

Across the road from the lodge there is a line of cliffs. These are worth a visit as they hold Hemprich's hornbill, brown-tailed rock chat and bristle-crowned starling, though getting anything more than record shots of them would demand a fair amount of time and preparation.

Nairobi National Park

Just half an hour from the centre of Nairobi is Nairobi National Park. A quick tour of it can be organized from any of the hotels and anyone with only half a day to spare in Nairobi would be well advised to take one.

From the park, the high-rise buildings of the city can be seen, but it is still a superb place for birds and mammals. There are no elephants, but most of the other mammals can be found. It is one of the best places for Coke's hartebeest and for eland. Black rhinos are possible.

Most of the park is fairly open and there is a comprehensive network of tracks and roads, so you have a reasonable chance of being able to approach an animal once you have located it. The birds are good too. Pools have the usual wetland birds and are also used by vultures for bathing. The open grasslands vary with the season but after rain are full of widowbirds and bishops displaying their fine feathers. There are longclaws, including pink-throated, francolins, bustards and shrikes.

Mount Kenya

In Aberdare National Park, Treetops is the best-known lodge, but The Ark and Mountain Lodge are just as rewarding. You will be taken there after meeting at a base a few miles away, and can look down on a water hole that may attract buffalo, giant forest hog, bushpig, lion, leopard, elephant, bushbuck and a variety of smaller animals. Being at treetop height, you get clear views of birds that are otherwise difficult to see well. The mammals are within range of a big lens, but shooting from high up isn't ideal. Downstairs you may find access to a hide, which offers a better angle and gets you closer, but for safety, the portholes are narrow, so you can't use big lenses.

You need to take your pictures in the evening and the morning, even though the water hole will be floodlit all night. These lights do not provide enough illumination for the camera, the colour bias will be extreme, and the distance precludes using flash. The birds will be out of camera range, unless something just happens to fly over. You can walk a short distance outside the lodge, even if it is only back towards the car park, and this will offer good birdwatching and an opportunity to photograph some of the monkeys.

The roads to the bases are all easily navigable in a small 4WD but, however you get there, the dust can be appalling. Everything, including your body, your clothes and your baggage, can get covered,

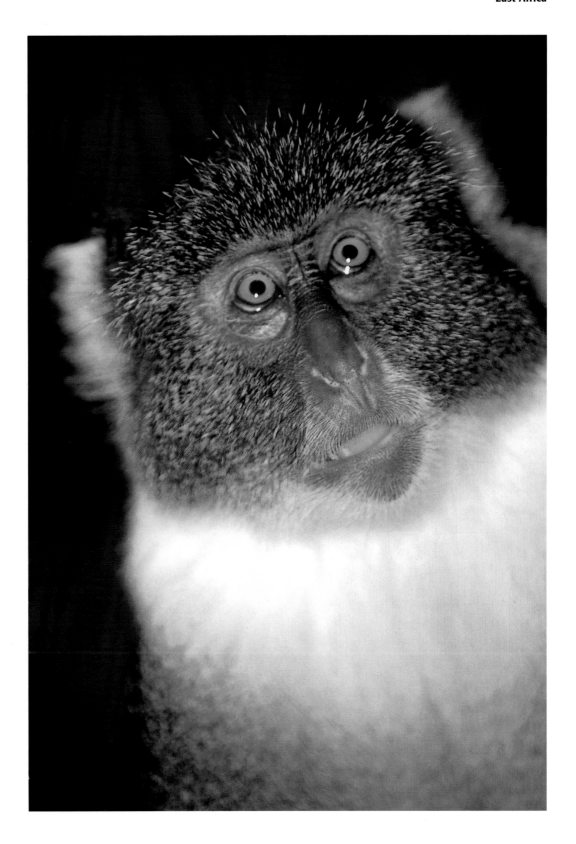

At tea time, the lodges in the Aberdare National Park are visited by blue monkeys
Nikon F2 with 105mm macro lens, Kodachrome 64, 1/60sec at f/11, flash

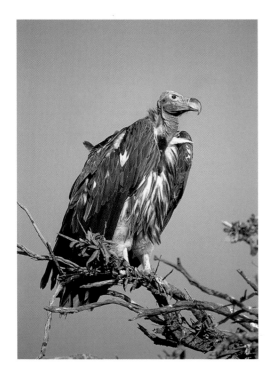

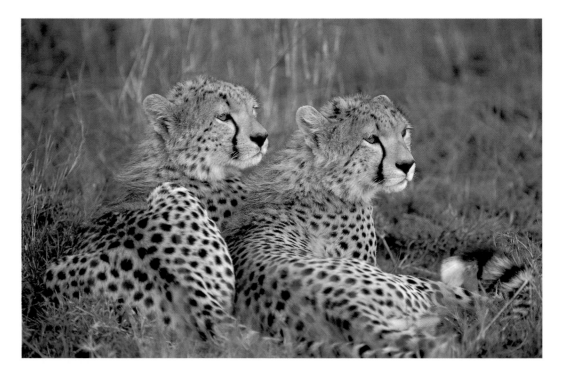

Lappet-faced vultures are the biggest of the family in the Mara
Nikon F4 with 500mm lens, Fuji Sensia 100, 1/200sec at f/8

Cheetah cubs wait together while their mother catches dinner ▲
Nikon F4 with 75–300mm lens, Fuji Sensia 100, 1/40sec at f/8

Hippos can swim quite briskly ▼
Nikon F4 with 400mm lens, Fuji Sensia 100, 1/250sec at f/5.6

and the red dust is not easily washed off. You and your vehicle will survive, but make sure your camera gear is protected.

Space is at a premium in all the lodges, so expect your room to be small and with limited facilities. There will be an alarm which the staff will operate if a species you particularly want to see turns up during the night.

Samburu

Samburu and its contiguous reserves lie in the dry north and offer many of the same species as other parks in Kenya, together with Grevy's zebra, fringe-eared oryx, reticulated giraffe and gerenuk. Greater kudu are possible but are very shy; they are much easier to photograph

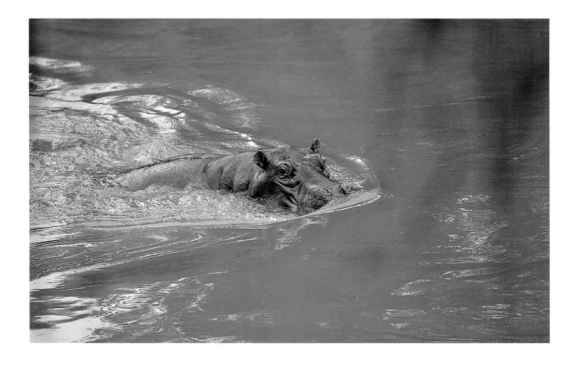

in South Africa. There are plenty of elephants and a sporting chance of both leopard and cheetah. Samburu is a good place to photograph the rather exotic vulturine guinea fowl.

It is a very dry area, so unless there has been recent rain, the animals tend to stay within walking distance of the river and lakes. There are several lodges and tented camps. The mass of tracks that are not signposted make navigation interesting, so be careful or take a GPS (global positioning system).

Masai Mara

This is the Kenyan extension of the Serengeti and is a favourite with television producers. It is a five-hour drive from Nairobi on rough roads or can be reached by plane. It is full of plains game, including topi and predators, especially lion, leopard, cheetah and spotted hyena. This is where you can see the migration of blue wildebeest and zebra, but to catch them crossing the rivers you have to be exceptionally lucky, as the timing is so uncertain. In any case, there will be gazelle, warthog, hippo and many birds. Vultures and marabous clean up the kills and there will be chances to photograph hornbills, kingfishers, shrikes and birds of prey. There are many camps and lodges providing comfortable quarters and serving good food. The tracks can be very rough, with deep mud after heavy rain, so you can struggle even in a 4WD.

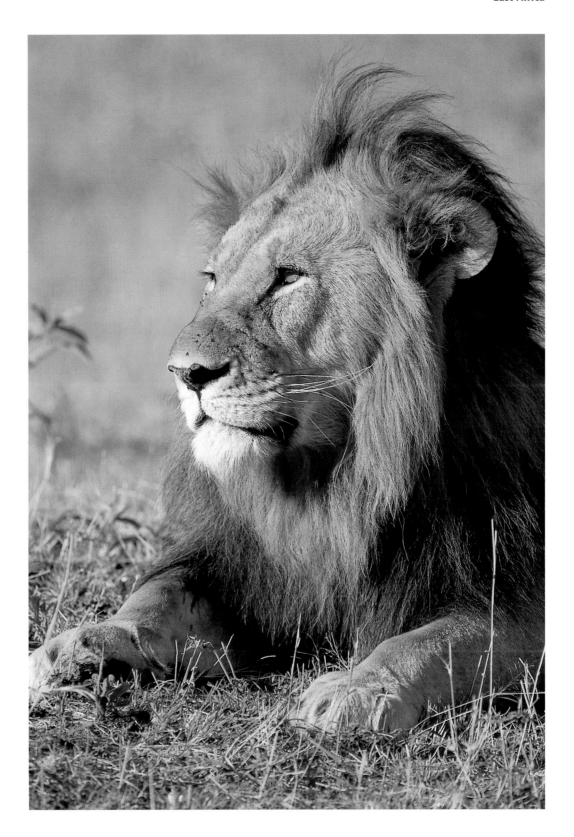

Lions are common in the Mara, but they do most of their work at night and doze for much of the day
Nikon F4 with 400mm lens, Fuji Sensia 100, 1/250sec at f/5.6

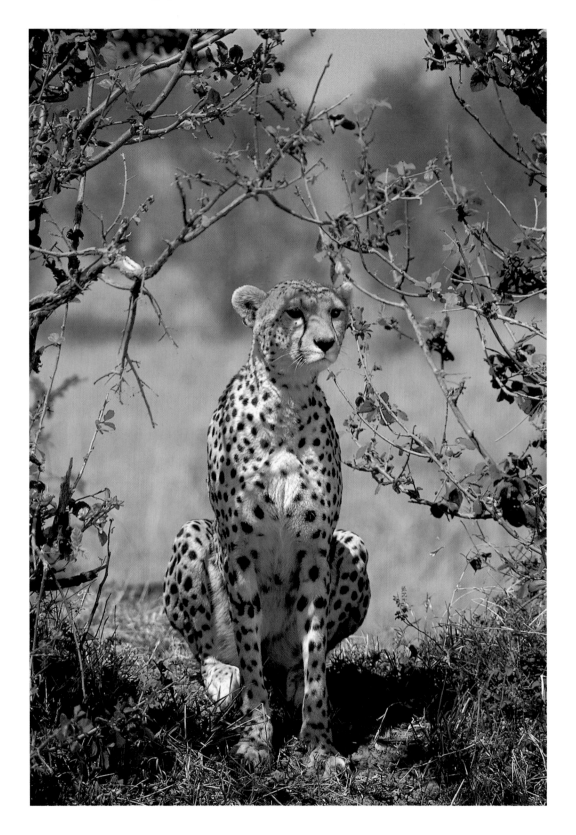

When a natural frame for your picture is offered, as with this Ruppell's griffon, use it
Nikon F4 with 500mm lens, Fuji Sensia 100, 1/200sec at f/8

Saddlebill stork, the tallest of the family
Nikon F4 with 500mm lens, Fuji Sensia 100, 1/500sec at f/5.6

Cheetah
Nikon F4 with 75–300mm lens, Fuji Sensia 100, 1/30sec at f/11

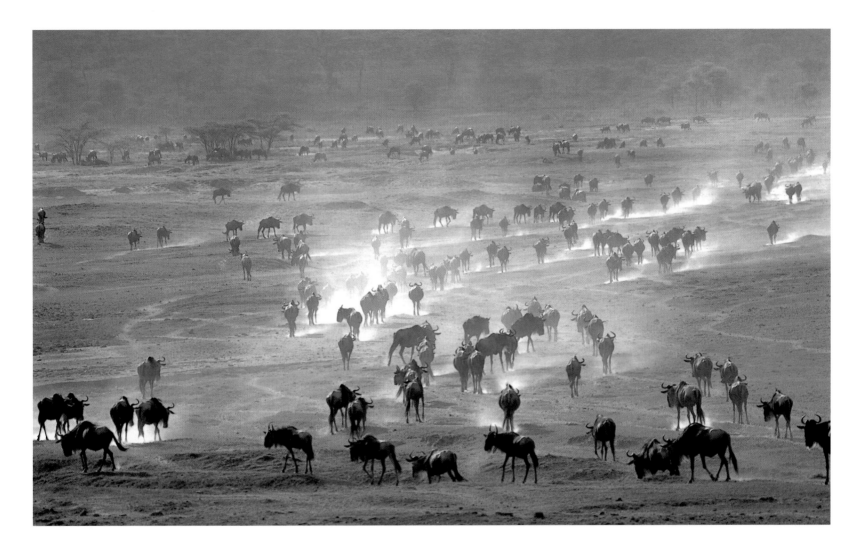

Mount Elgon

Mount Elgon offers a totally different experience. It is a major mountain, with Uganda on the other side. A track – 4WD recommended – will take you to about 11,000ft (3,350m). There are cave-dwelling elephants at the lower levels and signs of them much higher, but the bamboo thickets prevent you seeing much. I had the biggest fright of my life in one cave; I entered rather gingerly and was threatened by a most fearsome roar. As I backed out, expecting a leopard or worse, a black-fronted duiker,

about the size of a roe deer, hurtled past me, every bit as scared as I was.

Giant forest hogs feed at the forest edge. As you pass through the various vegetation zones, an interesting set of birds appear, including white-headed wood hoopoe and white-winged roughwing swallow. At the top of the track the air is pretty thin and, if you have not acclimatized, even a short walk with a camera is hard work.

An unpretentious lodge at Mount Elgon (a converted house with some bungalows in the grounds) has a few birds around.

Blue wildebeest move steadily across the plain in huge numbers, grunting as they go. This is one of the most impressive of all wildlife spectacles, but a difficult one to photograph well. You need to find one of the small rises, so that you look down on the herds and shoot into a low light in order to highlight the dust. Stop down to keep enough depth of field for the herd

Nikon F4 with 80–200mm lens, Kodachrome 64, 1/60sec at f/11

Long-tailed fiscal shrike
Nikon F4 with 400mm lens, Kodachrome 64,
1/750sec at f/5.6

TANZANIA

There are many good areas, but the Serengeti and the Ngorongoro Crater are best and rate highly by world standards. Driving to reach them is not easy as the roads can be rough and signposts are few. You could hire a vehicle with a driver who knows his or her way around, or settle for a commercial party.

The Serengeti

The Serengeti is an enormous plain with a few lakes. These support a great variety of birds, especially waders, but the edges of the lakes can be treacherous, so don't be tempted to go too close. Apparently firm ground quickly becomes semi-liquid under your wheels. If you get stuck you'll need a tractor to haul you out and the nearest one may be 10 miles (16km) away.

There are many inselbergs (rocky outcrops) and these are favourite places for predatory mammals, because they

Egyptian vulture
Nikon F4 with 500mm lens, Kodachrome 64,
1/250sec at f/5.6

Spotted hyenas see the herds as dinner on the hoof. They may scavenge from lion kills or pick out a weak animal for themselves
Nikon F4 with 80–200mm lens, Kodachrome 64,
1/250sec at f/5.6

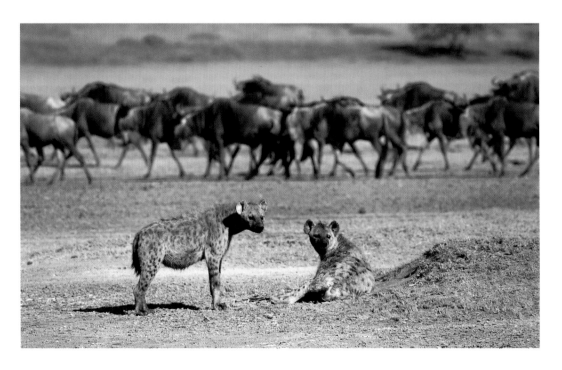

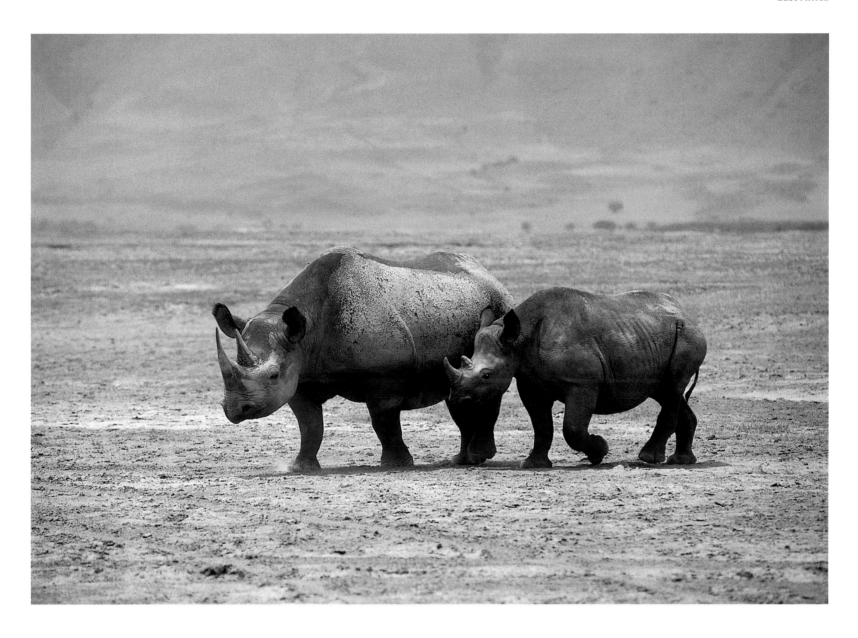

give a good view over the plain and provide sheltered places for mothers with young. You can do worse than simply drive from one inselberg to another, seeking lion, leopard and cheetah with rather good backgrounds.

Interesting birds, like Fischer's love-bird and rufous-tailed weavers, can be photographed at the lodges.

Ngorongoro Conservation Area

The volcanic crater of Ngorongoro has water all year round, so its animals do not need to make the usual migrations. The only access is by 4WD and it is usual to use vehicles from the lodges. The descent is steep and takes you to a lush plain, with trees and lakes. There are plenty of big mammals, including black rhino,

Ngorongoro is a good place to get black rhino in the open, because there they graze as well as browse. The crater wall makes a nice diffuse background
Nikon F4 with 300mm lens, Kodachrome 64, 1/125sec at f/8

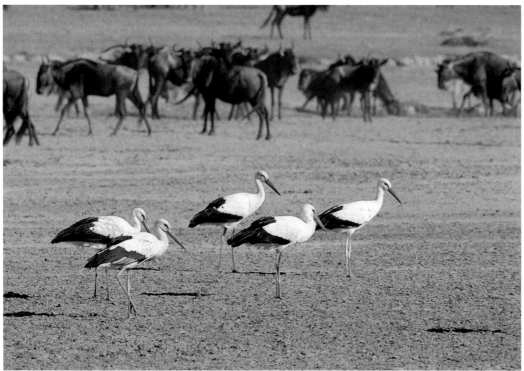

White storks
Nikon F4 with 400mm lens, Kodachrome 200, 1/125sec at f/11

Abdim's stork
Nikon F4 with 400mm lens, Kodachrome 200, 1/500sec at f/5.6

Birds bathing, like this sacred ibis, move their wings very energetically. Even with a high shutter speed, pictures often show more movement than you would choose
Nikon F4 with 400mm lens, Kodachrome 64, 1/250sec at f/5.6

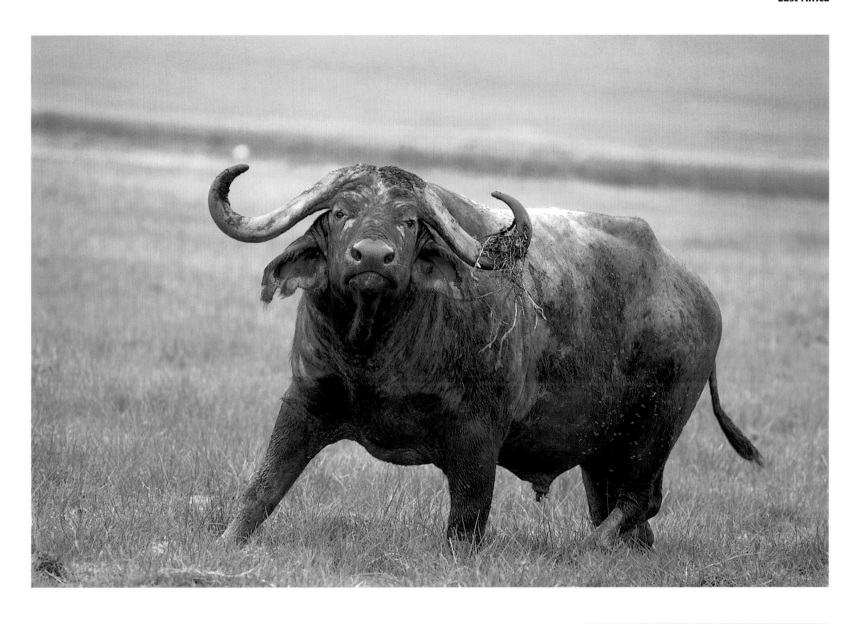

elephant, and lion. Abdim's and white stork are sometimes present in large numbers, as are water birds such as spurwing goose. The abundance of all sorts of wildlife is striking and is what makes Ngorongoro one of the world's prime sites for the wildlife photographer.

Buffalo are usually well-behaved when in herds, but lone ones may be bad-tempered. The dark coat can lead to overexposure
Nikon F4 with 400mm lens, Kodachrome 64, 1/250sec at f/5.6

Spurwing goose
Nikon F4 with 400mm lens, Kodachrome 64, 1/250sec at f/5.6

Southern Africa

Southern Africa is on a par with east Africa in terms of species and is better for travel and general organization. It is an easy area in which to arrange your own trip at a relatively low cost and there are also plenty of commercial tours. The roads, including those in the reserves, are well signposted and generally in good order. Crime, as usual, is a problem in urban areas, so avoid these and head straight into the countryside; 4WD is not normally needed. There is a comprehensive internal air service. The 'camps' in many of the national parks, which provide well-equipped huts with wildlife on the doorstep, are ideal for photographers and can be booked through the relevant park headquarters. Adjacent to the official reserves are many private ones. The accommodation and food in these are splendid but prices are high – sometimes astronomical. Means of exploration in the private reserves is usually limited to the camp vehicles and drivers. Hotels are generally abundant, of good quality, and cheap, but lie outside the national parks.

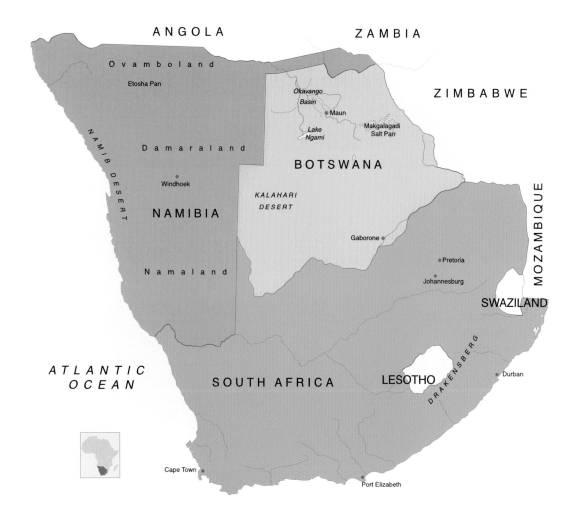

These spotted hyenas were denning in a culvert just outside one of the camps, and as the cub emerged while the sun was sinking, it required an exposure of 1/30sec

Nikon F4 with 80–200mm lens, Fuji Sensia 100, 1/30sec at f/2.8

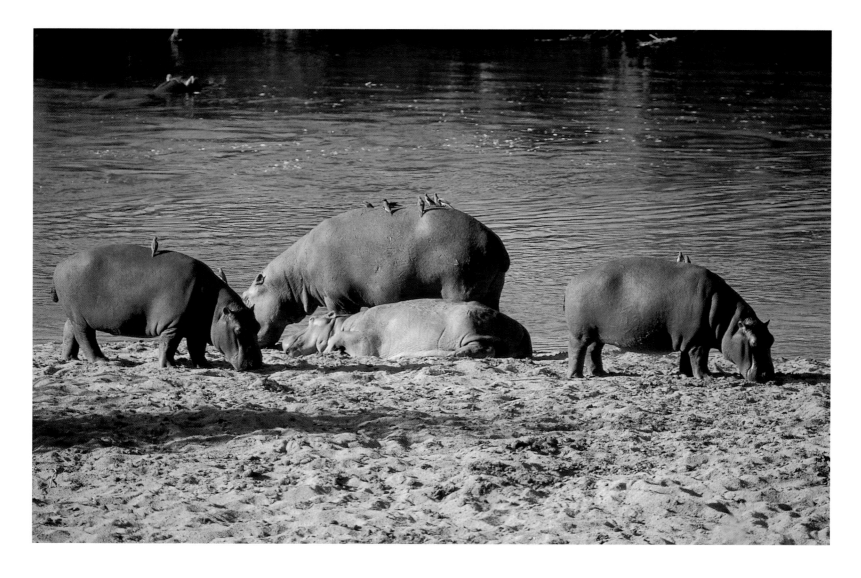

SOUTH AFRICA

Kruger National Park

The Kruger National Park is huge – about 250 miles (400km) from north to south and around 50 miles (80km) wide. If time is limited, work just the southern half. You can fly from Johannesburg to Skukuza, pick up a car and be in the park in five minutes. There are many camps within the park, some of them quite large; all provide accommodation and most have restaurants which serve plain but adequate food. Alternatively, you can buy food at the camp shop and cook for yourself. In the middle of the day you don't need to return to your own camp, but can stop at one nearer to where you happen to be to find a snack and a drink. The park's website gives details of all the camps, and the camp shops sell good maps of the park. Because it is so large, it is not crowded, except where a pride of lions parks itself at the roadside. The large animals are just as

Hippos are numerous along the rivers and, with a big lens, can be photographed from the road. The birds are red-billed oxpeckers

Nikon F5 with 300mm lens and 2X extender, Fuji Sensia 100, 1/320sec at f/5.6

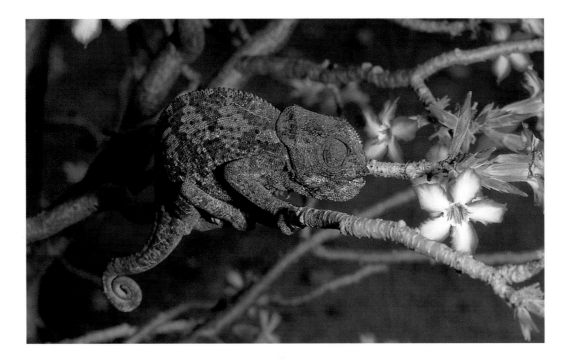

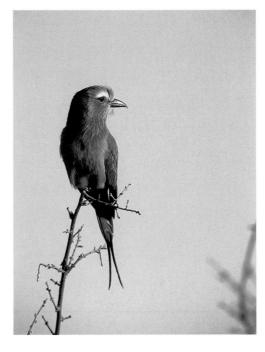

Flap-necked chameleon ▲
Nikon F5 with 105mm macro lens, Fuji Sensia 100,
1/250sec at f/11, SB24 flash gun

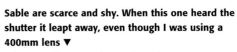

Sable are scarce and shy. When this one heard the shutter it leapt away, even though I was using a 400mm lens ▼
Nikon F4 with 400mm lens, Fuji Sensia 100,
1/180sec at f/5.6

Lilac-breasted roller photographed in very late afternoon sun
Nikon F5 with 300mm lens and 2✕ extender, Sensia 100,
1/80sec at f/8

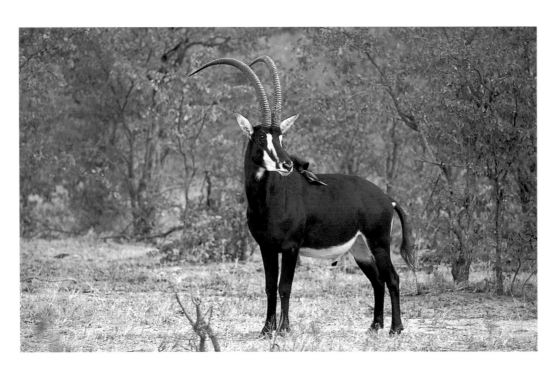

likely to be seen by the tarmac roads as by the dirt ones. You can expect to photograph Burchell's zebra, white rhino, warthog, hippo, giraffe, greater kudu, buffalo, waterbuck, blue wildebeest, steenbok, chacma baboon, vervet monkey, common duiker, impala, elephant and lion. Spotted hyena are plentiful too, and they sometimes den in roadside culverts. At night they patrol the camp fences in the hope of food scraps. With luck, you might get sable, wild dog, honey badger, and black rhino. There are 500 bird species in the park, though once out of camp bird photography is limited by your need to stay in the car. Despite this, you can still get plenty – red-billed, yellow-billed and ground hornbills, lilac-breasted roller,

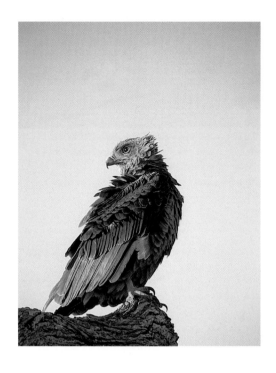

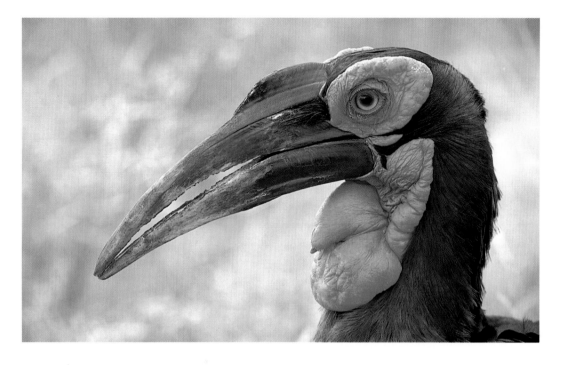

A young bateleur photographed as I was returning to camp at dusk ▲
Nikon F5 with 300mm lens and 2✕ extender, Fuji Sensia 100, 1/80sec at f/5.6

Sunset Dam outside Lower Sabie camp attracts many birds and mammals. This hamerkop is trying to rotate it in order to swallow it head first ▼
Nikon F5 with 300mm lens and 2✕ extender, Sensia 100, 1/250sec at f/5.6

Ground hornbills can be seen on some of the main roads, sometimes in family parties ▲
Nikon F4 with 80–200mm lens, Fuji Sensia 100, 1/180sec at f/4

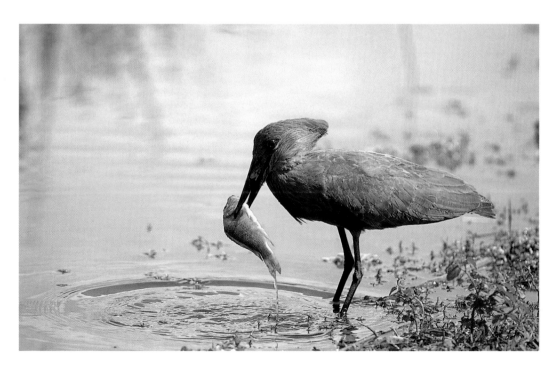

crowned guinea fowl, various sandgrouse, francolins, herons and birds of prey for a start. There are leopard tortoises, which grow quite big, and the lizards include the photogenic flap-necked chameleon.

Petrol and diesel are available, and cheap, at most camps. Some camps offer night drives in their own vehicles, but you cannot drive yourself after dark; hippos and other creatures are more aggressive at night, and the restriction also helps to reduce the disturbance of wildlife. The park vehicles are large, but open, and encounters with lions almost within touching distance are routine. Casualties are remarkably few, but one of the rangers was killed by a leopard when he got out of the vehicle to go to the toilet.

The Kruger is hot, wet and malarial in summer. That is when most of the birds breed and the vegetation is at its greenest, but it is also the most difficult time to photograph. The park is delightful from about June to September, when it is dry, sunny and warm, and photography is easy. Precautions against malaria are still required during these months, though the risk of infection is less.

Cape Province

The Kalahari Gemsbok National Park, now named Kgalagadi Transfrontier Park, is another huge one, with 1 million hectares in South Africa and a further 2 million in Botswana. The simplest approach is from Upington, from where it is a half-day's drive, part of it on dirt roads. The 'rainy' season, March to May, is the best time as new grass attracts herds to the river beds.

Although leopards are quite common and their tracks can be seen within the camps, they are nocturnal and shy – only very occasionally is one seen in daylight
Nikon F4 with 75–300mm lens, Kodachrome 200, 1/250sec at f/8

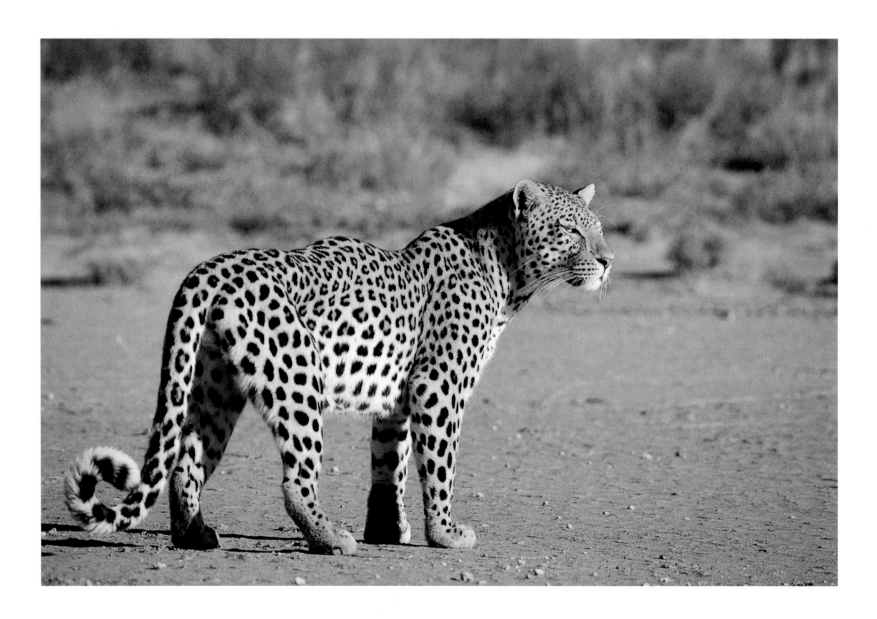

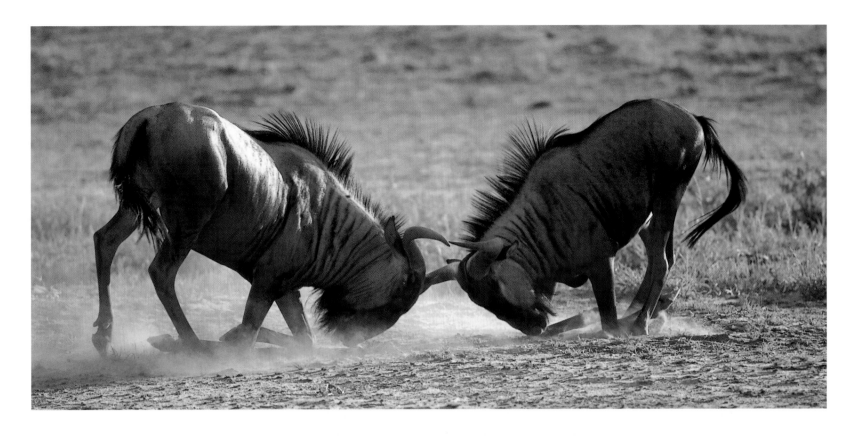

Blue wildebeest sparring
Nikon F4 with 300mm lens, Fuji Sensia 100,
1/250sec at f/4

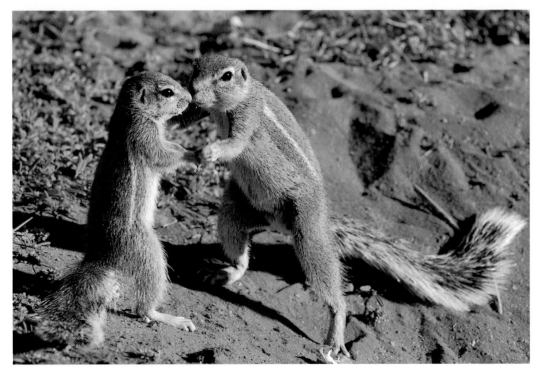

**Like any small animal, Cape ground squirrels need
to be photographed from as close as possible to
ground level. With care, you can crawl up to them in
camp or at one of the picnic places**
Nikon F4 with 300mm lens, Kodachrome 64,
1/125sec at f/11

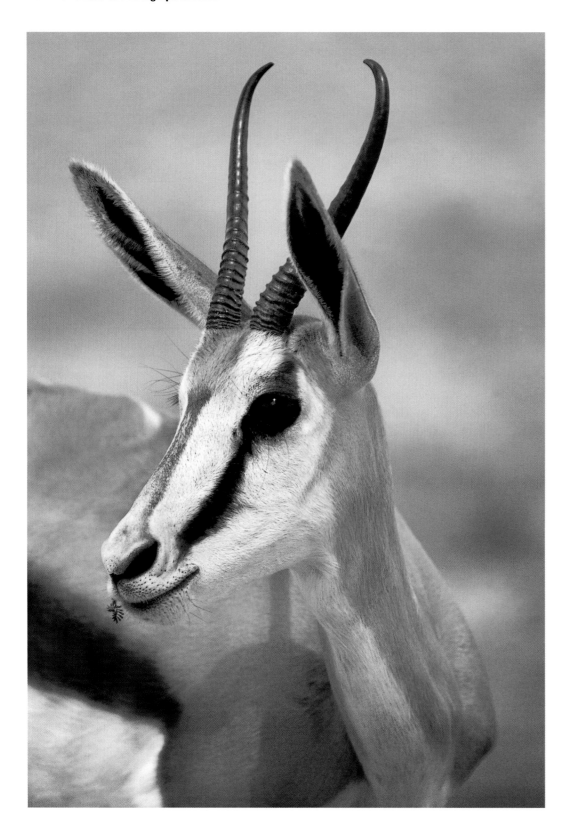

The rain falls mainly in impressive thunderstorms, which may briefly flood the roads. It is most unlikely that there will be any water visible in the riverbeds, but there is some deep down with big trees to prove it. A 4WD will be handy if you meet a wet spell. Without rain, it is dusty and hot.

Lions are quite conspicuous and may roar at night along the camp fence. The main prey animals are springbok, blue wildebeest, gemsbok (oryx) and a few red hartebeest. There are plenty of cheetahs and some leopards. Black-backed jackals are common but the spotted and brown hyenas are nocturnal and you have to be lucky to photograph them, as you cannot leave camp at night. There are meerkat, slender and yellow mongoose, Cape ground squirrel, Cape fox and bat-eared fox. Small birds come to drink at the water holes as do two species of sandgrouse. Huge communal nests of social weavers cannot be missed: they are sometimes shared with pygmy falcons and yellow Cape cobras, which visit the nests in order to eat the eggs and young. Of the bigger birds, pale chanting goshawk, lanner falcon, kori bustard and secretary bird are the most certain.

Cape Province also has some small national parks. Fly to Port Elizabeth and drive to Addo National Park, which has elephant, red hartebeest and black rhino, not to mention a rare dung beetle.

If you see a herd of springbok grazing towards a water hole, you can get in place and wait for them; they are less nervous if your vehicle is part of the scenery when they arrive
Nikon F4 with 300mm lens, Kodachrome 64, 1/60sec at f/11

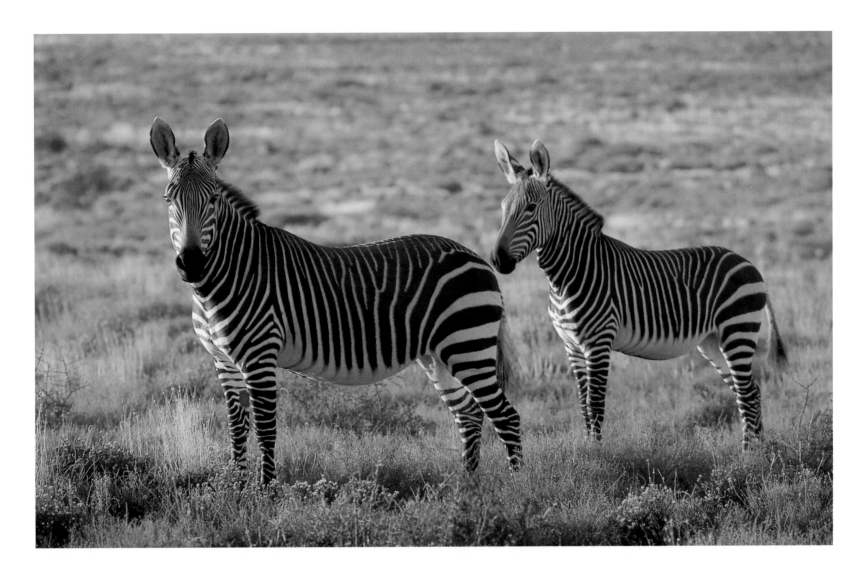

You can go on to Mountain Zebra National Park, for mountain zebras and grey rhebok. The Cape mountain zebra was very near extinction but has recovered under protection and breeding groups have been settled in other areas. Proceed to Karoo National Park for gemsbok, eland, black wildebeest, springbok and plenty of birds. All of these offer pleasant accommodation and a restaurant, though you can also barbecue your food as facilities are always available. Each camp

has a shop and petrol. At Boulders, near Simonstown, you can photograph jackass penguins. The West Coast National Park lies north of Cape Town and is the best place to find the scarce angulate tortoise. Whales appear from late July until the end of October, though these are better viewed along the east coast from Hermanus to the De Hoop National Park. It is an easy drive north to Lambert's Bay, which has a large colony of Cape gannets, accessible via a causeway and with a hotel across the road.

Cape mountain zebras have closer striping than Burchell's zebras

Nikon F5 with 300mm lens, Fuji Sensia 100, 1/60sec at f/11

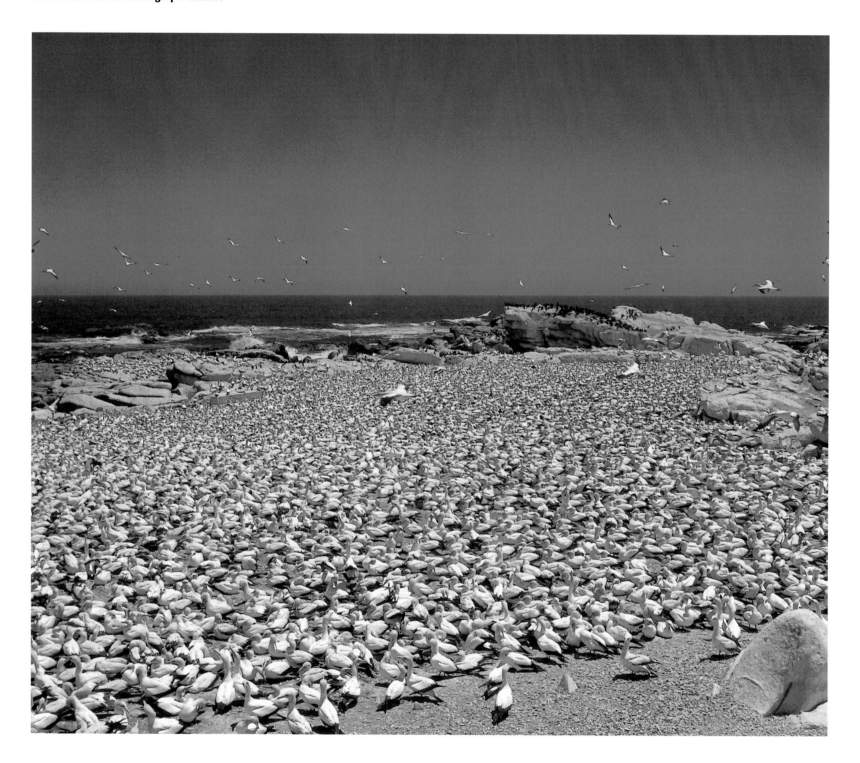

Cape gannets nesting at Lambert's Bay
Nikon F5 with 70–210mm lens, Fuji Sensia 100,
1/125sec at f/11, polarizer

Leopard tortoises require you to belly crawl to get the low angle you need. With your elbows on the ground, you don't need a tripod. In the small Cape reserves you can leave your car to take this sort of shot
Nikon F5 with 70–210mm lens, Fuji Sensia 100, 1/125sec at f/11

Eland are the biggest of the South African antelopes and were the prey most sought by the San people
Nikon F5 with 500mm lens, Fuji Sensia 100, 1/160sec at f/8

Black wildebeest
Nikon F5 with 500mm lens, Fuji Sensia 100, 1/160sec at f/8

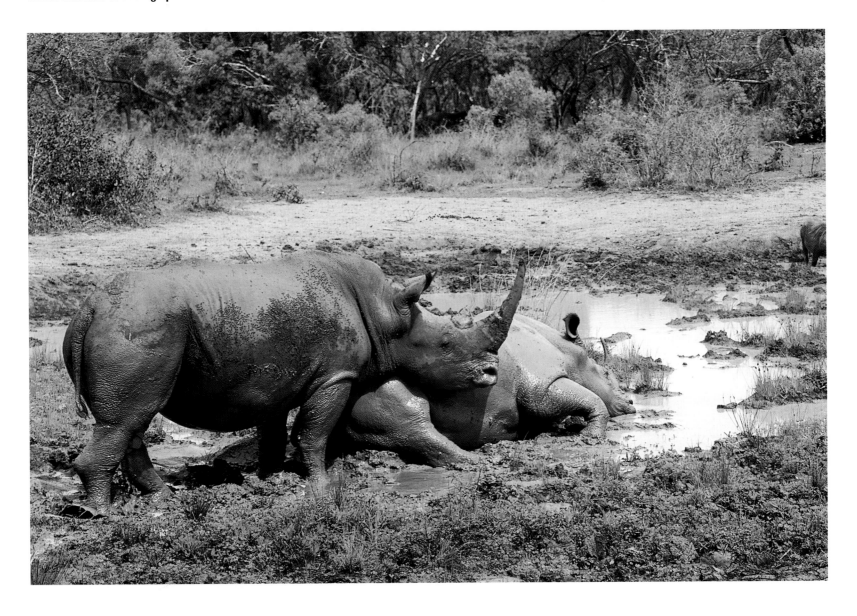

KwaZulu/Natal

The parks in KwaZulu/Natal have the most white rhinos and nyala and an abundance of other mammals and birds. Fly to Durban and drive from there – four hours on good roads. From Johannesburg it is a bit further – you should allow seven hours. Umfolozi-Hluhluwe still holds about a third of the world's population of white rhino, despite having supplied the rest of South Africa and Kenya. They are massive but quite docile, unless they have a young calf at foot. Mkuze, a little further north, has the world's finest photographic hides, where you can sit in the dry season and let the wildlife come to you. For a first visit, allow at least five films a day, even though the best light for the hides ends some time around midday, when shadows fall across the pools.

White rhinos courting at a mud wallow in Hluhluwe, taken from a permanent hide
Nikon F5 with 70–210mm lens, Fuji Sensia 100, 1/125sec at f/11

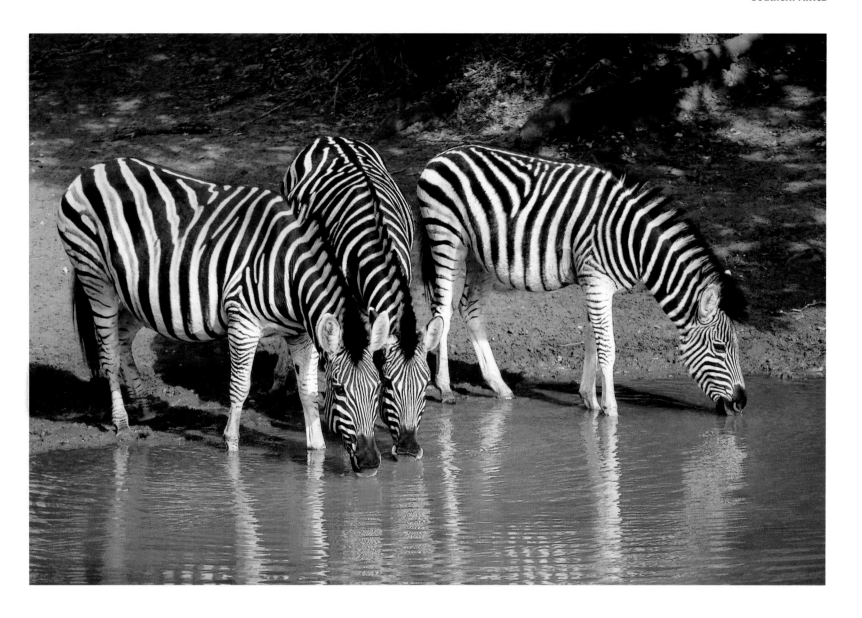

Burchell's zebras, taken from a Mkuze hide
*Nikon F5 with 70–210mm lens, Fuji Sensia 100,
1/250sec at f/8*

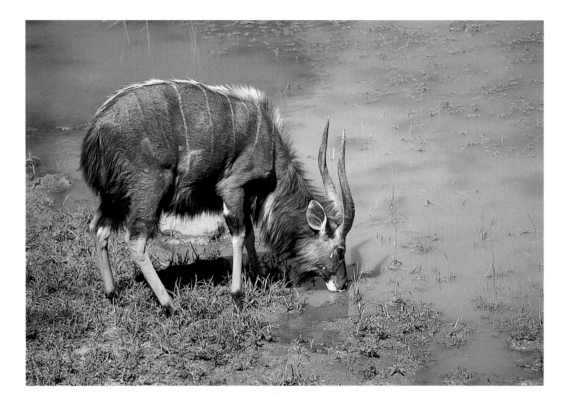

Nyala are common in the KwaZulu/Natal parks, but hard to find anywhere else
Nikon F5 with 70–210mm lens, Fuji Sensia 100, 1/250sec at f/8

On a hot day, Cape terrapins come out to take in the warmth
Nikon F5 with 300mm lens, Fuji Sensia 100, 1/60sec at f/11

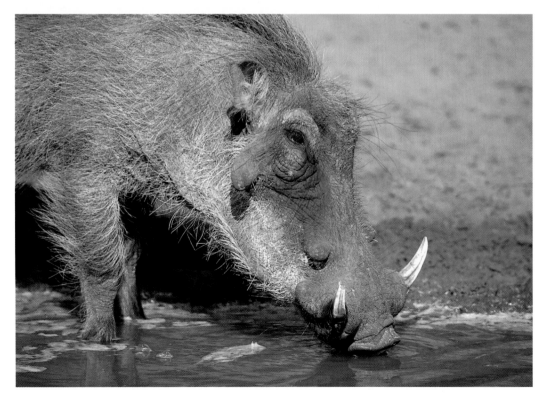

Warthog, taken from a hide in Mkuze
Nikon F5 with 300mm lens and 2✕ extender, Fuji Sensia 100, 1/250sec at f/8

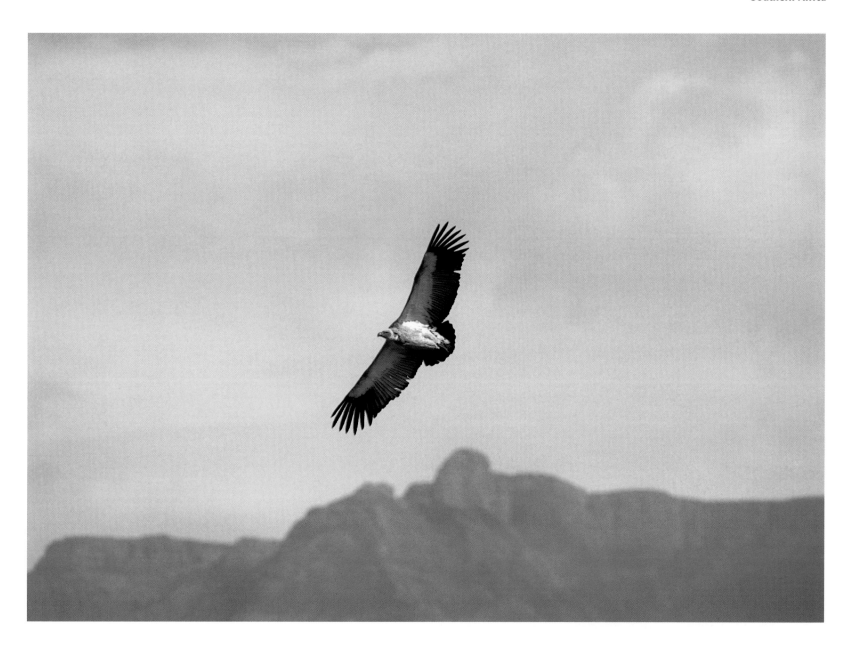

Giant's Castle, in the Drakensberg, offers lammergeier and Cape vulture in winter and a superb hide built into the cliff edge from which to photograph them. It is designed so that you can see out, but the birds cannot see in. It is only available during winter weekends, when the warden will put out bait. He will probably drive you up early in the morning, leaving you to walk back to camp when you have finished. Red-winged starling, Cape rock thrush and familiar chat will probably be the first to come to the bait. Take a 600mm lens and a beanbag. It will be cold – possibly frosty, and occasionally snowy – because of the altitude.

Cape vulture
Nikon F5 with 300mm lens and 2✕ extender, Fuji Sensia 100, 1/250sec at f/5.6

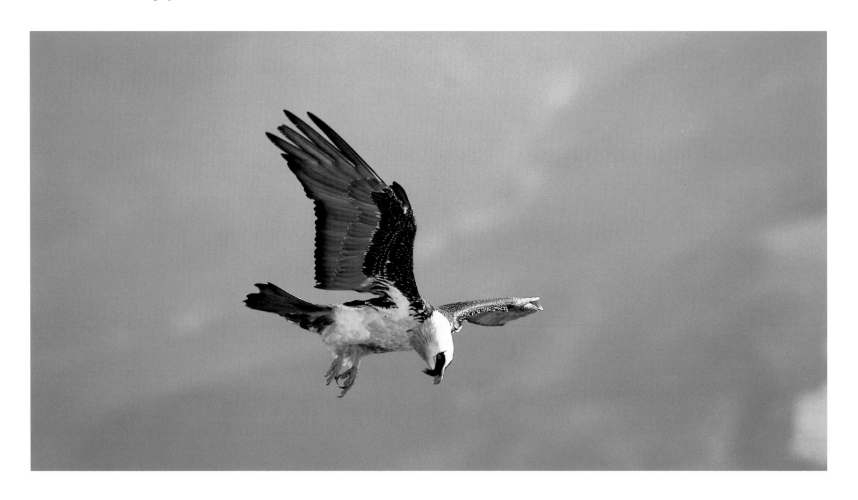

Lammergeiers and Cape vultures come to the vulture restaurant at Giant's Castle
Nikon F5 with 300mm lens and 2× extender, Fuji Sensia 100, 1/500sec at f/5.6

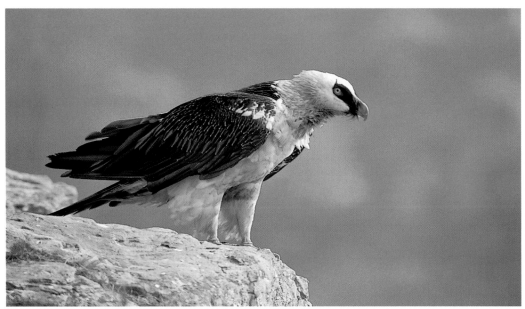

Lammergeier
Nikon F5 with 300mm lens and 2× extender, Fuji Sensia 100, 1/500sec at f/5.6

Black-eyed bulbul
Nikon F5 with 300mm lens and 2✕ extender, Fuji Sensia 100, 1/250sec at f/5.6

Smaller birds, like the red-winged starling, come to enjoy the bait long before the vultures. They come closer to the hide but a 600mm lens is still about right. You can use a beanbag
Nikon F5 with 300mm lens and 2✕ extender, Fuji Sensia 100, 1/250sec at f/5.6

Cape rock thrush
Nikon F5 with 300mm lens and 2✕ extender, Fuji Sensia 100, 1/250sec at f/5.6

NAMIBIA

Tourism is not yet a huge business for Namibia, but it is important and growing. Windhoek can be reached by air from Heathrow and Frankfurt and car hire is easily arranged; 4WD is not needed around Etosha in the dry season, but would be desirable in the wet, and essential if you leave the main roads and enter the sandy country near the west coast. The tarred roads in Namibia are very good and carry virtually no traffic. Minor roads are dirt but pose no problems unless you try to drive too quickly; excessive speed on them seems to cause significant mortality to residents and incautious tourists alike.

Etosha Pan, dry season
Nikon F4 with 28–70mm lens, Kodachrome 64, 1/125sec at f/8

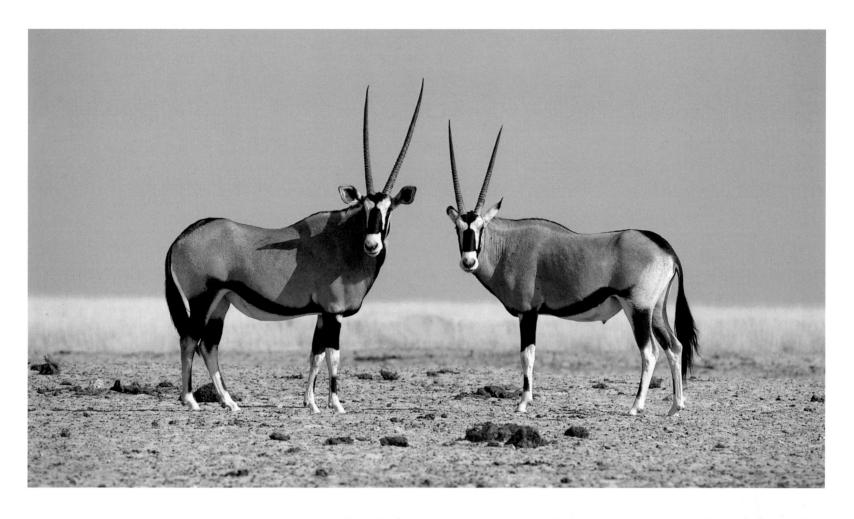

Gemsbok
*Nikon F4 with 300mm lens, Kodachrome 64,
1/250sec at f/5.6*

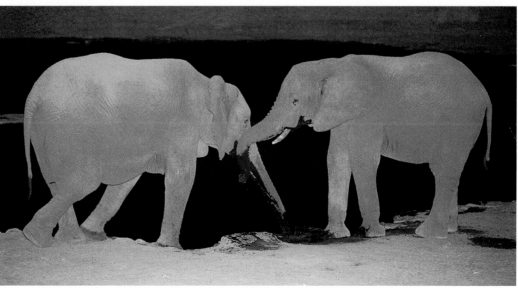

Elephants at night, photographed at Okaukuejo
*Nikon F4 with 80–200mm lens, Kodachrome 200,
1/60sec at f/2.8, SB24 flash gun*

Etosha National Park

The best wildlife opportunities are in the Etosha National Park, an easy day's drive north from Windhoek. You have a choice between privately run accommodation and that in the park. Although the private lodges range from the comfortable to the luxurious, and serve excellent food, they are expensive and you need to drive into the park to find animals in numbers. It is better to stay in the park, where the animals are on your doorstep – literally sometimes. There are three places to stay: Okaukuejo in the west, Namutoni in the east and Halali in the centre. Each camp offers bungalow accommodation of a good standard with air-conditioning and, usually, an en-suite shower and toilet; each

Herds of impala rarely form a tidy composition. This was the nearest I got to one
Nikon F4 with 80–200mm lens, Kodachrome 64, 1/250sec at f/8

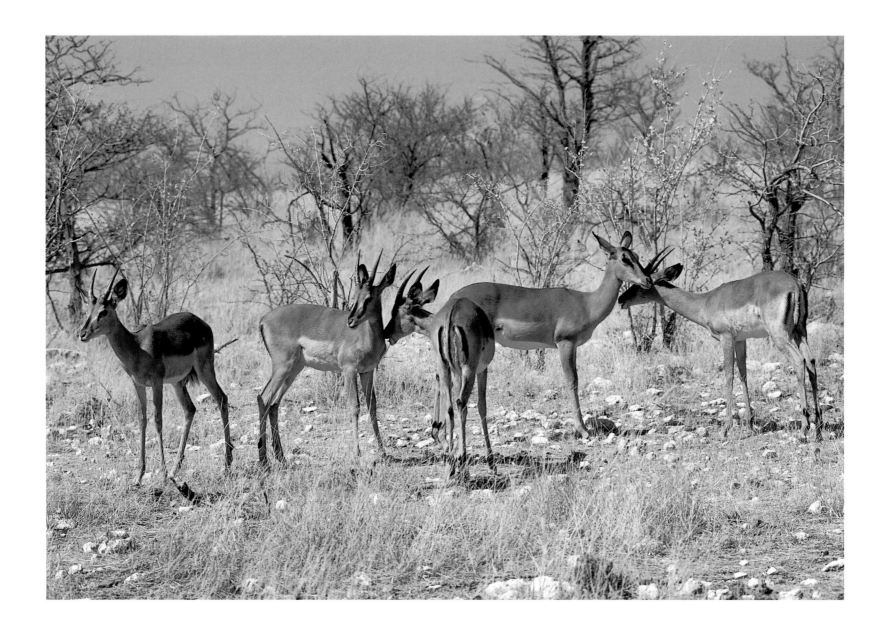

has a restaurant serving reasonable food. The staff are fluent in English and German. Book with the Namibian National Park authorities.

Okaukuejo is the biggest camp and has a water hole within it. This is visited by plains game during the day and by elephant and black rhino at night. There is a fence which keeps the big stuff away

Damara dik-diks stay in cover for most of the day; an early start gets you the picture and some interesting lighting
Nikon F4 with 80–200mm lens, Kodachrome 200, 1/60sec at f/2.8

Occasionally a grazing herd of red hartebeest will allow a vehicle to get close enough for this sort of shot; f/8 has kept both horns sharp at the expense of retaining more background detail than ideal
Nikon F4 with 300mm lens, Fuji Velvia 50, 1/180sec at f/8

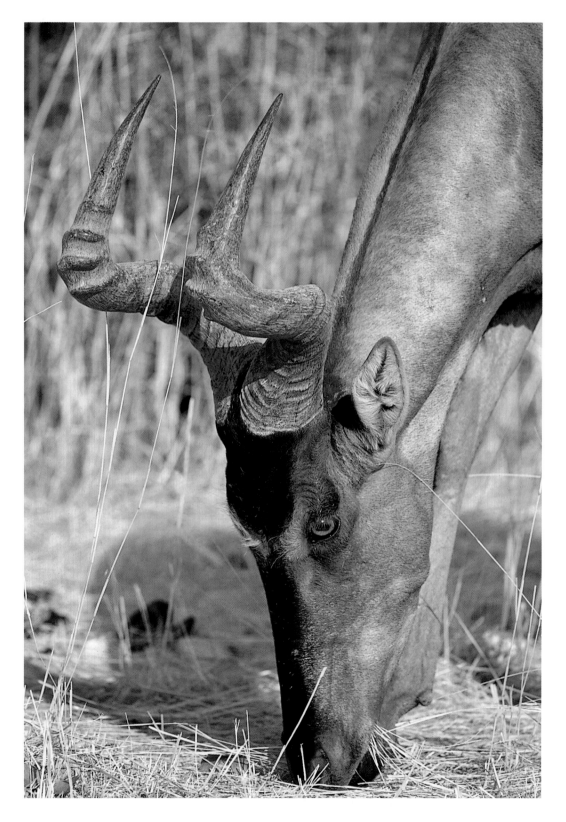

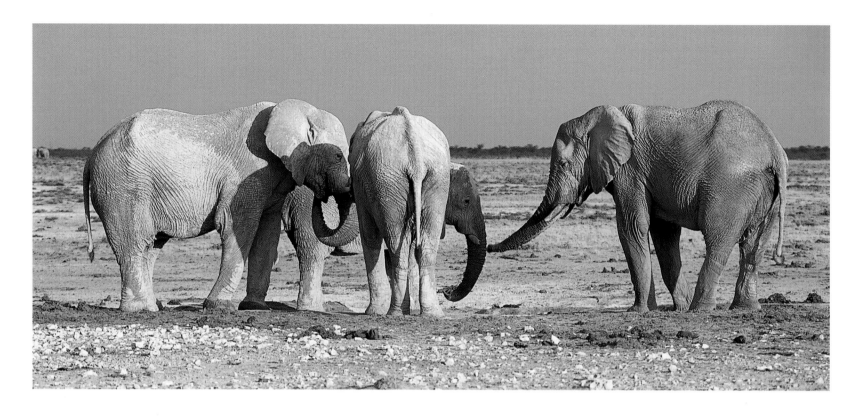

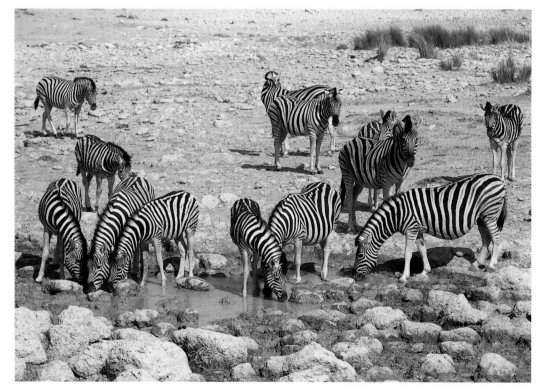

As the light is going, elephants gather at Nebrownii water hole
Nikon F4 with 400mm lens, Kodachrome 64, 1/125sec at f/8

from the huts and allows only the jackals to come scrounging. If you barbecue your dinner, a visit from them is likely. The water hole is floodlit at night and provides excellent viewing; record shots with a powerful flash gun are not difficult. As the animals stir up the mud, the smell can be memorable.

Burchell's zebra at a natural water hole
Nikon F4 with 80–200mm lens, Kodachrome 64, 1/125sec at f/11

Halali and Namutoni also have water holes, but they attract fewer animals. You cannot leave the camps at night, but the gates are open from sunrise to sunset, which is around 6.30am to 6.30pm in October. (In December it is open, roughly, between 5.30am to 7.00pm, and in July, from 6.30am to 6.00pm.) The game stays within reach of water and, as water holes are far apart, there are areas with few animals. In some places, water is supplied by pumping it into concrete troughs, which are effective but not photogenic.

Indeed, much of Etosha in the dry season is not very pretty. The pan itself is dry, grey clay. However, the animals are healthy and well fed. You can rely on finding herds of springbok, oryx (gemsbok) and Burchell's zebra, plus blue wildebeest, giraffe, elephant, red hartebeest, black-faced impala, steenbok and Damara dik-dik (a race of Kirk's dik-dik). Of the big predators, lion and spotted hyena are fairly common and easily found, leopard and brown hyena common but unlikely to show themselves, and cheetah scarce.

Lions are dominant. A pride usually kills at night near a water hole, then spends some considerable time eating and drinking. Until they have finished and moved away, the herbivores cannot risk reaching the water, so numbers build up and the area becomes a milling mass of animals. When elephants arrive, the lions move away. Nothing, but nothing, stands in the way of a herd of elephants.

Giraffes, despite their size, can almost disappear against the winter foliage
Nikon F4 with 80–200mm lens, Kodachrome 64, 1/125sec at f/5.6

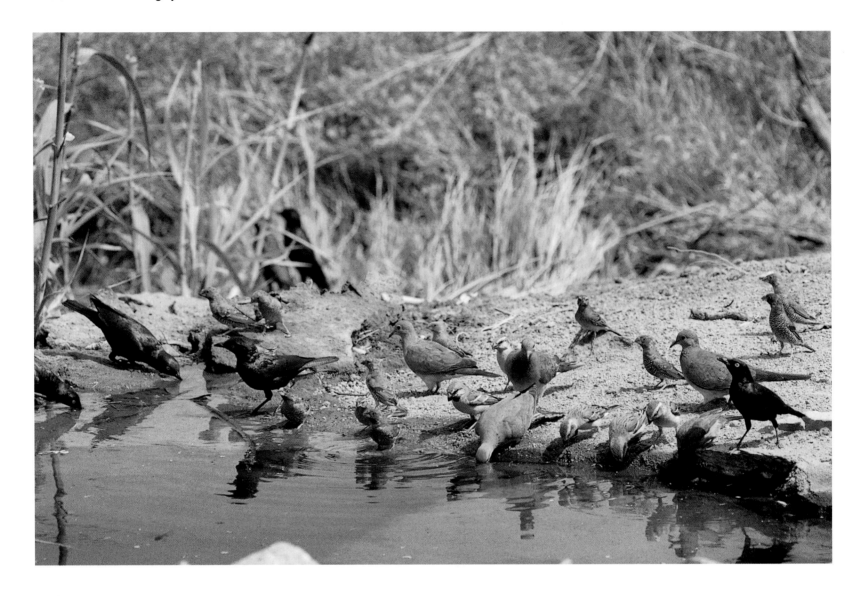

All the large mammals are easily photographed; problems are most likely to centre around their almost constant movement and having too many animals in the frame, which makes it difficult to achieve a pleasing composition. The backgrounds need all the care you can give them to reduce the harsh appearance of the calcrete, a hard, white mineral that is very common in Etosha. Getting close enough to the smaller animals needs more

time and persistence, but black-backed jackal, Damara dik-dik and Cape ground squirrel are relatively easy. As usual in the Tropics, the light is most pleasant early in the morning and late in the afternoon. Plain blue skies are the rule, so habitat shots need to be taken whenever some decent clouds show up.

Etosha in winter is not the greatest place for photographing birds, but around the water holes there are lark and other

Even a small pool can muster a host of birds. Here are Cape glossy starlings, laughing doves, great sparrows and red-headed finches
Nikon F4 with 400mm lens, Kodachrome 200, 1/250sec at f/11

Lark-like bunting
*Nikon F4 with 400mm lens, Kodachrome 200,
1/250sec at f/8*

Northern black korhaan
*Nikon F4 with 300mm lens, Kodachrome 64,
1/250sec at f/8*

Double-banded courser
*Nikon F4 with 400mm lens, Fuji Velvia 50,
1/125sec at f/5.6*

passerine, plus crowned guinea fowl and red-billed francolin. The woodlands offer chances of white-crowned and carmine-breasted shrike, fork-tailed drongo, hornbill, purple roller and chat flycatcher. Raptors are rather few, apart from pale chanting goshawk and greater kestrel. Vultures are not all that obvious, though I have known a group of over 100 take

three days to work their way through two elephants which had died, probably from anthrax. The most photogenic birds are the sandgrouse, both flying and at the water holes, and the bigger grassland species: crowned plover, spotted dikkop, double-banded courser and the bustards. Kori bustard and northern black korhaan are particularly amenable.

Sandgrouse generally drink at a regular time, so you can position yourself at the water and wait. Their call is one of the most evocative of all desert sounds
Nikon F4 with 400mm lens, Kodachrome 200, 1/500sec at f/8

BOTSWANA

There is a reserve in the south of the country that is contiguous with what used to be called the Kalahari Gemsbok National Park. For a long time managed jointly with South Africa, this has now been formalized as the Kgalagadi Transfrontier Park. Two-thirds of the reserve is in Botswana, but the easiest access and most comfortable camps are in the South African section. For this reason I have described it in the section on South Africa (see p 56).

The Central Kalahari reserve is noted for its brown hyenas, lions, leopards, cheetahs and many ungulates, especially springbok. This is harsh country without much water, but tourist operations are being developed for those willing to camp in fairly basic conditions. The official camping sites must be used. The trees on them provide welcome shade, but there are virtually no other facilities, so you must take everything with you. Temperatures can be extreme around the turn of the year, but heat-resistant visitors will enjoy the wilderness experience. Photographically, the Kgalagadi in South Africa offers the same species in greater abundance, with more comfort and at less expense.

As you fly in, the mosaic of islands and channels of the Okavango Delta is well displayed
Nikon F4 with 50mm lens, Kodachrome 64, 1/500sec at f/4

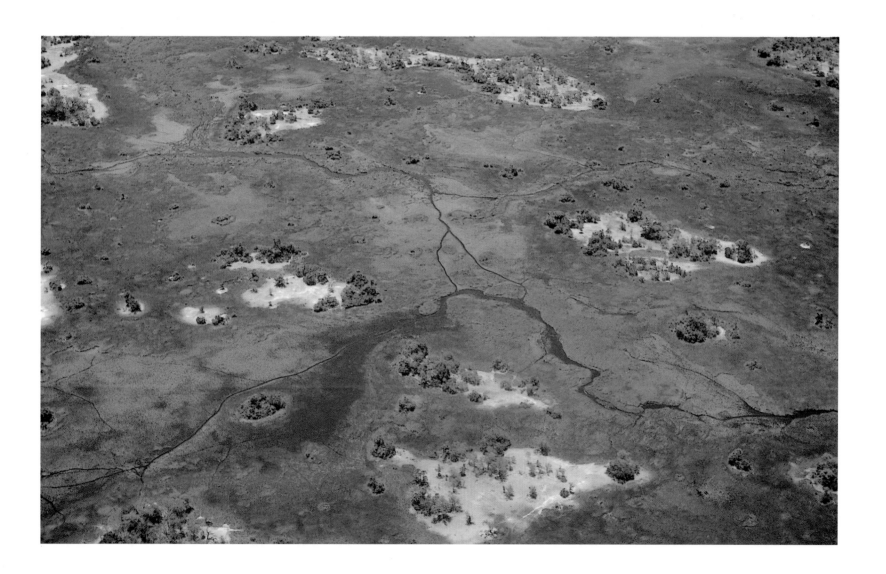

Okavango Delta

The area I can recommend without hesitation is the Okavango Delta in the north of the country. Several months after the rains in Angola, water drains through the 'panhandle' of the delta and spreads out into a great wetland of islands with palms and papyrus, separated by waterways of ever-changing shape. The water probably carried on through to the Zambezi at one time, but earth shifts have caused a barrier so that now it can only go into the desert, where it disappears.

Navigation by boat is difficult, because the forms and positions of the islands shift. It can also be hazardous because the hippos do not give way gracefully. Travel by road is difficult and slow even where it is possible, so small aircraft are the key to most current operations.

Dawn over the River Khwai ▲
Nikon F4 with 24–40mm lens, Kodachrome 64, 1/60sec at f/4

Mokoros are silent, but wobbly ▼
Nikon F4 with 75–300mm lens, Kodachrome 64, 1/125sec at f/8

You may share your lodgings with the locals
Nikon F4 with 105mm macro lens, Kodachrome 64, 1/250sec at f/16, SB24 flash gun

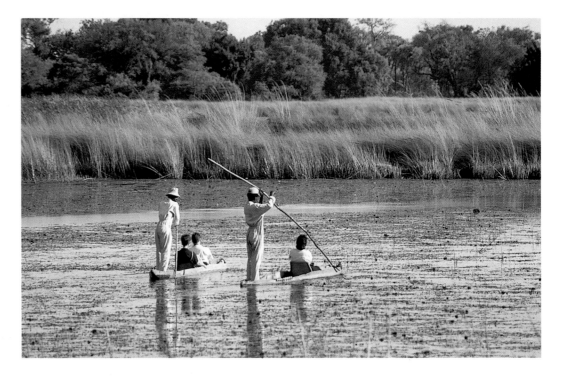

Many tourist camps have been set up, each with an airstrip. Fly to Maun and take it from there, using one of the many packages available. The camps are much more comfortable than anyone could reasonably expect in such a remote place. Only limited walking is possible, for obvious reasons, and most of the wildlife is seen from boats. There is usually a choice of a mokoru, the local form of dugout canoe, or a fibreglass boat with an outboard engine. Both will come with a boatman who knows how to find birds and mammals, but who may not be geared to photography. The minimal freeboard of the mokoru looks frighteningly small, but it is fine as long as the occupants sit still. It makes no noise so might appear to offer the best way to stalk the wildlife, but my experience was that the birds were more afraid of it than they were of the raucous sound of an outboard motor. As the fibreglass boats are larger and provide a higher and more stable viewpoint, they were my first choice.

Photography from boats is always difficult. Here you need a boatman who understands that the key to good pictures is getting really close to the subject and then holding the boat stationary. This is a counsel of perfection that is almost impossible to realize: the river currents are strong and the outboard motor must be cut to eliminate its vibration. The technique is to select a subject and set such a course and speed that the engine can be stopped and the boat allowed to continue under its own momentum to the desired position. There will be a moment when the range is right and the boat is still, before the current carries it away again. Of course, whenever the boatman gets it

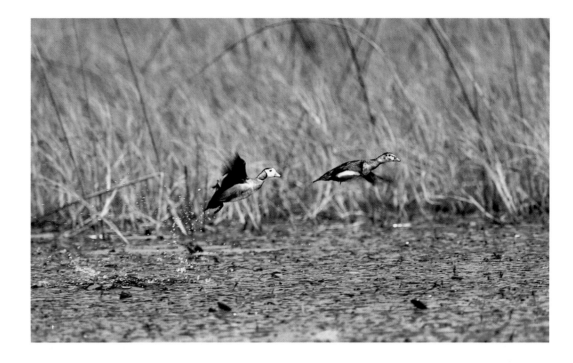

Pygmy geese photographed with a 400mm lens, hand-held in a mokoro ▲
Nikon F4 with 400mm lens, Kodachrome 64, 1/500sec at f/5.6

The female painted snipe is the smart one. Once she has laid the eggs, the male hatches them and brings up the family ▼
Nikon F4 with 400mm lens, Kodachrome 64, 1/125sec at f/11

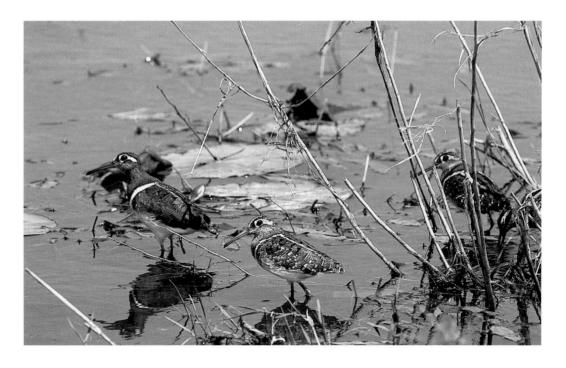

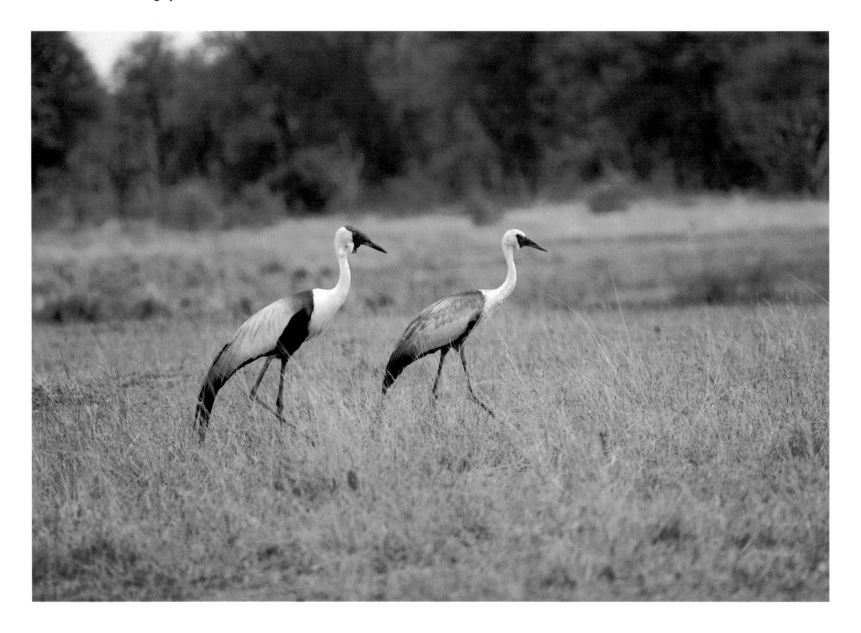

just right, the bird flies away at the crucial moment, but persistence and plenty of film may get you there in the end.

Most subjects will be members of the heron family; nearly all the African species can be found on the delta. There are also several breeding waders, including collared pratincole and water dikkop. Saddlebill stork, pink-backed pelican, pied and malachite kingfisher and fish eagle will be prime targets. Your boatman can bait for the eagles by tying a small fish to a piece of papyrus, calling up the eagle and throwing the bait into the stream. The eagle will swoop down and take the bait, giving you an opportunity to get the perfect shot. However, this happens very quickly and is hard to shoot well.

Adult and immature wattled cranes
Nikon F4 with 400mm lens, Kodachrome 200, 1/250sec at f/8

An adult and a young fish eagle watch proceedings from the papyrus
Nikon F4 with 400mm lens, Kodachrome 200, 1/250sec at f/5.6

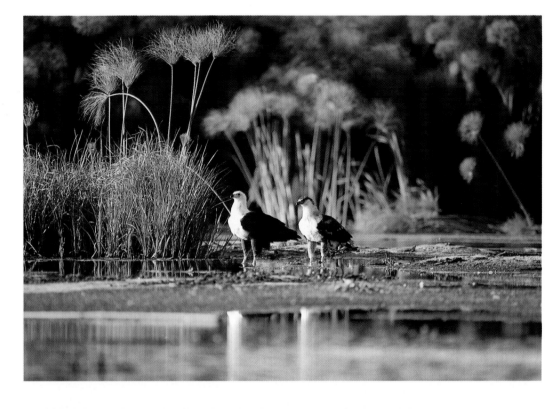

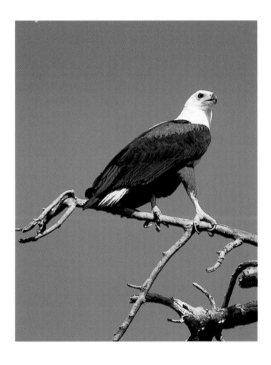

Fish eagles follow your progress down the channels
Nikon F4 with 400mm lens, Kodachrome 200, 1/500sec at f/5.6

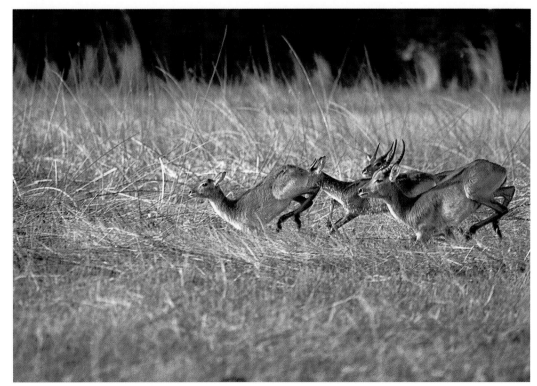

Something scared these red lechwe and they came hurtling past our boat
Nikon F4 with 300mm lens, Kodachrome 200, 1/500sec at f/5.6

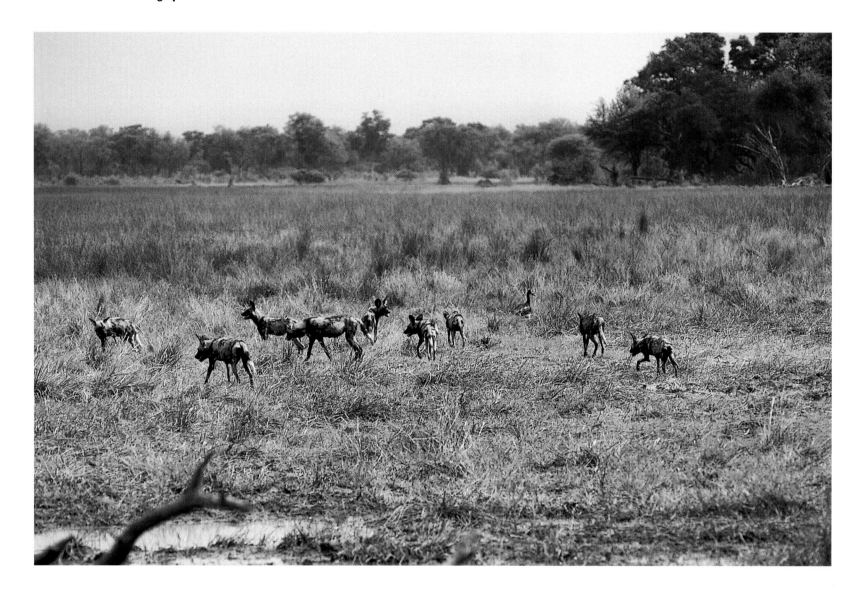

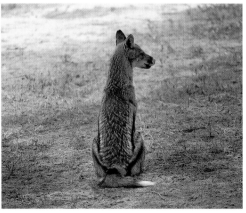

After several days of searching, we found a pack of hunting dogs. The light was poor even in mid-morning and the pictures reflect this
Nikon F4 with 300mm lens, Kodachrome 200, 1/125sec at f/8

Side-striped jackals are much more scarce than the black-backed species
Nikon F5 with 300mm lens, Fuji Sensia 100, 1/125sec at f/8

The mammal you are most likely to see is the red lechwe, which is common, but make sure you photograph it because there is no better place for them. There are sitatunga as well, but they are much more reclusive and shy; if you can picture them well it is a real achievement.

On the northern edge of the delta is the Moremi Game Reserve, bounded by the Khwai River. This is a dry land reserve, with the usual range of animals

in considerable abundance. In particular, there are plenty of elephants and the damage they can do to wooded land is very obvious. The herbivores are well represented; impala, waterbuck, tsessebe, red lechwe and common zebra on the land and hippo in the water.

There are several camps just across the river from the reserve. The big cats take their share of the prey species and this is one of the very few places where you still have a serious chance of finding wild dog. There are some notable birds to be found along the river. The biggest is the wattled crane, for which the delta offers both a breeding ground and a feeding place for birds that have nested elsewhere. This is also a good place to find the slaty egret, another bird with a very small world population.

Like so many wetlands, the Okavango Delta is under threat. Botswana is a dry country and there are many who would like to divert its water for cattle ranching and for use in the diamond mines. These activities are crucial to Botswana's economy so, if the water is to stay for the use of wildlife, the delta has to earn an economic return via tourism.

The government levies a substantial toll on each visitor and this is one reason why it is an expensive area to visit. It is for a good cause though, so, if you can afford it, go and make your contribution and photograph one of the finest wildlife spectacles anywhere in the world.

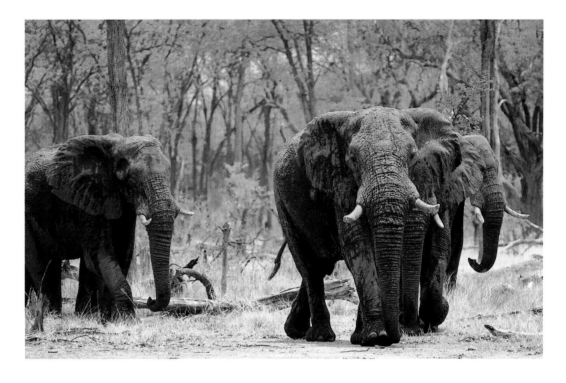

There are large numbers of elephants to be seen in the woodlands ▲
Nikon F4 with 300mm lens, Kodachrome 64, 1/125sec at f/8

The coppery-tailed coucal is one of the special birds of the Okavango ▼
Nikon F4 with 400mm lens, Kodachrome 200, 1/500sec at f/5.6

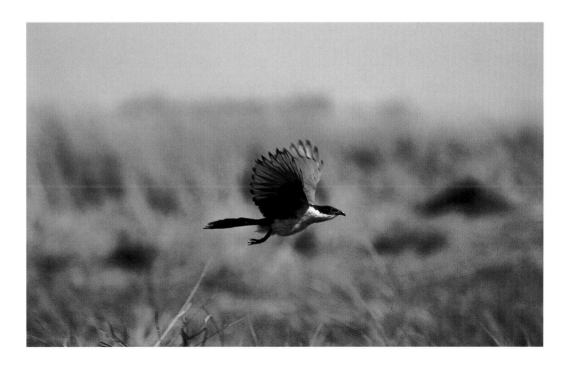

Florida

Although I have no intention of trying to describe the many good sites in North America, Florida has to be covered, because it is so frequently visited by European birders and photographers. Florida provides some of the easiest and best bird photography in the world. Go there when you are fed up to the back teeth with trying to photograph little birds that won't sit still in the dim, dull gloom that passes for light during a large part of the north European year. Florida offers a full house of herons and other water birds that are big, stationary and confiding, in glorious sunshine, with softer light on tap at the beginning and end of the day. You can go when your legs have grown tired and your arms are too weak to carry the gear very far: in many places you don't even need to get out of the car and, even where you do, it is only to walk a short distance. There really is nowhere in the world where birds can be photographed with greater ease and certainty and where accommodation and car hire is more readily and abundantly available at reasonable cost. In the summer the weather is unpleasantly hot and humid – even the residents like to escape then – but from November to April it is ideal.

Miami receives the most flights from the UK and is closest to the Everglades, but it's a big, unattractive city with an airport to match. Immigration can be slow, though things may be improving. You need to be sure of your route on to the freeway as mugging, especially of tourists, is a popular pastime. Keep the car windows shut until you are out of town. Orlando offers an easier entry and Tampa is easier still, but it receives fewer flights.

The Everglades

Your starting point will probably make no difference to your mileage because, to cover the best places, you will need to make a circular tour of the southern half of the state. The two bankers for easy photography are the Anhinga Trail in the Everglades and Merritt Island by NASA's space station at Cape Canaveral. If you start at Orlando, it's a few hours down the turnpike to Homestead, the best base for the Everglades. From Miami, it is only

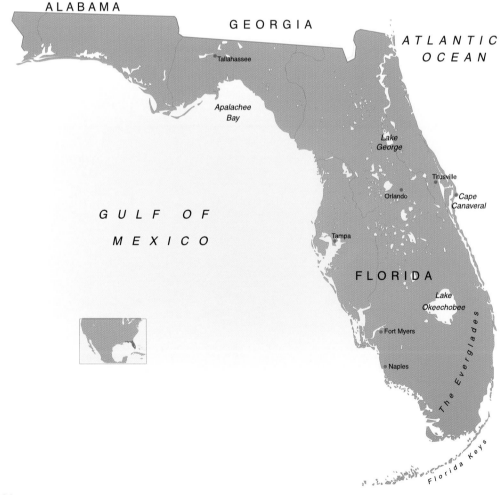

an hour. Homestead is half an hour from the Anhinga Trail, which is no marathon walk, but a short stroll on tarmac and then along a boardwalk, with the herons, ibises and alligators just a stone's throw away. There can be a lot of people; the birds take no notice of them, but they are a problem as they make the boardwalk vibrate, which does nothing for the definition of your pictures. With patience and persistence, though, there are enough quiet times for you to get first-class shots, and most of the birds can be photographed from the hard path before the boardwalk begins.

You can expect to shoot four species of heron (great blue, little blue, green and tri-coloured), great and snowy egrets, white ibis and alligator, all in a few hours. Osprey, black-crowned night heron and moorhen are among the other birds that will probably also be on offer. Keep an eye open for turtles and snakes as there are usually a few around, though the snakes are bad at posing.

Other parts of the Everglades are also well worth a visit. For example, if you continue down the road past the Anhinga Trail and Flamingo, you aren't likely to find flamingos, but will pass several trails and ponds. The trails here are good for birds and mosquitoes, though not for photography. Two of the ponds, Mracek and Eco, sometimes offer very close views of herons, and other birds which are difficult to photograph elsewhere, including glossy ibis and some of the rails. It is certainly worth stopping at Mracek Pond to look carefully at the bushes and other vegetation close to the parking lot. There will be many herons far out, but sometimes they fish almost underfoot.

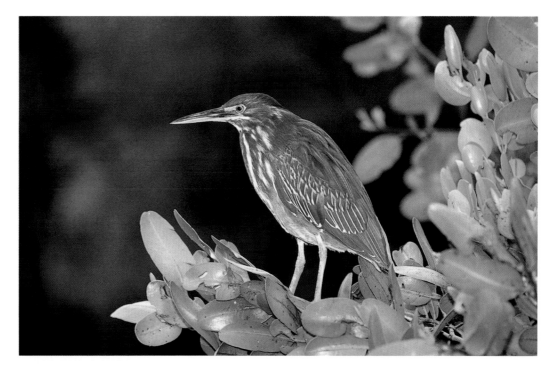

Green herons are right little posers ▲
Nikon F4 with 300mm lens, Kodachrome 64, 1/125sec at f/8

Around the jetty at Flamingo, the brown pelicans take no notice of humans ▼
Nikon F4 with 75–300mm lens, Kodachrome 64, 1/250sec at f/5.6

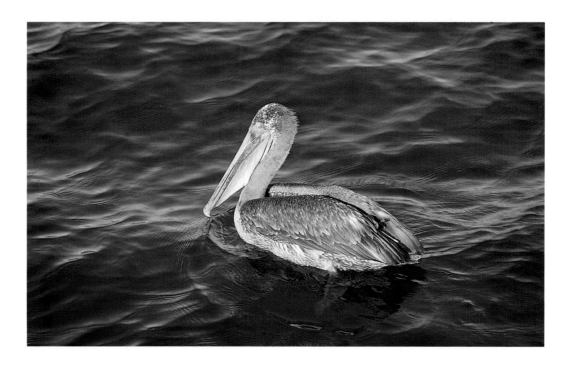

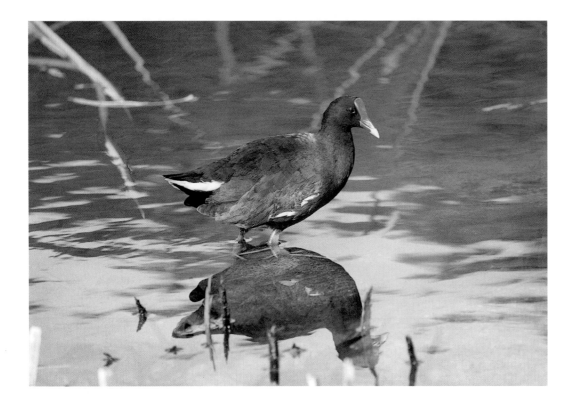

The American species of moorhen is the same as the European, so it might seem silly to go from Europe to photograph it; my philosophy is to take any good images on offer, and I liked the reflection
Nikon F4 with 400mm lens, Kodachrome 64, 1/125sec at f/8

Bird names are not always totally accurate; immature little blue herons are white
Nikon F4 with 400mm lens, Kodachrome 64, 1/250sec at f/8

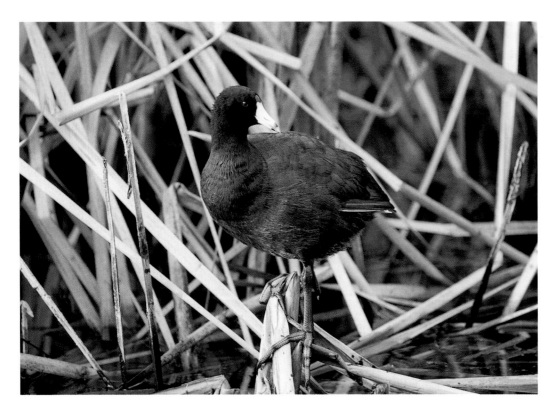

Eco Pond offers good opportunities to photograph American coot
Nikon F4 with 400mm lens, Kodachrome 64, 1/125sec at f/8

At Eco Pond, a walk around the pool may also produce birds close enough to photograph, certainly moorhen and American coot, and maybe also Virginia or one of the bigger rails. The thick vegetation at the water's edge is a problem, but also the reason for the birds being there. The trees may hold painted bunting and other attractive birds. There are plenty of alligators, and the sheltered areas are good for butterflies. At Flamingo, the boating facilities provide good perching places, notably for brown pelicans and laughing gulls. Both are used to people and can be photographed with short lenses – even a 50mm for the pelicans. There may be black skimmers as well. The restaurant here is convenient for a midday break and offers a fine view over the mud flats.

This is a little blue heron in adult plumage
Nikon F4 with 400mm lens, Kodachrome 64, 1/125sec at f/8

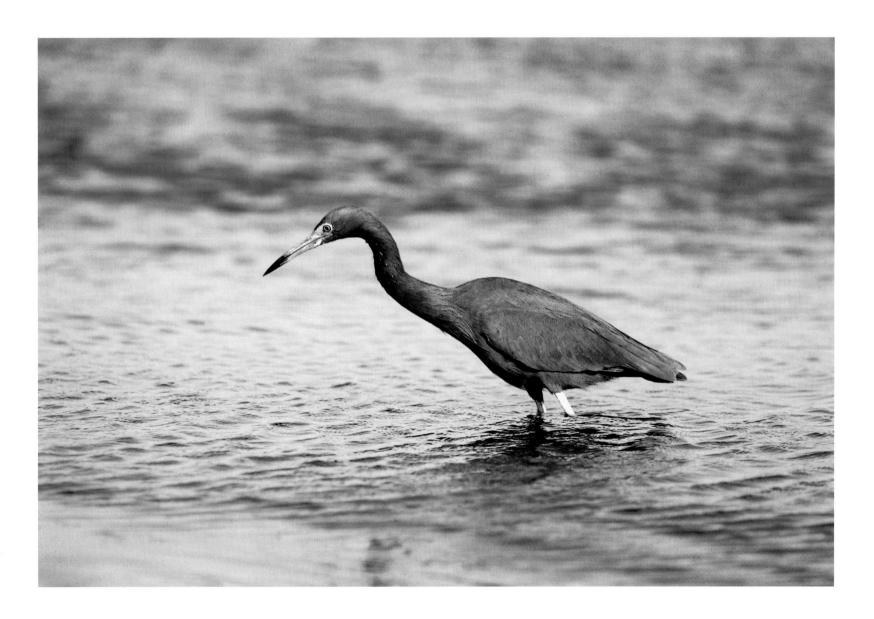

Merritt Island

The National Aeronautics and Space Administration's (NASA's) Merritt Island reserve can be even more productive than the Everglades and, if you start at Orlando, could be your first port of call, as it is only an hour along the Beeline Highway. The NASA Visitor Center is in a class of its own for anyone with the slightest interest in the space programme and even for a birder, is worth a half-day diversion. If there is a space launch while you are there, viewing facilities at a safe distance are provided. The little pond adjacent to the space station restaurant has some of the local turtles, and birds come down to drink, but the background is not very good. The reserve lies just to the north of the space station, but you have to go back to the public road to get there,

Tri-colored heron
Nikon F4 with 400mm lens, Kodachrome 64, 1/125sec at f/8

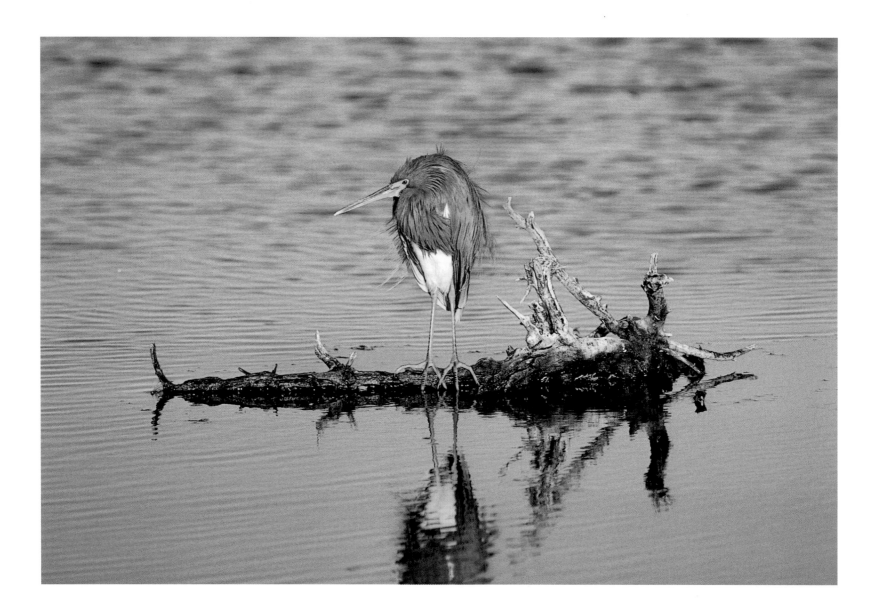

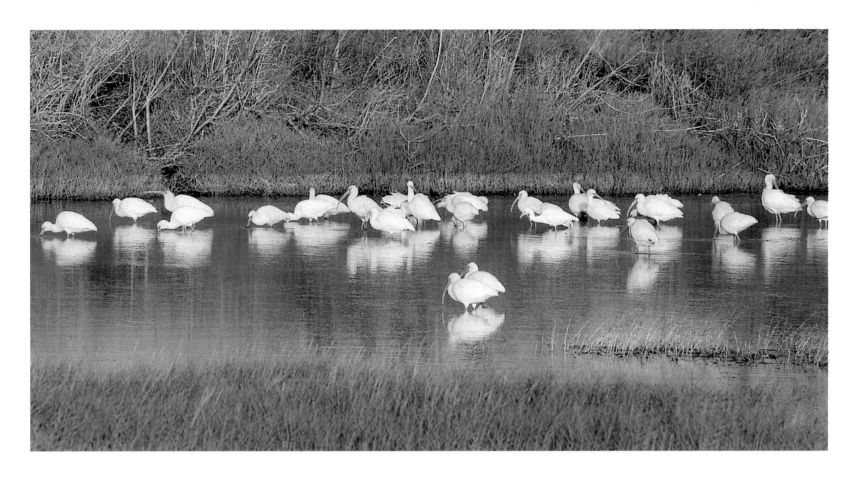

The American white ibises at Merritt Island show well in the early morning light; in more powerful light it is difficult to prevent their white plumage burning out
Nikon F4 with 400mm lens, Kodachrome 64, 1/60sec at f/8

Although pied-billed grebes are tiny, by working the car close, you can manage with a 400mm lens. A 600mm might save time, but who's hurrying?
Nikon F4 with 400mm lens, Kodachrome 64, 1/100sec at f/5.6

American darter or Anhinga ▲
Nikon F4 with 400mm lens, Kodachrome 64,
1/125sec at f/8

Reddish egrets are difficult to photograph because they move so erratically; either choose your moment carefully, or use a high shutter speed ▼
Nikon F4 with 400mm lens, Kodachrome 64,
1/250sec at f/5.6

as the NASA road has been closed. Take the Fl-402, which runs east from the north end of Titusville. Coming back, watch out for the fact that US 1 is divided here and you must cross the first traffic lights and only turn at the second set for Titusville and US 1 South, otherwise you will cause all sorts of excitement. There are plenty of motels in Titusville.

Merritt Island is a wetland reserve and, with the pools lying close to the road, the best technique is usually to cruise slowly along the 6 miles (9.7km) of Black Point Drive until a suitable target is found and then to shoot from the car. At the end of the drive, you simply complete the one-way circuit and do it again. The middle of the day can be spent heading back to Titusville and having a meal, or taking a stroll around the Interpretation Centre. That will leave time for at least half a dozen circuits, which may seem excessive, but new or better opportunities usually turn up each time round. The birds include most of those found on the Anhinga Trail but there is a better chance of getting good shots of American white pelican, wood stork, reddish egret, assorted waders and pied-billed grebe. The big flocks of American coot are sometimes chivied by a northern harrier. Otter and bobcat are present, but elusive. Nine-banded armadillo are more likely to show, especially in the late afternoon. The birds are not quite so blindly uncaring about the human presence as they are along the Anhinga Trail; most will allow a close approach by car, but only a few will permit shooting from a tripod set up outside. The early morning is best: there are fewer visitors and more of the birds are feeding close to the road. Late afternoon

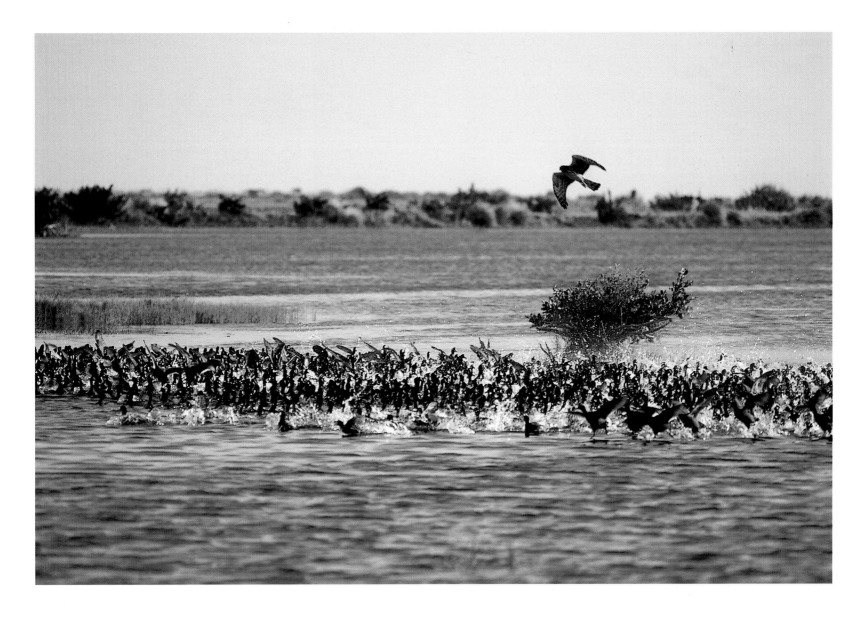

can also be good. Most of the action is in the middle section of the drive, but have a good look at the small reedy pools towards the end of the main part, because they can produce crakes and rails, which you will probably not otherwise see.

Because of their size, the great blue heron and the great egret make the easiest targets; they also pose better than the others. Depending on the metering system of your camera, white birds against dark, muddy backgrounds may pose an exposure problem. If the image is small against a dark background, it is easy to overexpose the plumage and get pictures with no feather detail. An image filling most of the frame will be underexposed. If you are in doubt, try bracketing your exposure or, better, do some trials with something large and white before you go abroad.

The local northern harriers know a good meal when they see one; a plump American coot will do nicely
Nikon F4 with 400mm lens, Kodachrome 64, 1/250sec at f/5.6

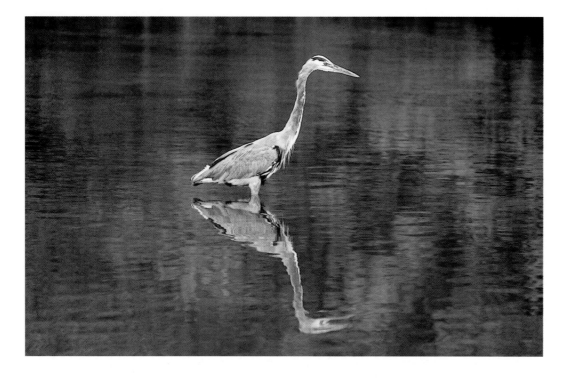

Great blue heron ▲
Nikon F4 with 400mm lens, Kodachrome 64, 1/125sec at f/8

West Indian manatee ▼
Nikon F4 with 400mm lens, Kodachrome 64, 1/125sec at f/5.6, polarizer

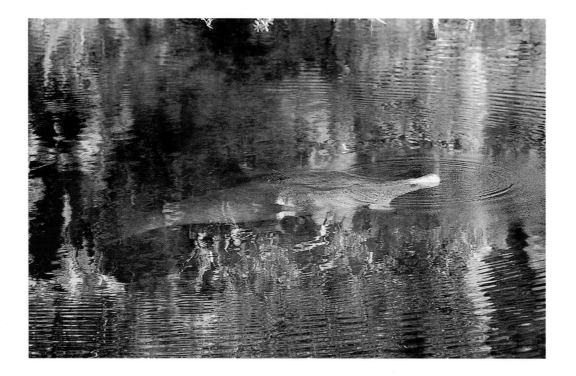

In April, the waders along Fort Myers Beach and some of the nearby areas are excellent. This is a job for stalking on foot, and there is a good variety of species to try to work through. They are pretty confiding by wader standards but, even so, you will benefit from using as big a lens as you can muster if portraits of individuals are your aim. In midwinter, many of the waders move away, but in early spring they will be there in abundance.

Other worthwhile sites

There are plenty of other good sites in Florida, and an abundance of literature describing them. A few deserve special mention. Just west of Fort Myers lies Sanibel Island which, like Merritt Island, is reached across a causeway. There is plenty of accommodation on offer, but it is a bit more expensive than Homestead and Titusville. The island has the whole range of wetland species, though you do have to walk a little way to get within photographing range. Double-crested cormorant and roseate spoonbill may be easier to shoot here than elsewhere. The cormorant is not a very exciting bird to look at when simply perched, and it is worth trying to get it with its wings open. Even in this position, it is quite motionless. At its best, Sanibel Island is as good a place as any in Florida, but it can also be disappointing.

A bit further south, near Naples, is the Corkscrew Swamp, a real swamp, thickly wooded and full of the smaller wildlife. Wood storks sometimes breed there, but the opportunities for photographing them or the other birds are not first class. It would be better to concentrate on the insects, turtles and snakes.

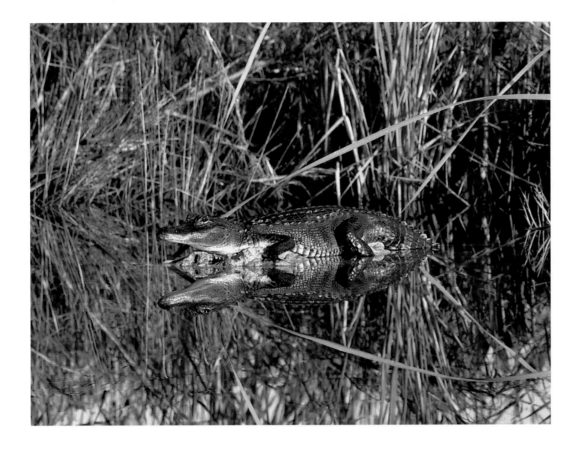

There are plenty of alligators posing along the Anhinga Trail, but these were by Interstate-75, where we stopped for breakfast and to see the snail kites
Nikon F4 with 400mm lens and 1.4× extender, Kodachrome 64, 1/60sec at f/11

After this is the Tamiani Trail, the main road running across the northern boundary of the park. The trail can be misty in the early morning, but it soon clears. This is the place for the snail kite, readily seen from the road, but you will need a big lens and a lot of luck to photograph it. The Brazilian pantanal is the place to go to get pictures of them. It is another good area for alligators. You can go for a ride on an airboat, which may be exciting but will not be much use photographically.

The reserve at Shark Valley is another one worth a visit. You can walk or cycle or have a conducted tour, using the tram. The first tour is at 9am and, in addition to the birds and alligators, you might be lucky with white-tailed deer and marsh rabbit. The tour does not allow much time to take pictures, but does offer a description of the ecology of the Everglades and the threats which still hang over it. Afterwards, you can walk back along some of the route and try to photograph some of the birds you have spotted, which will probably include American purple gallinule. You may be attracted by some rather photogenic insects and spiders. The best bet for West Indian manatees is at Blue Springs, in Orange County, to the north. They surface about every 10 minutes and, if you are quick enough to spot them, focus and shoot, pictures are possible. A polarizing filter will help remove some of the unwanted reflections.

The Falkland Islands

The Falkland Islands, which lie some 600 miles (950km) east of the coast of southern South America, offer a taste of the sub-Antarctic from lodges on shore, which provide a high standard of comfort and food. Inevitably, in such a location, the weather is not always favourable, but in the southern summer, say from November to March, it is not savagely cold and can be positively warm. The light is often much more powerful than might be expected, even when there is no direct sunshine.

There is no difficulty in tailor-making your own itinerary, using the services of the Falkland Islands Tourist Bureau. Whether this is worthwhile is debatable, if you are satisfied with a two-week stay, as you will inevitably use the same lodges and transport and will not enjoy much of a saving. The route followed by most Europeans is to take the Tristar, operated by the RAF, from Brize Norton Airport near Oxford. This service is primarily for the needs of the forces but, subject to this, it can be used by tourists to Ascension Island and the Falkland Islands. The plane refuels at Ascension Island, where there will be time to see the endemic frigate bird, but not for any photography. There is a generous luggage allowance on the Tristar, but only 30lb (14kg) is permitted on the Falkland inter-island services, including cameras and tripods. Warm, windproof and waterproof clothing is essential and you should not cut down on the film stock, as you will surely shoot as much here as you would in the prime sites in Africa.

The Falkland Islands Government Air Service (FIGAS) provides an efficient transport system using a fleet of Norman Britten Islanders. Each lodge takes its visitors to the airstrip at the appointed time. The driver acts as fireman for the flight and, on arrival at the airstrip, will couple up his Land Rover to the fire extinguishing tender in case of accidents. He also acts as airport controller, advising the pilot on the local wind conditions, by radio. The inter-island schedule is set to meet demand and flight times for the following day are broadcast over the radio system each evening.

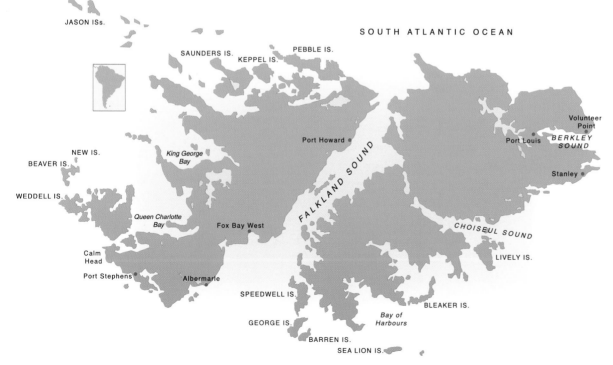

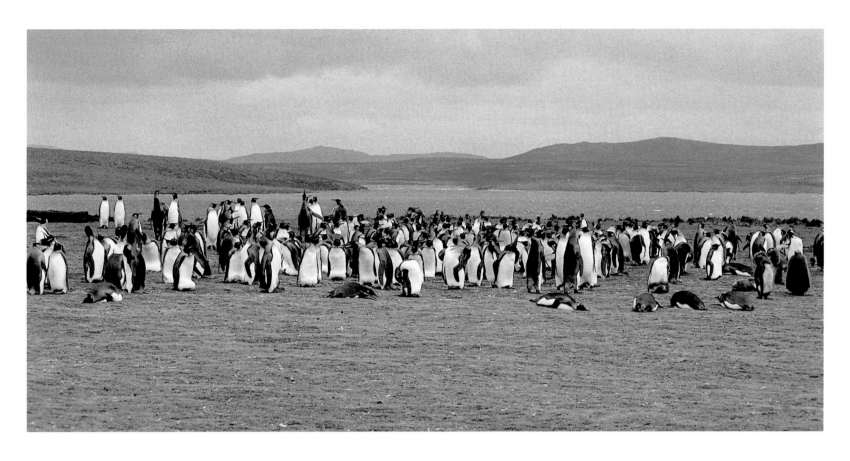

King penguin colony at Volunteer Point
Nikon F4 with 28–70mm lens, Kodachrome 200, 1/500sec at f/8

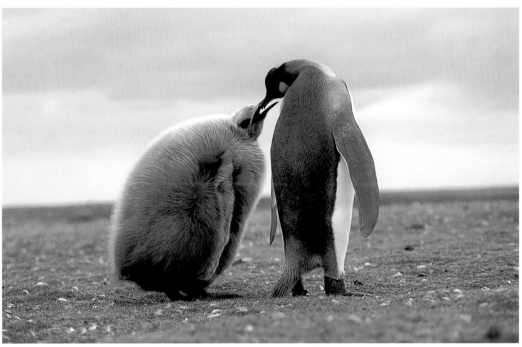

A fluffy king penguin chick pesters to be fed
Nikon F4 with 75–300mm lens, Fuji Sensia 100, 1/250sec at f/8

Southern giant petrels are magnificent fliers …
Nikon F5 with 300mm lens, Fuji Sensia 100,
1/500sec at f/4

… but disgusting eaters, as shown here outside
the abattoir
Nikon F5 with 70–210mm lens, Kodachrome 200,
1/320sec at f/8

The islands

Bird life on the main islands has been much reduced, but a visit to Volunteer Point, north of Stanley, is one of the highlights. It can be reached by Land Rover in about four hours. King penguins are the main attraction, as this is the only place they breed in the Falklands. The penguins aren't nervous creatures and, given a quiet approach, can be photographed with ease. Their breeding cycle is long, so you will find some brooding eggs and others with chicks larger than themselves. The chicks are inquisitive and will waddle up to you to check out your tripod and feet. There are plenty of other birds around Volunteer Point, but unless you stay overnight it is unlikely you will find time to deal with them.

You will inevitably have some time in Stanley and this can be used to get first-class shots of some of the common birds. Just outside the Upland Goose hotel, and elsewhere along the shoreline, kelp and dolphin gulls, in their various plumage, feed and preen. Southern giant petrels are best photographed at the outflow from the abattoir, where there are also antarctic skuas. The rocky beach collects a lot of kelp, with its associated small animal life. The Falkland Islands flightless steamer ducks here are sometimes very confiding, and may have ducklings as early as November. Crested ducks and night herons feed along the shore. There are birds nesting on the hulks in the harbour, but they are too distant for photography.

Saunders Island has black-browed albatrosses in numbers, nesting along the cliff edge. The birds allow a close approach on the nest and can also be photographed as they fly past the colony.

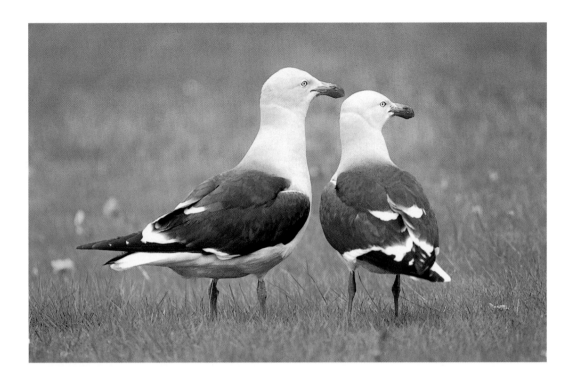

Dolphin gulls ▲
Nikon F4 with 75–300mm lens, Kodachrome 64, 1/100sec at f/11

Flightless steamer duck with duckling ▼
Nikon F4 with 75–300mm lens, Kodachrome 64, 1/125sec at f/8

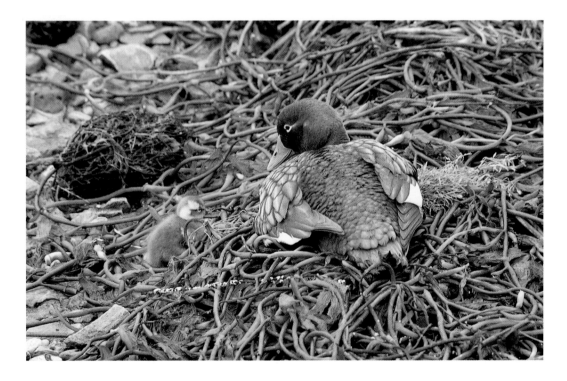

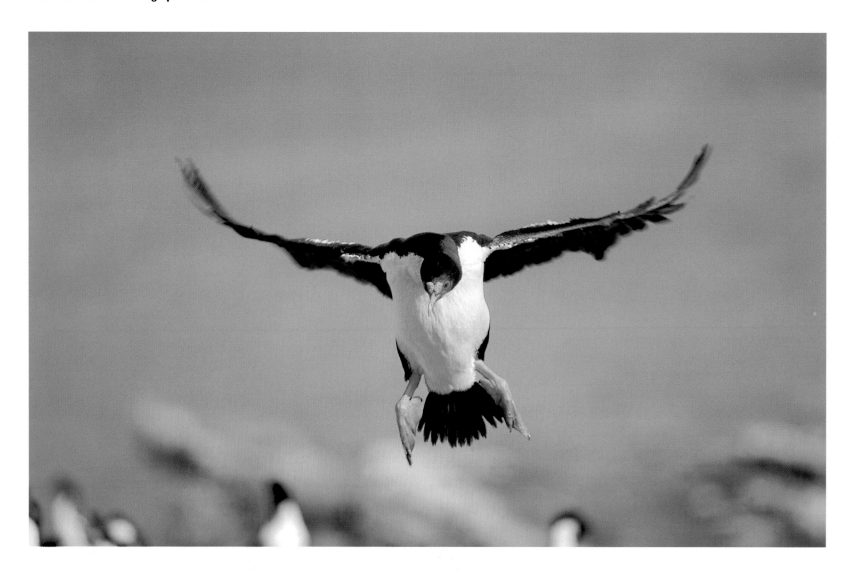

King cormorant landing. Expect to use plenty of film on this sort of photography to get a couple of usable shots
Nikon F5 with 300mm lens, Fuji Sensia 100, 1/1000sec at f/4

White-tufted grebe
Nikon F4 with 75–300mm lens, Kodachrome 64, 1/60sec at f/4.5

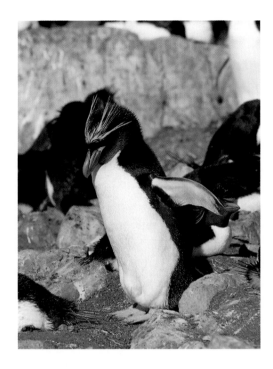

Macaroni penguin
Nikon F5 with 300mm lens, Fuji Sensia 100, 1/200sec at f/8

Rockhopper penguin
Nikon F5 with 300mm lens, Fuji Sensia 100, 1/200sec at f/8

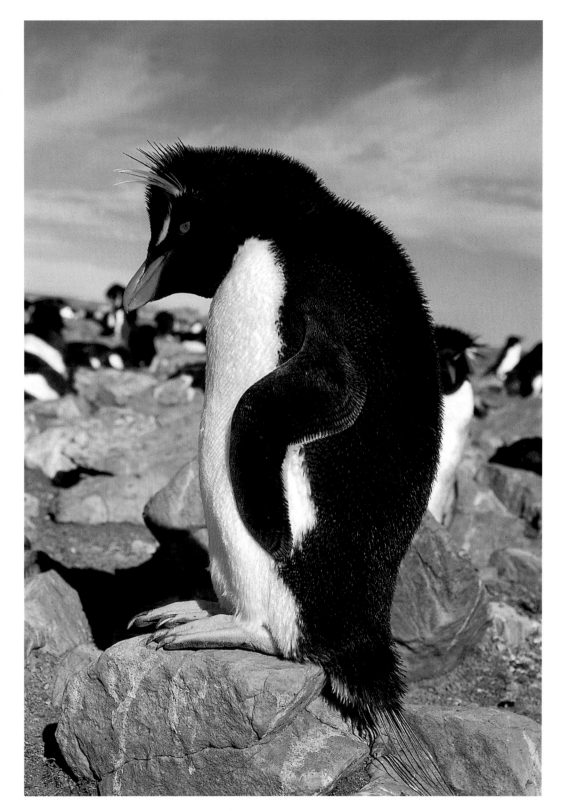

Pebble Island probably has the greatest variety of birds, including silvery and white-tufted grebes and black-necked swans. Rockhopper penguins are easy, and within one of the colonies can be found a few macaroni penguins and, perhaps, an erect-crested penguin, way out of its normal range in the islands south of New Zealand. Gentoos and magellanic penguins are present, too, and they can be photographed as they come ashore through the surf.

New Island
*Nikon F5 with 28–70mm lens, Fuji Sensia 100,
1/250sec at f/8*

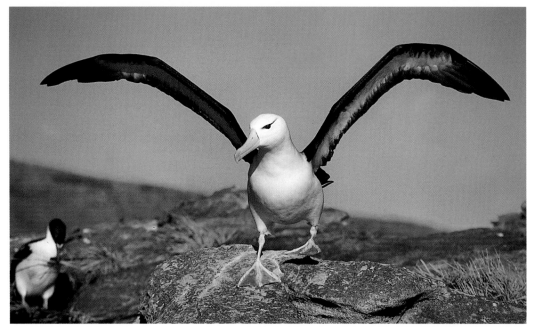

**Black-browed albatrosses need plenty of space
for take-off**
*Nikon F5 with 70–210mm lens, Fuji Sensia 100,
1/500sec at f/5.6*

New Island has only recently been made accessible to visitors. The drill is to overnight on Weddell and thence by boat to New Island. This is notable for its fur seal colony, large numbers of black-browed albatrosses, king and rockhopper penguins and some slender-billed prions. Self-catering is the norm on New Island and the accommodation, in A-framed huts, is simple but comfortable. The boat journey from Weddell to New Island can be rough.

The best place to photograph many of the Falklands' birds is Sea Lion Island. Most species can be found within a short walk of the lodge, and the accommodation and food are excellent. In line with its name, the southern sea lion breeds here, but the more impressive sight is that of the beachmaster elephant seals contesting the rights to a section of beach and the females that come with it. They are very big – up to 20ft (6m) in length – and can weigh up to 4t (4000kg). They are not to be trifled with. Even their breath can shatter those with delicate sensibilities!

There are good colonies of rockhopper and gentoo penguins; in some the rock-hoppers are mixed with king cormorants and all are subject to the depredations of skuas. The island has quite a few striated caracaras, now a rare species elsewhere. These caracaras do not depend on disturbing a bird from its nest, but are capable of simply walking into a colony, seizing the nearest adult and biting off its head. There are plenty of magellanic penguins near the lodge and although they are inclined to disappear down their burrows, they are also inquisitive and will pop up again if you sit and wait. Others nest in the thickets of tussock grass that have

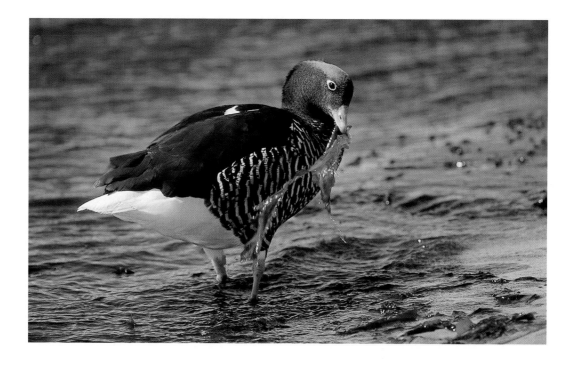

Kelp goose female ▲
Nikon F5 with 300mm lens, Fuji Sensia 100, 1/250sec at f/8

Kelp goose gander. When they are occupied with feeding, some of the ducks and geese can be approached with a 300mm lens, provided you stay on your knees ▼
Nikon F5 with 300mm lens, Fuji Sensia 100, 1/125sec at f/8

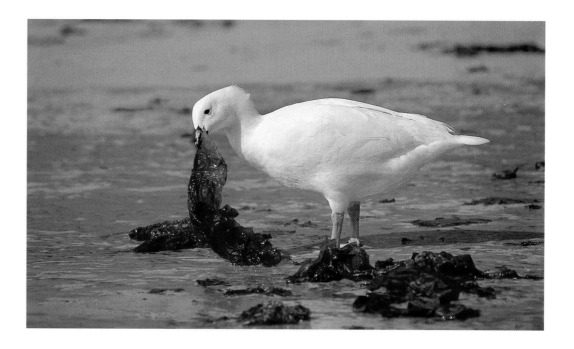

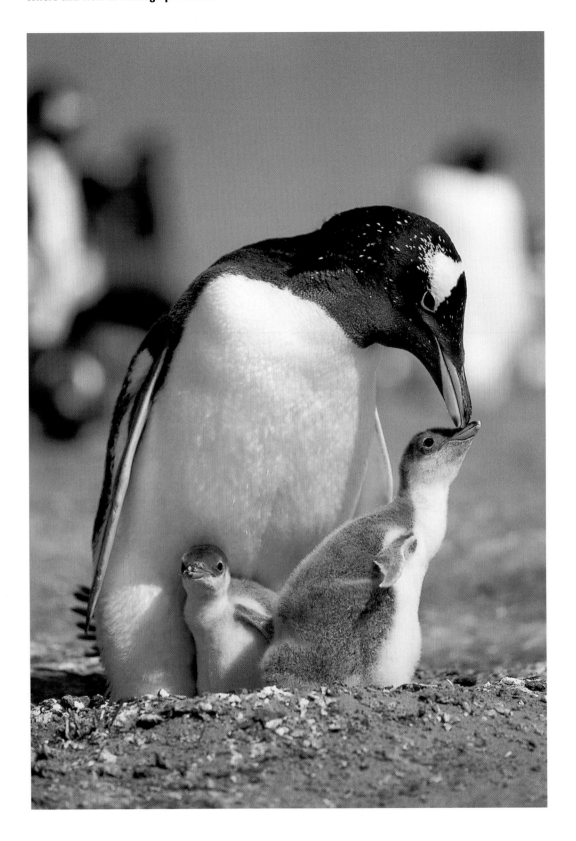

Nothing is wasted if a sheathbill is around. If you sit quietly by a penguin colony with a 300mm lens, you can shoot whenever a picture breaks
Nikon F5 with 300mm lens, Fuji Sensia 100, 1/250sec at f/8

Gentoo penguin with chicks
Nikon F5 with 300mm lens, Fuji Sensia 100, 1/250sec at f/8

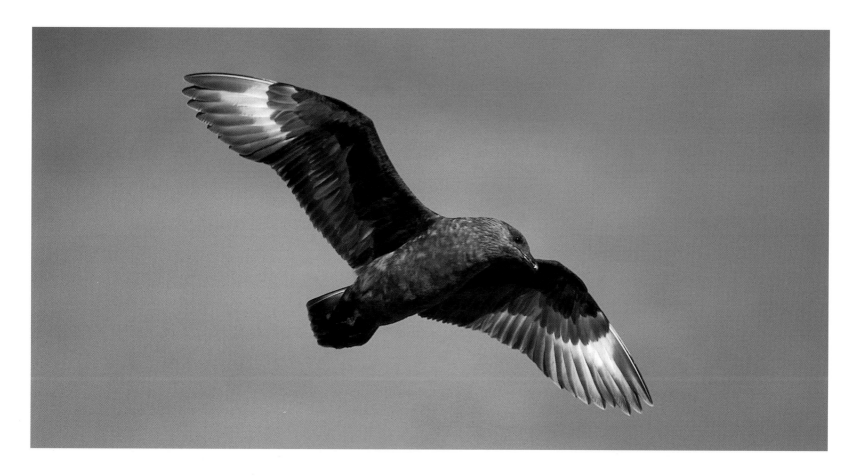

Antarctic skua with early morning light bringing up the underwing
Nikon F5 with 70–210mm lens, Fuji Sensia 100, 1/500sec at f/5.6

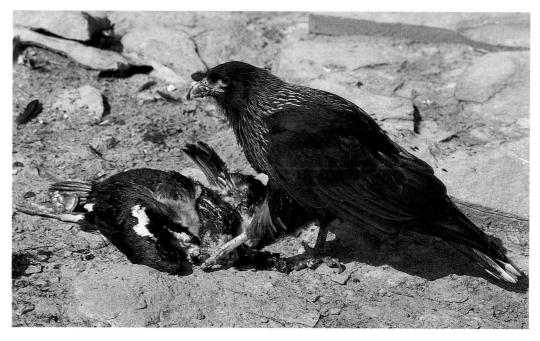

Striated caracara dismembering a king cormorant. Even in the Falklands, fierce sunshine can lead to harsh shadows, but you have to take the shot when it's offered. Fill-in flash would have helped – moral: always pack your flash gun
Nikon F4 with 75–300mm lens, Kodachrome 64, 1/250sec at f/8

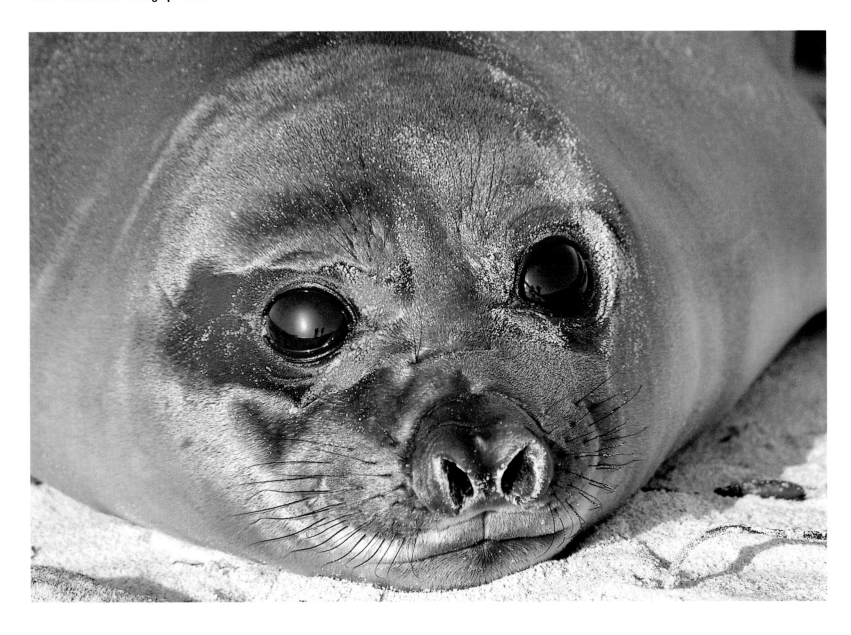

been protected from the sheep by electrified fences. Treat these fences with care as they can carry quite a punch. Remember, too, that these places are also used by elephant seals and, since visibility in the tussock is almost nil – it can grow up to 10ft (3m) – you can both get a big surprise.

The island has an abundance of geese; upland, ruddy-headed and kelp can be photographed well. Magellanic oyster-catchers are all over the place. The rufous-chested dotterel nests on the drier areas of moorland, where diddle-dee occupies a similar role to that of the heathers in northern Europe. This is one of the species for which a long lens will be worthwhile. The smaller, two-banded plover nests near the shoreline and can be stalked as it feeds.

There is a good nesting colony of dolphin gulls, which can be approached with care, and the birds will carry on displaying and mating before you. The giant petrels nesting here are shy and best left alone.

The Falklands are not rich in passerine birds. The tussock bird (blackish cinclodes) is generally not shy and will feed around your feet, but this is not terribly helpful.

Elephant seal pups have gorgeous eyes. Pups are not aggressive, provided you are sensible … ◄
Nikon F4 with 75–300mm lens, Kodachrome 64, 1/125sec at f/8

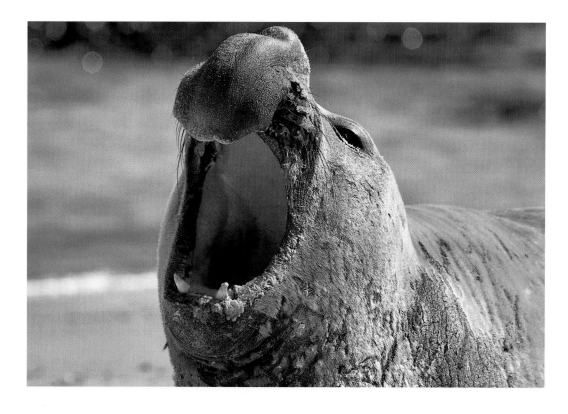

… but the big bulls can be difficult… ►
Nikon F4 with 75–300mm lens, Kodachrome 64, 1/250sec at f/5.6

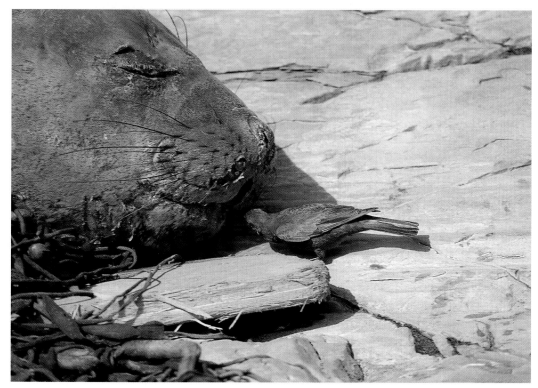

… Even so, tussock birds pull dead skin off them as they moult
Nikon F5 with 300mm lens, Fuji Sensia 100, 1/250sec at f/5.6

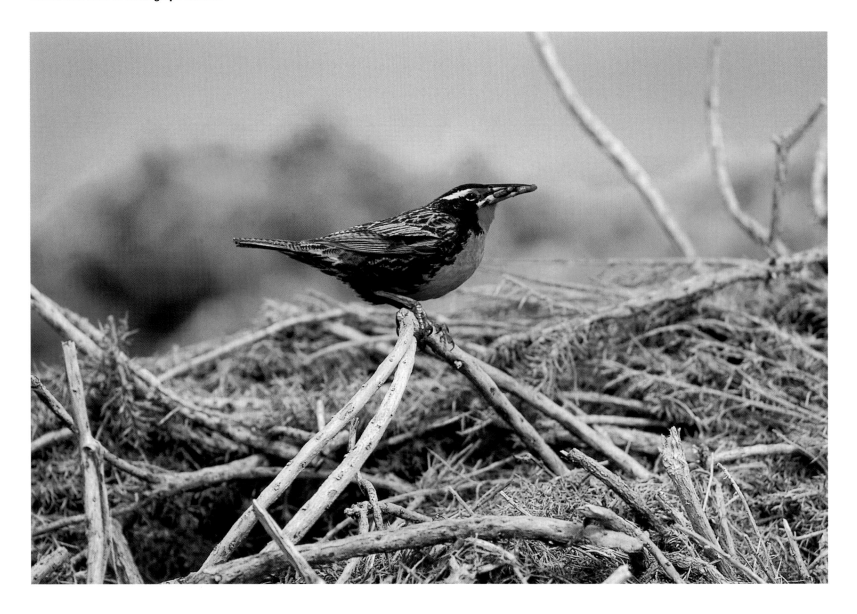

Long-tailed meadow lark
Nikon F5 with 300mm lens, Fuji Sensia 100, 1/250sec at f/5.6

One approach, which I am told works well, is to pull out a strand of sea-weed and rest it on the ground; the tussock bird will then spend some time finding and eating the insect and other life on the kelp and will thus be confined to a workable area while you take your pictures. They can also be found biting off pieces of dead skin from moulting elephant seals. This attention is not always welcomed by the seals and dramatic shots of a seal's response are possible, if you react quickly. Dark-faced ground tyrants and Falkland pipits are well distributed, but shy, and the gorgeous long-tailed meadowlark is not much better. That leaves the house and sedge wrens, Falkland thrush, black-chinned siskin and black-throated finch, all of which will test your speed of reaction, but are possible with persistence.

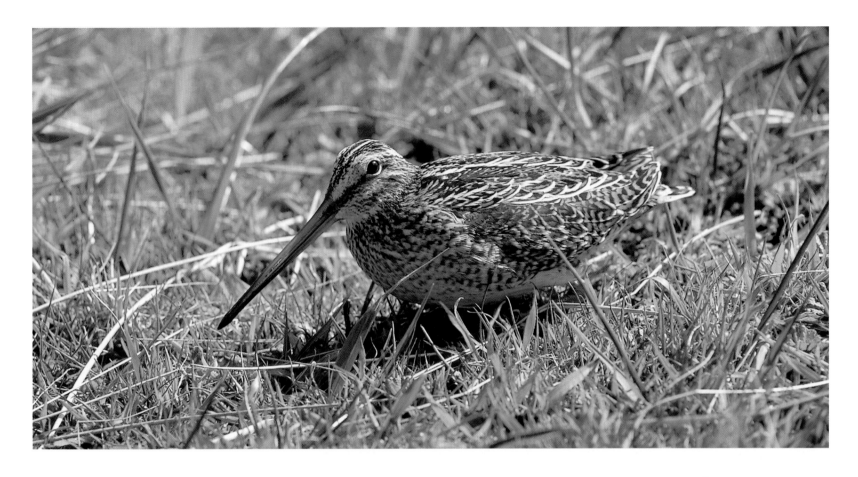

Paraguayan snipe. This is another hands-and-knees job to get a low angle. For flexibility you may choose to dispense with the tripod
Nikon F5 with 70–210mm lens, Fuji Sensia 100, 1/125sec at f/8

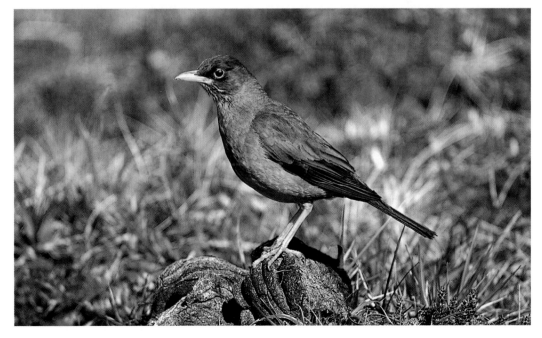

Ground birds like this austral thrush look best perched on *something*, no matter what that may be
Nikon F4 with 75–300mm lens, Kodachrome 64, 1/250sec at f/5.6

The Galápagos Islands

These enchanted islands have to rate among the finest in the world for a whole variety of wildlife. They provide nesting sites for large numbers of sea birds, some of which nest nowhere else in any quantity. Most of the land birds are completely endemic, notably the mockingbirds and the finches that helped Darwin formulate his theory of natural selection. Moreover, most of the birds show no fear of people and can be approached closely. Then there are the sea lions and fur seals, marine and land iguanas and several species of lava lizards, all similarly confiding. In many ways it is a photographer's paradise, but the traveller must recognize that his movements will be much restricted. The islands have become so popular that the number of people visiting them threatens the creatures which make the islands such a magnet. No-one is allowed ashore without a guide, who will be well trained in the vulcanology and ecology of the islands, but may not be particularly sympathetic to photographers. Access in most areas is only allowed along marked trails, which are commonly only a metre or two wide. As each party must keep together, it is inevitable that whenever there is a tempting subject, one photographer gets in the way of another. Even where no-one is in the direct line of fire, watch out for shadows across the subject.

Nearly all the islands have English and Spanish names, and while both forms are still used, it seems that the Spanish is becoming the norm.

Guides work to a timing that allows good viewing of the wildlife, but is generally a bit quick for photography, especially when the group includes several photographers. Thus, speedy working is essential and using a tripod is not always a good idea. If you do use one, its legs must not extend beyond the pathway, even on to bare rock, so it is going to be a major obstruction. However, the light is good, the wildlife is close, and there is no need for long lenses, so hand holding is quite feasible. Lenses that smooth out vibrations may be helpful but are not essential. If you feel lost without a camera support, try a unipod. A 70–300mm zoom provides the flexibility that helps quick working, but I frequently settled on a 105mm macro,

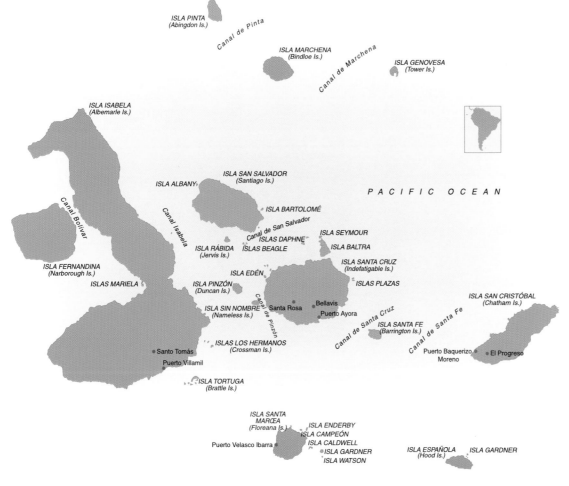

with which I could readily switch from birds to lava lizards and close-ups of vegetation and iguanas.

Few parties land much before 8am, by which time the sun is already powerful and gaining strength by the minute – you are, after all, right on the Equator. The heat can be fierce, though it is usually a dry heat. About one year in seven, the cold ocean current coming up from the south is displaced by a warmer one from the north. When this happens, the weather becomes more humid, the sea is more likely to be rough, and the warm water supports little of the rich fish life on which the sea birds normally depend for food, so they do not nest. On the other hand, in these El Niño years, the normally parched vegetation becomes green and the land birds flourish.

Most visitors eat and sleep on their boats. These range from large, holding up to 90 tourists, to small, taking only four or six. Air conditioning is mainly restricted to the big boats, which are also generally faster than the smaller ones. However, they are only allowed at certain landing sites. Overnight journeys are necessary on the longer, inter-island trips, but most nights are spent at a sheltered anchorage. If all this makes the islands seem a poor bet, don't believe it – they are magnificent, but your social skills may be tested a bit.

Your flight will probably be to Quito, the capital of Ecuador. Some tours spend a few days in the Andes or in the rainforest; both options are worthwhile, but neither will provide much in the way of wildlife for your camera. From Quito, it is on and across the Pacific some 600 miles (970km) to where your boat is waiting. Here you will be introduced to the procedure for

Bartolomé Island ▲
Nikon F4 with 24–40mm lens, Kodachrome 64, 1/125sec at f/8

A typical tourist boat ▼
Nikon F4 with 24–40mm lens, Kodachrome 64, 1/250sec at f/5.6

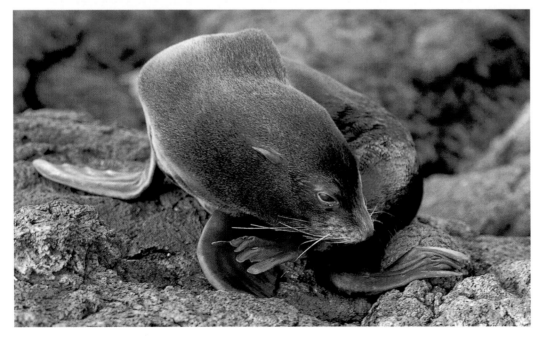

Galápagos penguins can survive here because the cold water current from the south brings plenty of fish. This photograph was taken from the panga
Nikon F4 with 75–300mm lens, Kodachrome 200, 1/250sec at f/8

Galápagos fur seal
Nikon F4 with 75–300mm lens, Kodachrome 200, 1/250sec at f/8

boarding the dinghy (panga) and then taken in it to your boat. The drill is to get *yourself* in or out safely and have your camera gear passed over when you have gained a firm footing. Most landings are wet, which means that you drop from the side of the panga into the sea, usually only ankle-deep. There are very few accidents, even though many visitors are elderly and far from agile. The boatmen are highly skilled at getting the panga ashore and there are always helping hands to steady you and to pass your equipment across when you are ready.

Some of the creatures, sea lions for example, can be seen on any of the islands, but others are limited to one or a very few of them. Comprehensive coverage will demand time on most of the islands and require at least two weeks, though there are plenty of shorter trips that will give you a sample.

The central islands

From Baltra, Santiago (James) and its satellite, Bartolomé, are close at hand. The area around the landing at Puerto Egas, on Santiago, is one of the few where access is not restricted to a narrow path. Here there is a long stretch of coast with rocky pools and small inlets, full of good things. You can get close to some of the waders, lava herons and yellow-crowned night herons. Save some time for the fur seals, because this is the only place you are likely to see them. Santiago is also a good place to see some of the intricate patterns that were made by rope-like strands of thick lava before it finally set; you can have fun taking pictures of this 'pahoehoe' lava in strong side- or backlighting. On Bartolomé there is a nice little peak, which gives a fine view to the adjacent islands.

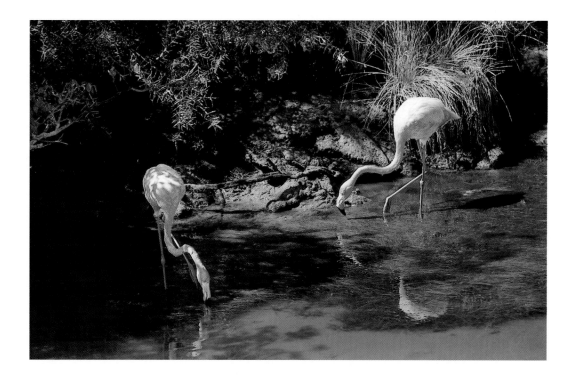

Greater flamingos ▲
Nikon F4 with 80–200mm lens, Kodachrome 64, 1/250sec at f/8

Although this lava heron looks quite different, it is just a subspecies of the green or striated heron ▼
Nikon F4 with 105mm macro lens, Kodachrome 64, 1/60sec at f/11

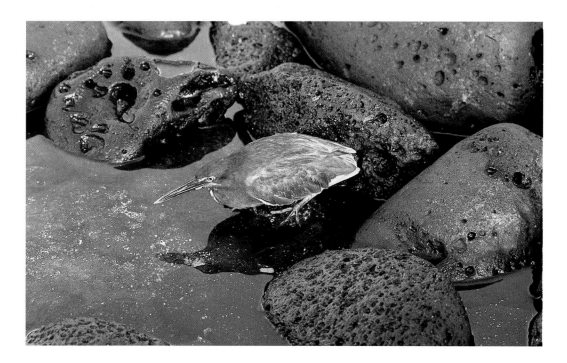

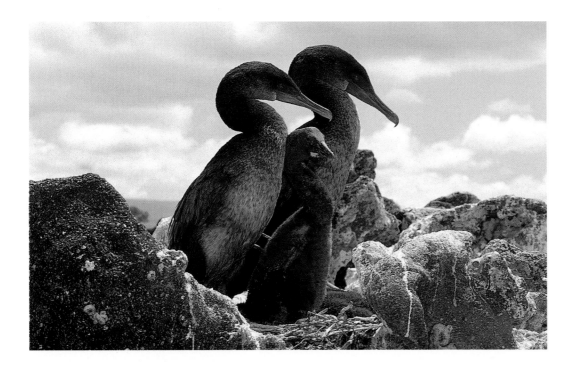

Flightless cormorants
Nikon F4 with 80–200mm lens, Kodachrome 200, 1/100sec at f/11

Elliot's petrels sipping whale blood
Nikon F4 with 75–300mm lens, Kodachrome 200, 1/500sec at f/5.6

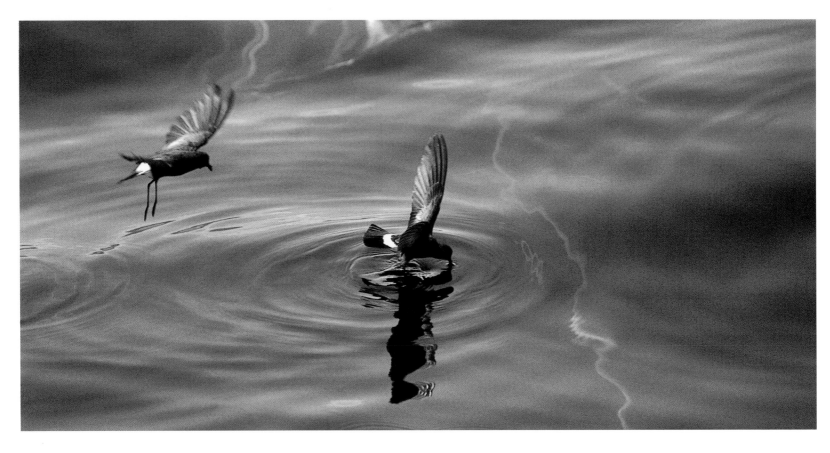

The bay here is one of the most likely places to see the endemic Galápagos penguin. Catch them sitting around on one of the lumps of rock just offshore and approach them in the panga.

Rábida is another of the islets off Santiago and is noteworthy for the deep red-brown colour of its beaches and a lagoon just inland, which has a small nesting colony of greater flamingos. Look carefully at the gulls, which are generally recorded as Franklin's, because they may be immature laughing gulls.

Another of the central islands, Santa Cruz, holds the major port in the islands, Puerto Ayora, the headquarters for the national park and the Charles Darwin Research Station. This is the only place where the giant tortoise is likely to be seen, and then only in captivity. There are still quite a few tortoises in the wild, but they are thin on the ground except in remote locations, like Volcan Alcedo on Isabela. The interior of Santa Cruz rises quite sharply from the shore and the habitat changes to damp highland forest. There are finches and vermilion flycatchers, but there is not much for the photographer. The much smaller island of Santa Fe lies a few miles to the south east. It is note-worthy for the tall opuntia, which grows into substantial trees and is a habitat for the cactus finch. There are also endemic species of land iguana and lava lizard, but both it and Santa Cruz could be missed out if time is short.

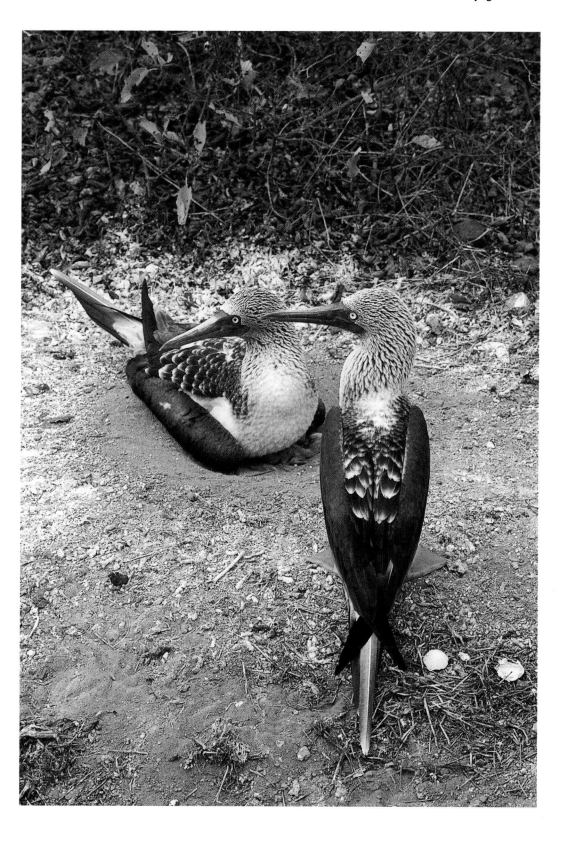

Blue-footed boobies
Nikon F4 with 80–200mm lens, Kodachrome 64, 1/30sec at f/16

The western islands

Away to the west lie the larger land masses of Isabela and Fernandina. Isabela is huge relative to the other islands and it is easy to spend a week sailing round it and landing from time to time. It has five volcanoes, which dominate the scene when they are not obscured by cloud. The surrounding waters are the most likely places to hold dolphins and whales. Bottle-nosed dolphins are likely to swim alongside your boat, though you may need to hang over the side to see them well and this can be a bit exciting if the boat is heaving in rough seas. Whales are less likely, but several species occur. The killer whales here are not satisfied with feeding on the abundant sea lions and we witnessed a party of four

South Plaza land iguana

Nikon F4 with 75–300mm lens, Kodachrome 200, 1/60sec at f/16

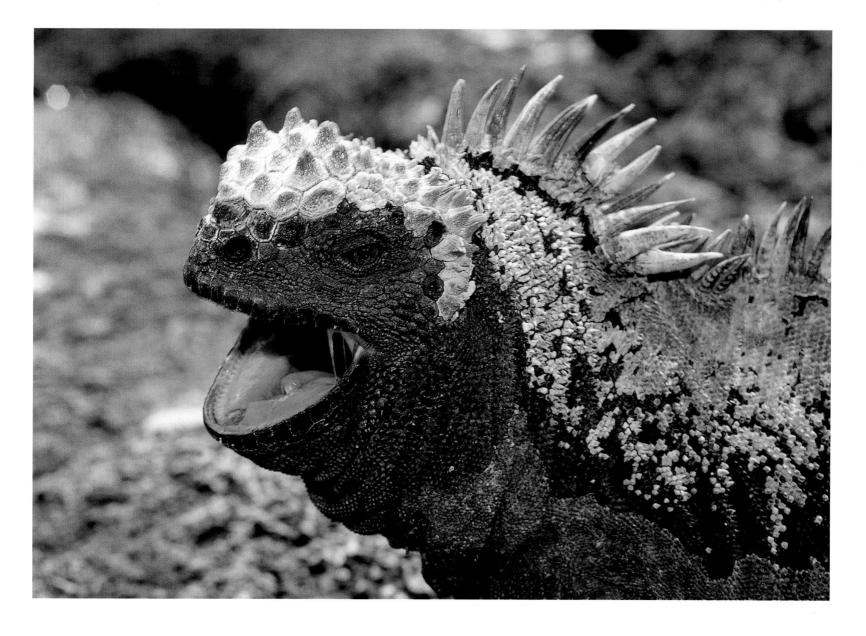

Marine iguana
Nikon F4 with 80–200mm lens, Kodachrome 64, 1/250sec at f/8

attacking and killing a Cuvier's whale, with much spilling of blood, on which the hovering Elliot's storm petrels were quick to feed.

Some of the sheltered coves can be explored by panga and it is possible to get good views of rays and turtles as they swim in the clear water. Isabela holds the main populations of Galápagos penguin and flightless cormorant; Urbina Bay is one good locality for the latter. San Cristóbal is the capital of Galápagos province and can be good for nesting populations of great and magnificent frigate birds, as well as the three boobies – masked, blue-footed and red-footed – but we were there once in an El Niño year and virtually none of the birds were nesting.

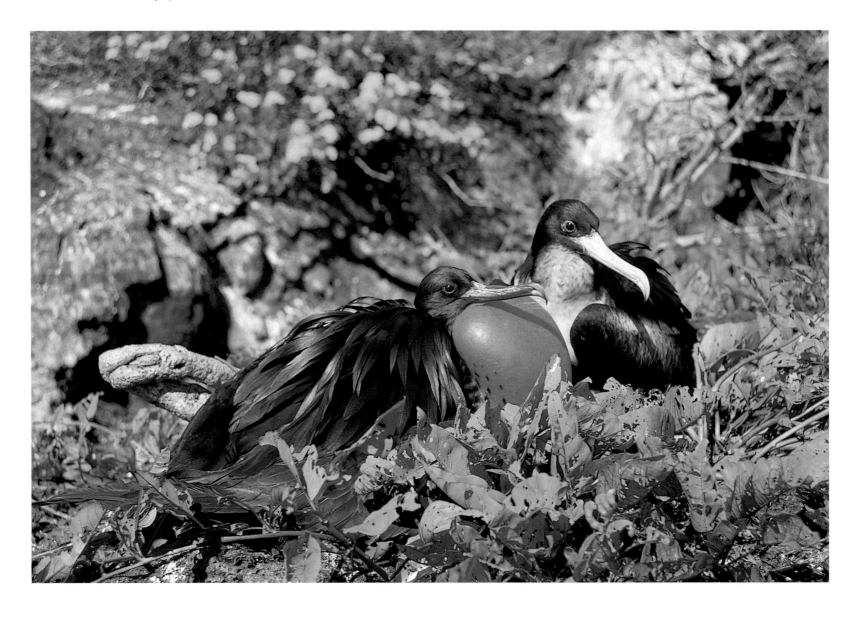

Great frigate birds

Nikon F4 with 105mm macro lens, Kodachrome 64, 1/250sec at f/8

Genovesa

That leaves the two islands which should be included in any planned visit; Genovesa (Tower) in the north and Española (Hood) in the south. On Genovesa you will land on a sandy beach to be greeted by swallow-tailed gulls, backed up a few paces away by nesting great frigates. Males, with their brilliant scarlet air pouches blown up in displays to passing females, sit on the low bushes. Walk into the Palo Santo woodland and there will be red-footed boobies nesting. Nearly all are dark phase brown birds, but there may be one or two white ones as well. Walking around the area of rocks just in from the landing beach will bring more swallow-tailed gulls, probably a lava gull or two, and possibly a lava heron and yellow-crowned night heron. Genovesa is a good

place for the large cactus finch and for the sharp-billed ground finch, but you will need to be lucky to get close to them. The area at the top is good for masked and other boobies and a panga ride along the bottom of the cliffs should bring red-billed tropic birds. Hammerhead sharks reputedly swim here in the deeper waters of the caldera.

Española

The most colourful marine iguanas are the ones on Española, with their touches of green and big red blotches. They are just as confiding as the ones on other islands and there are times when you have to be careful not to tread on one while you're looking at something else. The lava lizards here, too, are better coloured than they are on the other islands. From the landing at Punta Suarez, it is a short walk to the booby nesting areas, with both masked and blue-footed. Further on, you reach the albatross nesting ground, though the

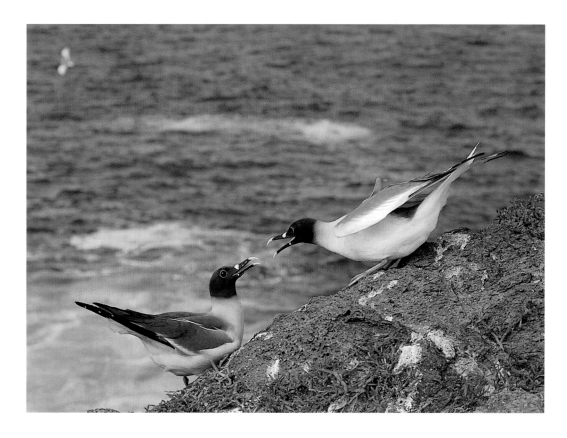

Swallow-tailed gulls displaying
Nikon F4 with 300mm lens, Kodachrome 64, 1/400sec at f/8

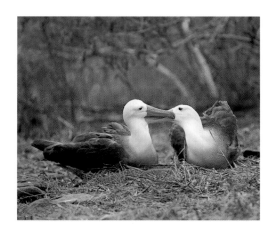

Waved albatrosses breed only on Española (Hood)
Nikon F4 with 300mm lens, Kodachrome 200, 1/250sec at f/8

Hood mockingbirds follow closely in your footsteps to seize on any insect you may disturb
Nikon F4 with 105mm macro, Kodachrome 64, 1/250sec at f/8

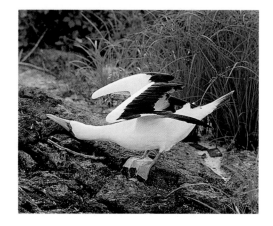

Masked booby display
Nikon F4 with 300mm lens, Kodachrome 64, 1/125sec at f/5.6

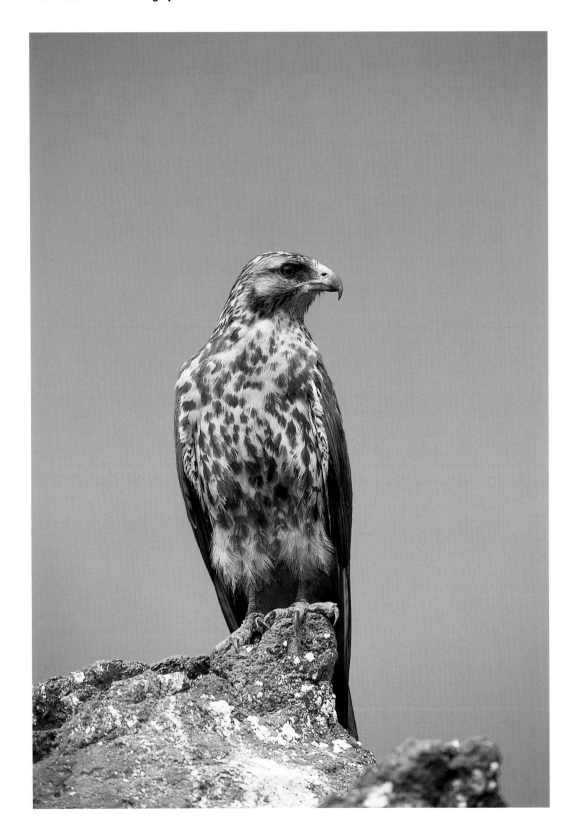

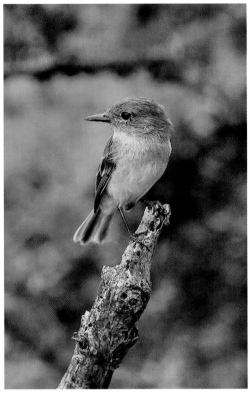

Galápagos flycatcher
Nikon F4 with 75–300mm lens, Kodachrome 200, 1/125sec at f/5.6

The Galápagos hawk is the rarest of all the Galápagos breeding birds
Nikon F4 with 80–200mm lens, Kodachrome 200, 1/500sec at f/8

numbers of all the nesting sea birds varies with the season and from one year to another. Hood mockingbirds will come around your feet. They seek insects, which you may disturb or be carrying: they are not looking to be hand-fed as no food is allowed ashore (nor can you bring a bottle of beer to quench your thirst). These birds belong to an endemic race or species, depending on whether you are a 'lumper' or a 'splitter'. There are four mockingbirds altogether in the Galápagos. The most difficult to photograph is the Charles (Floreana) mockingbird, which has become extinct on Floreana and now requires a visit to the islet of Gardner. You cannot go ashore, but your boat can go very close, if the weather is helpful, and the birds often oblige by sitting well up in the opuntia and the bigger bushes. Even so, you will not be in camera range.

General

The other bird species may turn up on several of the islands and it is difficult to plan for them. Audubon's shearwaters and Elliot's storm petrels are widespread on the inter-island runs, but getting close enough to photograph them is difficult. Sometimes the petrels will fly around your boat while it is at anchor, but they are so tiny that you really need a few of them together or a big lens to make a picture. Brown pelicans are common and approachable; you can afford to be choosy about angle, lighting and background.

Common noddies are most likely to be seen when you cruise along the cliffs in the panga, as are red-billed tropic birds. Short-eared owls and the endemic Galápagos hawk are very mobile, though you might not think so if you are fortunate enough to catch the hawk in an indolent mood. Galápagos doves are widespread and not very shy; Galápagos flycatchers and yellow warblers are fairly common, but they are restless birds and you need to be quick on the trigger. So are the Darwin's finches, all 13 species of them.

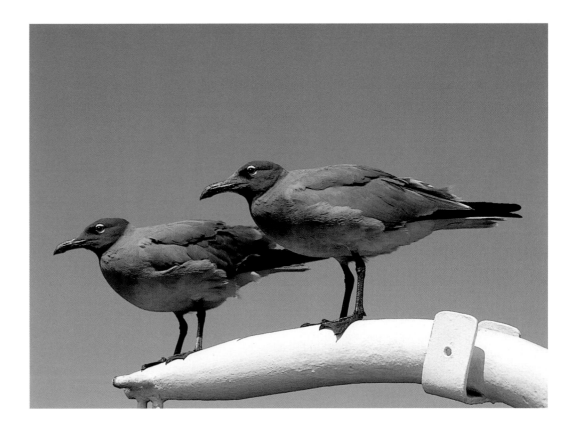

The dusky or lava gull is the rarest of the family, with a total population of only a few hundred pairs
Nikon F4 with 105mm macro lens, Kodachrome 64, 1/125sec at f/11

Senegal and The Gambia

The Gambia is a small country comprising a narrow strip of land along the Gambia River that is within the larger country of Senegal. Senegal has some fine reserves, including one with big mammals at Niokola Koba, but The Gambia is much more convenient to reach from most of Europe and has a more developed infrastructure for wildlife tourism. It also has the great advantage for many of us that English is widely spoken. It is easy to extend the trip into Senegal, if desired. From November to March, Senegambia is hot, sometimes very hot, and dry.

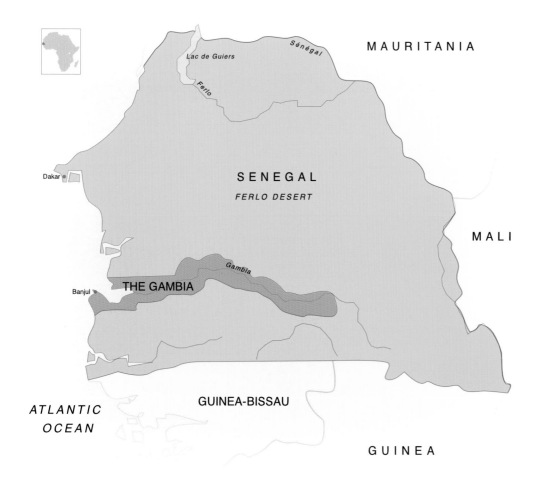

THE GAMBIA

There are plenty of cheap charter flights and hotel packages to The Gambia, as well as wildlife tours. Most of the hotels are near the beach to the west of the capital, Banjul. The shore has grey-headed gulls and several terns, including royal, lesser crested and sandwich, plus a few waders, especially whimbrel. Many more species of wader frequent the muddy pools that lie behind what is left of the coastal bush. Greenshank, bar-tailed godwit and wood sandpiper can be relied on. Marsh sandpiper and several plovers, including Kittlitz's, are quite likely to turn up. The dry land plovers, like the wattled and spurwing, can be found only yards away, with a chance of black-headed as well. Like many of the birds here, the waders are less shy than they are elsewhere and there is every chance of getting good pictures. Some of the hotels have sizeable gardens and baiting in them could be productive. As the birds are not shy, a few may be photographed by baiting near your room and setting up the camera on your veranda. Waxbills and firefinches will be the first to turn up. They are tiny, so you need to be close, even with a big lens.

Abuko Nature Reserve

Hire cars are a doubtful proposition and taxis are the usual means of transport. The national park of Abuko, no great distance from the airport and easily reached by taxi, is a key area. Some of the hotels organize visits, but they are too brief and start too late in the morning. Small as it is, Abuko demands plenty of time and an early start, so the best plan is to hire a taxi, bargaining for a sensible fare, and arrange

to be picked up from the park in the evening, when the light has gone – the park closes then, anyway. You should pay the fare after the return journey, though we found the drivers perfectly reliable. Take some food and plenty to drink and spend the middle two or three hours of the day quietly in the shade.

There can be up to five species of roller as you walk into the park. The Bamboo Pool, with its large hide and education

Long-tailed cormorants can be found wherever there is water

Nikon F4 with 400mm lens and 1.4X extender, Kodachrome 200, 1/125sec at f/8

centre, is near the entrance. Many birds, mammals and crocodiles either live here or come down to drink. Distances are too great for really good photography and a big lens is essential for even the biggest birds; maybe an extender too. This is the best place for crocodiles, both swimming and sunning themselves on the bank. There are other hides along the trail from the Bamboo Pool hide and these may offer closer views, but less light. Green vervet and red colobus monkeys come to drink and stay to eat from the trees. The vervet is found in many parts of Africa, but the colobus is a scarce animal.

Long, thin, camouflaged birds, like this long-tailed nightjar roosting on a thatched roof, do not make exciting pictures
Nikon F4 with 400mm lens, Kodachrome 200, 1/10sec at f/11

Tendaba Camp

Away from Abuko, there is plenty of secondary forest and, dry as it may appear, it is full of birds. This can be explored by taxi or by joining one of the organized visits to Tendaba Camp. Vultures are abundant, mostly hooded, but lappet-faced, Ruppell's griffon, white-backed and white-headed are around, too. Marabous, yellow-billed storks and pink-backed pelicans nest in quite large colonies in this part of The Gambia. The nests are in high trees, so take the biggest lens you have. Beware of the sun, which is extremely fierce in the middle of the day. At Tendaba you can take a boat trip up the creeks, which is fascinating but may not produce much in the way of pictures. If you continue a long way further up the Gambia River, you will find a stretch that is good for Egyptian plover during the right season.

SENEGAL

Senegal is a much bigger country than The Gambia and, being a former French colony, is French-speaking. The main airport is at Dakar. Saloon cars and 4WD vehicles are available for hire, at a price.

Djoudj

In the dry north of the country the main national park, Parc National aux Oiseaux du Djoudj, is at Djoudj, five hours' drive from Dakar, mostly on tarmac road. The roads near Dakar can be very congested and a good deal of patience is needed. Djoudj is seasonally flooded, though various barrages and sluices have been built, so the flooding is controlled to provide the right conditions for growing crops, mainly rice. In winter, it is an amazing place for huge numbers of waterfowl – hundreds of thousands of pintail, garganey and shoveler – and smaller numbers of many others. Waders are present in large numbers, too, especially ruff, which have taken to a vegetarian existence here. They feed in the rice fields, gleaning the spilt grain after the harvest, before returning to roost by the water. There are substantial reed beds and large expanses of open acacia woodland.

Many European passerines winter and the Wetland Trust operates a ringing station that catches large numbers of European and African birds. Photography is not easy though, except for birds in the hand at the ringing station. There are permanent hides on the Grand Lac and an abundance of birds on the lake, but the distances are usually too great. The park holds a big colony of white pelicans and this can be visited by boat. You cannot land, because that

Black bush robins are resident. Shots of birds in the hand have no pictorial merit, but may still be of interest
Nikon F4 with 105mm macro lens, Kodachrome 64, 1/60sec at f/11, SB24 flash gun

would cause too much disturbance, but you will be taken to convenient shooting range for a 300 or 400mm lens.

Accommodation and meals of an adequate standard are available at the park encampment. Long-tailed nightjars roost under the trees and on the thatch of some of the huts. The light can be surprisingly poor, as dust from the Sahara cuts down its penetration. If you are asthmatic, this dust may be a problem.

Langue de Barbarie

A short distance from St. Louis there is another reserve, the Parc National Langue de Barbarie. Here you can go out, in a pirogue (a dugout canoe), to the islands. These hold big colonies of sea birds, mainly grey-headed and slender-billed gulls, and terns of several species, including royal. There are also greater flamingos and pink-backed pelicans. You cannot land on the islands, but can go in fairly close by boat, and there are many birds on the shore and the water. Remember to take a hat and sunscreen.

The ringing teams at Djoudj catch large numbers of migrants and residents. This red-spotted bluethroat had already been ringed, but continued to feed in the vicinity
Nikon F4 with 400mm lens, Kodachrome 200, 1/60sec at f/5.6, SB24 flash gun

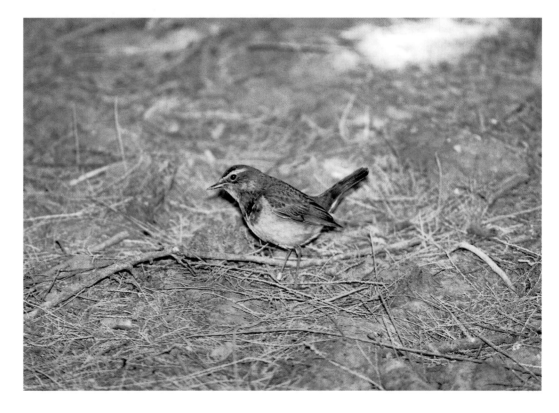

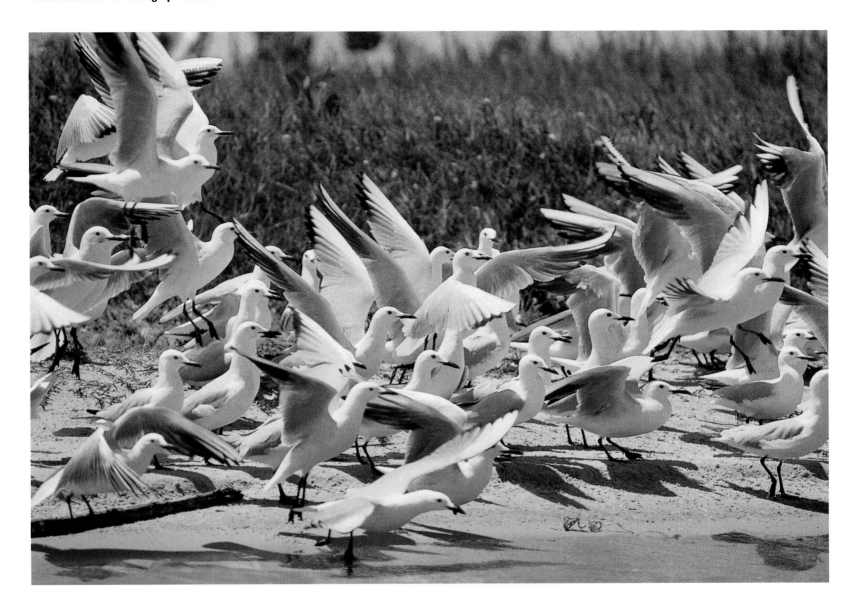

Siné-Saloum Delta

To the south of Dakar and close to the border with The Gambia is the Parc National du Delta du Saloum. This has a major sea bird nesting site at the Ile aux Oiseaux, which can be visited by pirogue, and has masses of gulls and terns, rather like the Langue de Barbarie. The many channels of the estuary are lined with mangroves. They are not particularly rich in birds, but there are pied and malachite kingfishers in addition to a variety of herons. Most of the park comprises Guinea savannah and holds a good and varied selection of birds and mammals, including Geoffroy's ground squirrel and Gambian sun squirrel. Hotel accommodation can be found just outside the park, but the park encampment, the Gîte Touristique de Bandiala, offers good rooms and food.

The Langue de Barbarie hosts a big colony of slender-billed gulls (photographed from a boat)
Nikon F4 with 400mm lens, Kodachrome 200, 1/500sec at f/8

Against a deep blue sky, birds show up rather well, like these white pelicans. In such circumstances you don't need a polarizing filter
Nikon F4 with 75–300mm lens, Kodachrome 200, 1/1000sec at f/5.6

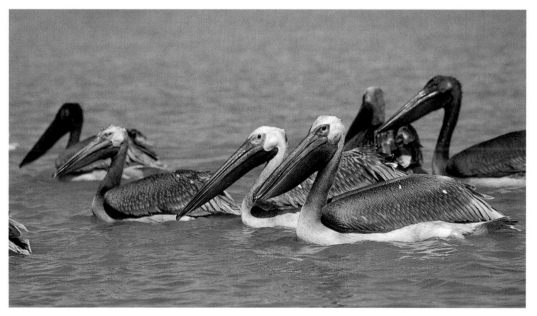

The colony of white pelicans at Djoudj seems to be highly successful, judging by the number of young ones swimming around (photographed from a boat with a 300mm lens, hand-held)
Nikon F4 with 75–300mm lens, Kodachrome 200, 1/500sec at f/8

India

Photographing in Africa is exciting and fun; photographing in India is an experience. There are excellent national parks, a good internal air service and first-class hotels. But the parks only remain because they are in remote areas where industry and intensive agriculture have not been profitable, so the best ones are 100–200 miles (160–320km) from the nearest airport – and even 100 miles (160km) on Indian roads is a long and hazardous journey. The bulk of some journeys can be made by rail, but you will do well to get local help to obtain your ticket and your seat/bed reservation. Whether you travel by road or by rail it will be slow; 25mph (40kmph) is the maximum to be expected, so transferring between localities will normally take a full day. Some parts of India are well covered by the travel companies; if you can find a tour that suits, it will save you much hassle. The trains are reasonably comfortable, though slow and crowded. Take food and drink. You can't bring rupees into India; you must convert money upon your arrival at the airport or at a hotel. Don't expect to be able to change money whenever you want, nor to convert surplus rupees when you leave.

Bharatpur

Most tourist parties start at Delhi and proceed to the bird sanctuary at Keolado Ghana (Bharatpur) and the tiger reserve at Ranthambhor. You can get to Bharatpur by road or rail in a day, taking in the Taj Mahal at Agra, which is truly marvellous, even for those who profess to be interested only in birds. Forest Lodge, at Bharatpur, has been greatly improved and is the closest to the reserve. There is plenty of accommodation in the town, but this leaves a fair trek into the park. Travel is usually by bicycle rickshaw or by hired bicycle. Even if you have a car, it cannot be taken into the reserve.

White-breasted kingfisher
*Nikon F3 with 400mm lens, Kodachrome 64,
1/250sec at f/5.6*

The water birds mostly nest at the time of the monsoon rains, around July and August, but most photographers visit early in the year, when the nests are empty. In winter the pools are full of ducks and geese which have been driven south to Bharatpur, to escape the Arctic winter. Photography is not as easy as might appear at first sight: many of the birds are too far out to permit shots of individuals and with a big lens it is difficult to get enough depth of field to avoid most of a flock being out of focus. Birds closer to shore, like the herons, Asian darter, painted and black-necked storks, may give better pictures. There is a good selection of small fry, including little green bee-eater, magpie robin, bluethroat, various waders and wire-tailed swallow. Most of these will be seen as you walk (or take a bicycle rickshaw) from the entrance towards the temple

Asian darter ▲
*Nikon F5 with 80–400mm lens, Fuji Sensia 100 uprated
to ISO 200, 1/125sec at f/5.6*

Python ▼
*Nikon F5 with 80–400mm lens, Fuji Sensia 100 uprated
to ISO 200, 1/30sec at f/16*

after which the reserve is named. Near the temple there are rhesus macaques, ring-necked parakeets and a variety of small birds. Siberian cranes winter in small numbers – in 2001 there were only two out of a world population of this race of five. Sarus cranes are more numerous.

Bharatpur has good mammals as well as birds. You can find small Indian mongoose, wild boar, nilgai and golden jackals. A couple of the small cats are present, but are more likely to be seen than photographed. If your taste is for reptiles, the place has pythons in numbers and any of the guides will take you to a hole. Unless both of you are quiet, though, you will only see the rear half of the snake sliding into its home. There must be many other snakes around, but they keep themselves well out of the way.

Siberian cranes
Nikon F5 with 80–400mm lens, Fuji Sensia 100 uprated to ISO 200, 1/500sec f/5.6

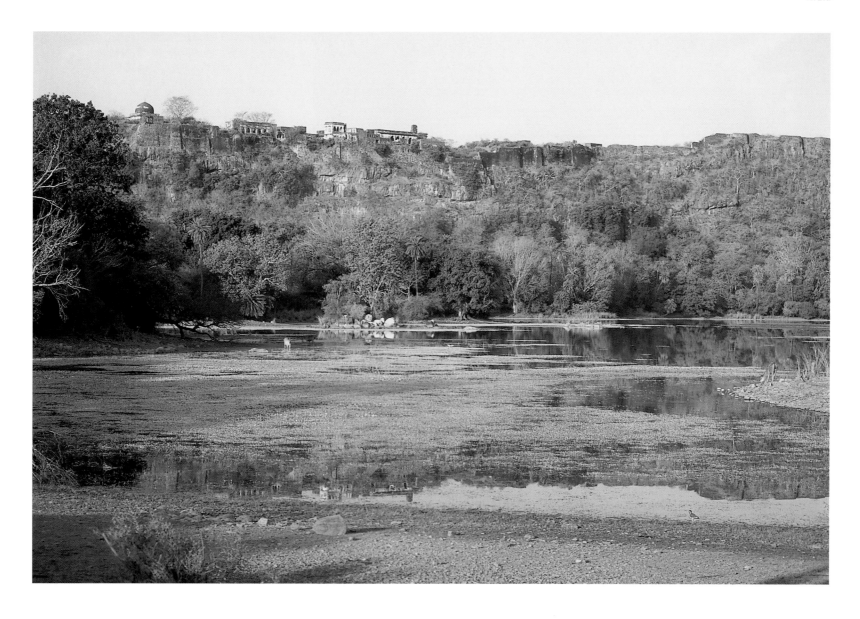

Ranthambhor

Ranthambhor can be reached by train (it is 7¹/₂ miles (12km) from the train station at Sawai Madhopur) or by road. It is only a half-day's drive from Bharatpur if the road is in fair condition, but it can be appalling. There is a choice of good accommodation. You are not allowed to use your own vehicles at Ranthambhor, but your lodge will convey you by Maruti 'jeep'. These are well suited to the work, but are quite small. With a driver and a guide, three photographers is the maximum for comfortable working. These vehicles must be booked well in advance. The park is very scenic, with woodland and lakes all overlooked by an ancient, half-ruined fort. From a vehicle you can photograph Hanuman langur, chital, sambar, nilgai, wild boar, golden jackal

The pretty lake by the park headquarters at Ranthambhor attracts many animals, including tigers
Nikon F4 with 28–70mm lens, Fuji Sensia 100, 1/125sec at f/8

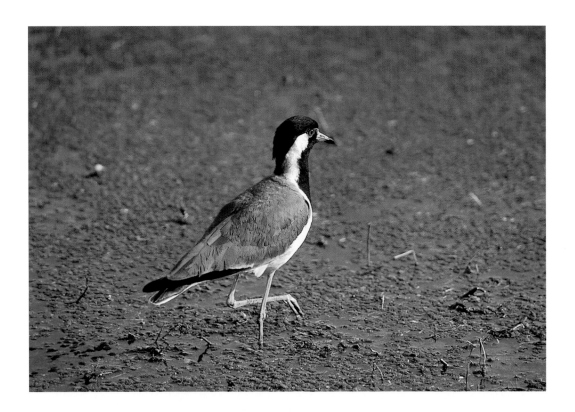

Red-wattled lapwing
Nikon F5 with 80–400mm lens, Fuji Sensia 100 uprated to ISO 200, 1/60sec at f/5.6

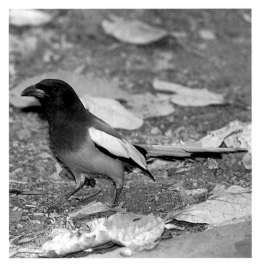

Indian treepie
Nikon F4 witih 300mm lens, Fuji Sensia 100, 1/250sec at f/8, SB24 flash gun

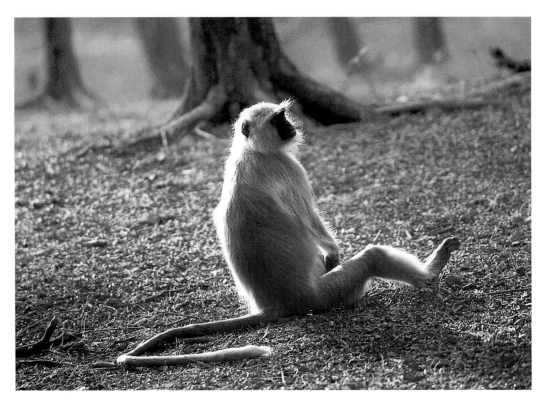

Common (hanuman) langurs are widespread
Nikon F5 witih 80–400mm lens, Fuji Sensia 100 uprated to ISO 200, 1/60sec at f/8

Blue bull (nilgai)
Nikon F4 with 80–200mm lens, Fuji Sensia 100, 1/125sec at f/8

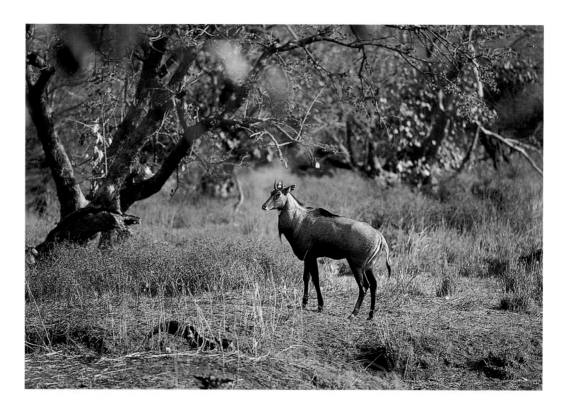

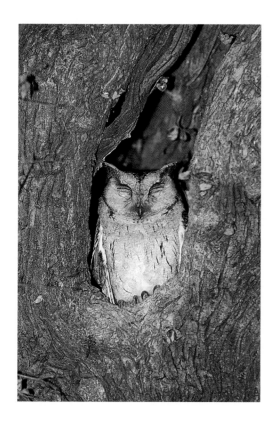

Collared scops owl at its nest hole
Nikon F4 with 300mm lens, Fuji Sensia 100, 1/125sec at f/8

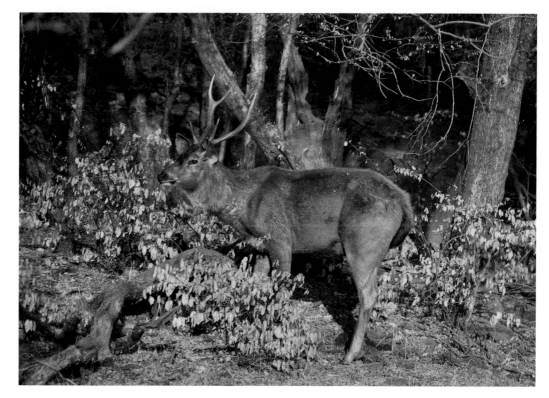

Sambar stag
Nikon F5 with 80–400mm lens, Fuji Sensia 100, 1/60sec at f/8

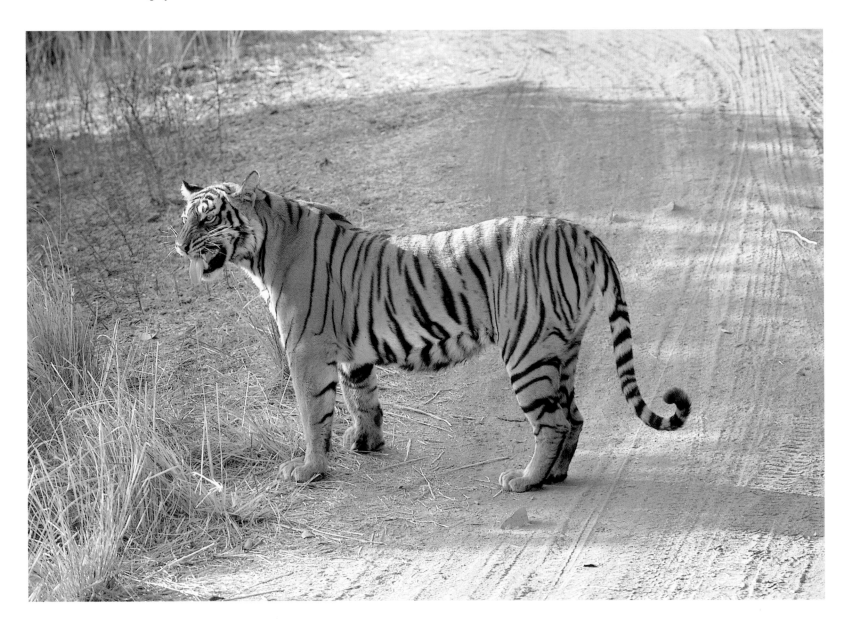

and mugger crocodile. Tigers are more difficult, but they are what most visitors want and the drivers and guides are as keen to find them as you are. Visitor pressure is high, so the park authorities dictate the route and the times of entry and departure for each jeep. It is possible to do very well, but you need to be lucky. There is just a chance of sloth bear and

porcupine. Treepie and several other bird species, including some of the babblers, occur around the headquarters and some of the stopping places; hoopoe and brown rock chat are available near the fort. The lake areas have a variety of accessible ducks and wader species along with photogenic sambar deep in the water, feeding on aquatic vegetation.

Tigress

Nikon F5 with 80–400mm lens, Fuji Sensia 100 uprated to ISO 200, 1/125sec at f/5.6

Indian monitor lizard
Nikon F5 with 80–400mm lens, Fuji Sensia 100 uprated to ISO 200, 1/60 at f/11

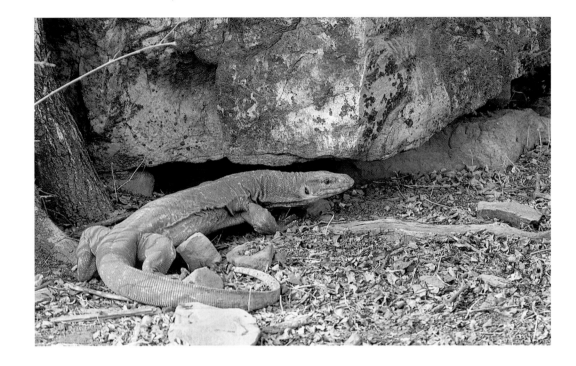

Muggers are the only common crocodilians in India. They are mainly fish eaters
Nikon F5 with 80–400mm lens, Fuji Sensia 100 uprated to ISO 200, 1/125sec at f/8

The Tumbril; all kinds of things can be used as hides, and the staff at Tiger Haven made one from a cart ▲
Nikon F3 with 28mm lens, Kodachrome 64, 1/60sec at f/5.6

Red jungle cock photographed from the Tumbril ▼
Nikon F3 with 300mm lens, Kodachrome 64, 1/60sec at f/5.6

Dudwa National Park and Tiger Haven

Further north, near the border with Nepal, is the Dudwa National Park and Tiger Haven, the base for Billy Arjan Singh's work for tiger conservation and his extraordinary rehabilitation of tigers and leopards. It is best reached via Lucknow, from which it is a five-hour drive. The accommodation is simple but excellent and the food is superb. The paths you walk by day are used by tigers at night – you can see the tracks. Just by the house, two species of nightjar hunt and display at dawn and dusk and red jungle fowl feed on the open land. In the park, there is plenty to photograph from a vehicle or from an elephant's back, but the tigers and sloth bears may not co-operate. Swamp deer, on the other hand, are relatively numerous and not too shy. Smooth otters can be photographed on the river bank. There are substantial lakes with a good range of water birds, and hides that give fine views through binoculars, but you cannot get close enough to photograph well.

Kaziranga

Still in the north, but much further to the east, is Kaziranga in Assam. It is not always possible to get a visa to enter, but the park is so good that it is worth some effort. It is mainly swamp and forest and there is some attractive hill country just outside the park, with clear streams and tribal villages. Access is from Gauhati or Jorhat airports, and is a full day's drive from the former – the usual route. On arrival, it may be necessary to report to the police, where the forms granting you permission to enter will be completed over a friendly cup of tea. Accommodation and

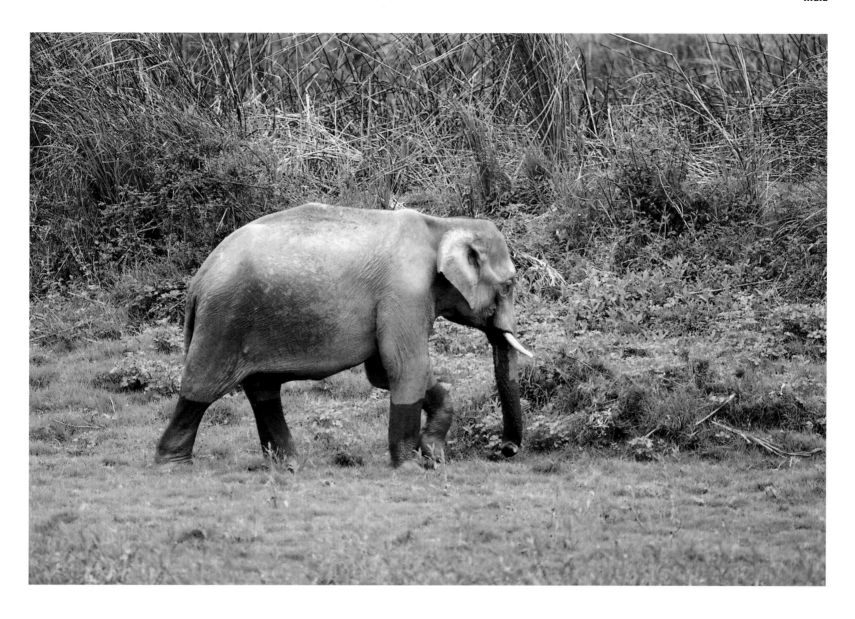

food are adequate; do use the mosquito nets provided by the lodge and take precautions against malaria.

There are regular tours, on elephant back, of swamp and grassland. From your perch, water buffalo, swamp deer (a different race from the ones at Dudwa) and hog deer can be photographed. This is not easy because, although the mahouts try to stop in the right place, the elephants do not always perform as they might. In addition, they give great shudders from time to time, usually at a critical moment. One-horned rhinos with young may charge the elephants, but not with much determination, and they normally amble off into cover. There is a theoretical chance of tigers but, in reality, not much more. The rest of the park can be covered by car, carrying a guide as well

Indian elephant
Nikon F3 with 400mm lens, Kodachrome 64, 1/125sec at f/5.6

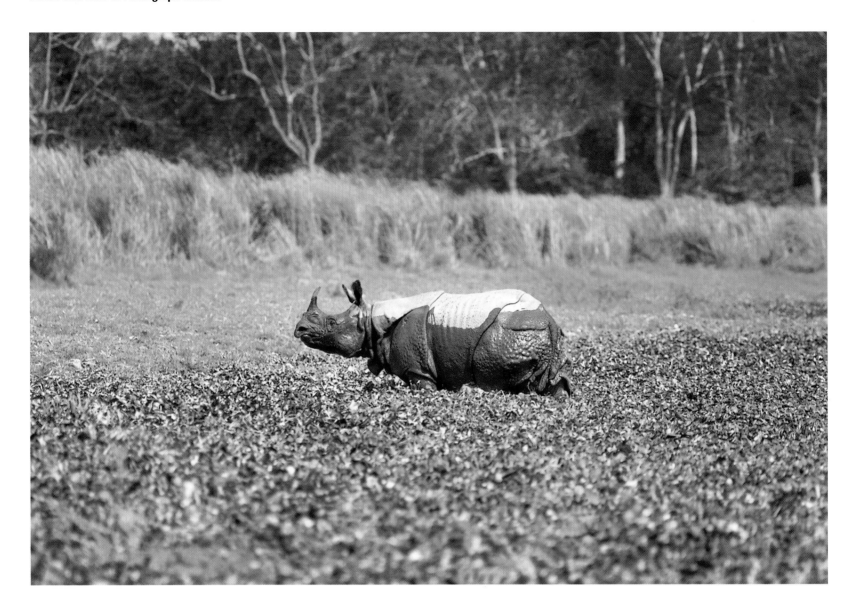

as a driver, so no more than two photographers can be fitted in. The supply of guides and guards is arranged by the forestry office, near the lodge. Where permitted, it may be better to go on foot with your guide, but the animals, especially Indian elephants, can be aggressive. Rhinos can probably be deterred by a shout and, easily, by your guide firing a blank, but elephants need to be treated with caution. Around the pools, there is a good chance of getting spot-billed pelican plus a good variety of herons and storks, including black-necked; there is also a possibility of both adjutants. The grey-headed fishing eagle stands out among the birds of prey. The weather at Kaziranga can be a problem – it can drizzle for days – and the light is generally not very good.

One-horned rhinoceros photographed from on foot
Nikon F3 with 400mm lens, Kodachrome 64, 1/125sec at f/5.6

Gujarat

The weather is more favourable at Gir, in Gujarat. The forest here is dry and generally leafless, not very tall, but quite thick. It is reached by plane from Mumbai to Keshod or Rajkot, and then by road. There is a convenient lodge at Sasangir. Gir is the only place where the Asiatic lion still survives. Chital are abundant, but the fine assortment of other large mammals known to be in the park, including nilgai, leopard, and the four-horned antelope, are difficult. Dust is a problem – reckon on a good deal of camera and lens cleaning.

Small Indian mongoose
Nikon F5 with 105mm macro lens, Fuji Sensia 100 uprated to ISO 200, 1/125sec at f/11

Little Rann of Kutch

This applies too, if you visit the Wild Ass reserve at Zainabad, in the Little Rann of Kutch. The 2001 earthquakes did some damage here, but the accommodation and hospitality remain intact. The ass are not too shy and, travelling in the camp vehicle, you can find flamingo, common and demoiselle crane, Indian courser and, maybe, MacQueen's bustard. On the way to Zainabad you can visit the blackbuck sanctuary at Velvadar. There are plenty of blackbuck and nilgai, but they are shy.

Wild asses live in the large expanse of dried mud that is the Little Rann of Kutch in the dry season
Nikon F5 with 80–400mm lens, Fuji Sensia 100, 1/250sec at f/5.6

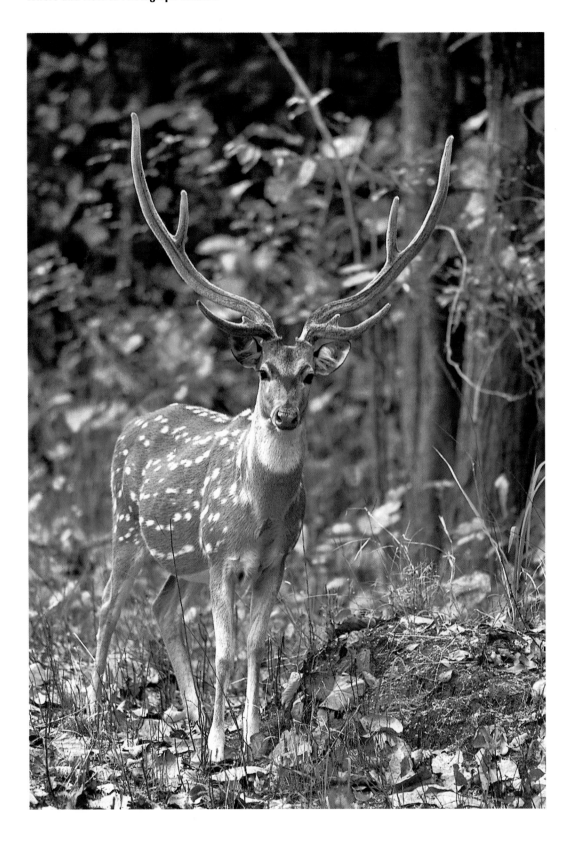

Kanha National Park

Kanha National Park lies in the centre of the subcontinent, in Madhya Pradesh. Getting there is a struggle, as it is 170 miles (270km) from Nagpur, the nearest airport, though you can get closer by overnight train, via Agra. In some ways this is the pick of the parks and there are several places to stay. The park was set up to protect another race of swamp deer, but now it is best known as a place to see tiger from elephantback. The light in the forest is poor and an elephant does not provide a very stable platform, but your tiger will tolerate quite a close approach, so you can use a lens of moderate focal length and a wide aperture. You can also try to chance upon a tiger as you are driven around in your vehicle. The alarm calls of chital are a good guide. Apart from chital, there are sambar, wild boar, barking deer, jackal, leopard, dhole and gaur. Much of Kanha is scenically pleasant, with lovely park-like areas and plenty of birds.

Mumbai

If you pass through Mumbai and have a few spare hours, you could do worse than spend them in the Sanjay Gandhi National Park, which is right by the city. It holds bonnet macaque, which are not too shy, Indian hare, chital and a whole stack of birds. Even your international hotel might have a grey musk shrew whizzing around the dining room.

Chital stag. Chital are the main prey of tigers – their alarm calls give a clue as to a tiger's whereabouts
Nikon F4 with 300mm lens, Fuji Sensia 100, 1/125sec at f/8

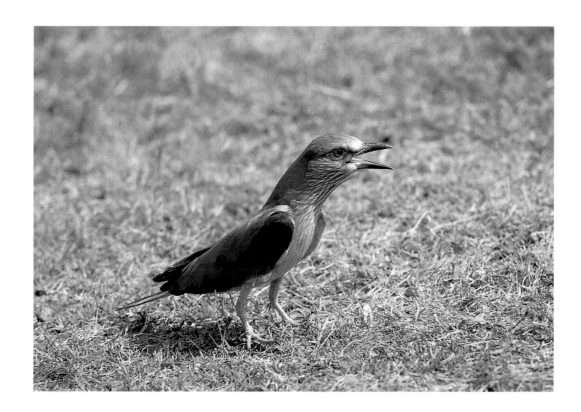

Indian roller
*Nikon F4 with 300mm lens, Fuji Sensia 100,
1/250sec at f/8*

**You can photograph jungle crows while you're waiting
for the elephant from which you may see a tiger**
*Nikon F4 with 300mm lens, Fuji Sensia 100,
1/250sec at f/8*

Thailand

Thailand is another country for photographers who like a challenge. It has a very good range of birds and mammals, but getting them on to film is difficult. Part of the problem is that many species are only to be found in the forest and, like forests everywhere, they are not easy to work in. In addition, there seems to be a good deal of hunting, even where this is officially forbidden, so the wildlife is extremely shy.

Khao Yai National Park

One of the best national parks is at Khao Yai, a half-day's drive north from Bangkok. The traffic in Bangkok itself is dense and chaotic. Once outside the city though (and the airport is on the right side for Khao Yai), driving is easy. The park is a mixture of forest and patches of tall grassland, the result of agricultural use of the land before the park was gazetted.

There is a hotel in the park, round which great-eared nightjars fly at dusk, or you can stay in one of the bungalows that have been built in the more open areas. They typically have two bedrooms, a lounge, and a veranda. There is electric power for lighting and charging batteries. The park authorities closed these bungalows at one time, so you would need to check whether they are available.

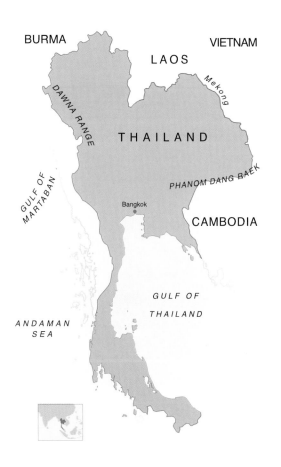

The spacious wooden bungalows are ideal for photographers, but you must make your own arrangements for meals ▲
Nikon F3 with 50mm lens, Kodachrome 64, 1/125sec at f/8

Most of the mammals, like this muntjac, are shy ▶
Nikon F3 with 400mm lens, Kodachrome 64, 1/250sec at f/5.6

Khao Yai is mainly thick forest with interesting tracks that are marvellous for birdwatchers, but not for wildlife photographers
Nikon F3 with 28mm lens, Kodachrome 64, 1/30sec at f/8

Early in the morning and at dusk there are plenty of sambar and some barking deer to be seen in the open – the golf course is one area worth a try. These animals are not usually approachable, but you might strike lucky. On the forest edge, pig-tailed macaques are possible. The elephants are much more difficult as they rarely leave the forest and are very nervous. One local photographer took some pictures by creeping up to the animals as they fed in the forest, but that is a technique strictly for heroes: Asian elephants are more aggressive than African ones.

There are quite a number of marked trails through the forest and these are fine for birdwatching, but not for photography. You need to be careful, because the less used ones are only slight paths and, where elephants have been passing, their tracks can supersede the proper one, then disappear without trace. There are not many landmarks and you can find yourself a long way from home without a trail in sight. After rain, the leeches become active and you have only to stand still for a minute to see the forest floor heaving with the little beasts, which have nosed out the possibility of a meal and are heading steadily for you. The thought of them is worse than the reality, as their bites are painless and they do not carry any disease. Once they have had their fill they drop off, leaving a bit of blood, but doing no real

harm. Once the forest floor dries out, they go underground and are no problem at all.

After the evening meal you can tour slowly around in the car, looking for nocturnal mammals like large Indian civet, palm civet and leopard cat. You can try just using the headlights, but a spotlight makes a huge difference. There are tigers in the park – something to keep in mind when you are walking around in daylight

and to discourage you from exploring on foot in the dark. We found one on the rubbish tip near the hotel. Binoculars make it easier to distinguish animals at night.

In the early morning, gibbon serenade each other with howls that can be heard for miles. The light at this time of day is poor and it is often misty as well. Once the sunshine reaches the treetops, many birds emerge briefly to enjoy it and there may

Gibbons serenade you at dawn, but are elusive. This one was approachable and had become habituated to the local people
Nikon F3 with 70–210mm lens, Kodachrome 64, 1/125sec at f/5.6

Common sailor and other butterflies settle on your clothes and baggage to drink your sweat
Nikon F2 with 105mm macro lens, Kodachrome 64, 1/60sec at f/14, SB12 flash gun

be opportunities for photographs. Within half an hour they will have gone again. There are several arboreal squirrels, including variable, little striped, grey-bellied and the black giant squirrel, which is about a yard long. There is a big colony of wrinkle-lipped bats in a cave just outside Khao Yai. They come out like a stream of swirling smoke when it is nearly dark.

It is an impressive sight and might be worth trying with some high speed film.

Although Khao Yai holds a fine selection of birds, including many that are

Atlas moth
Nikon F2 with 105mm macro lens, Kodachrome 64, 1/60sec at f/14, SB12 flash gun

Paris peacock
Nikon F2 with 105mm macro lens, Kodachrome 64, 1/60sec at f/16, SB12 flash gun

Common staff sergeant
Nikon F2 with 105mm macro lens, Kodachrome 64, 1/60sec at f/16, SB12 flash gun

Magpie crow
Nikon F2 with 105mm macro lens, Kodachrome 64, 1/60sec at f/16, SB12 flash gun

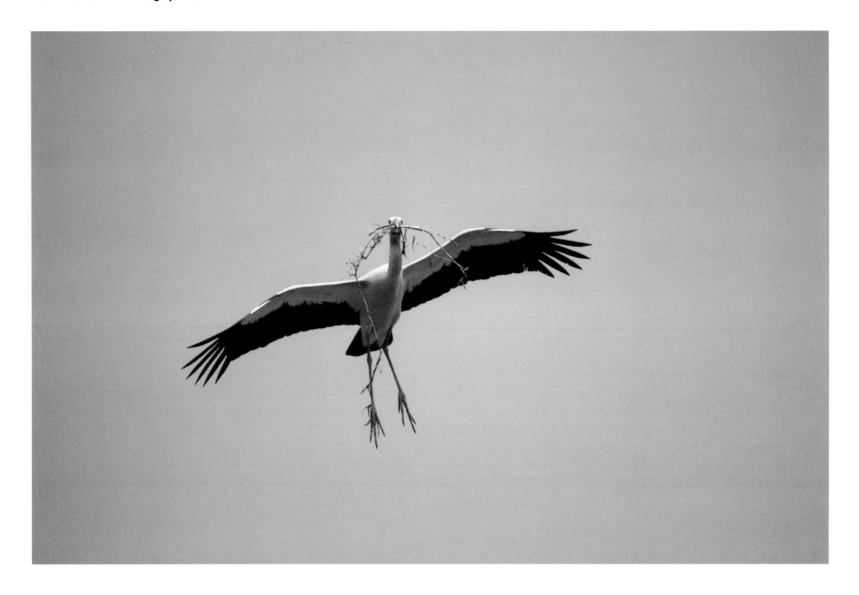

endangered, they are shy and it may be more rewarding to spend your time on lesser beasts. One of the most attractive features of Khao Yai is the number of clear streams that tumble down through the forest, often with pretty waterfalls. There are marked trails with plenty of dragonflies and butterflies. Some fly high in the canopy and stay well out of range, but many come to drink, some on the pebbly areas, others on the damp sand. The stream

above Heiw Suwat waterfall is one good stretch. Some of the species names are very impressive – who could forget a great Mormon, a purple sapphire or a Siamese Royal Assyrian? Other names are quite dismissive; the common sailor, small staff sergeant and common bluebottle for instance. The availability of the illustrated guide by Nuhn and Reeves, *Some Butterflies of Khao Yai National Park*, printed in Thai and English, helps with identification.

Asian openbill stork
Nikon F3 with 300mm lens, Kodachrome 64, 1/500sec at f/5.6

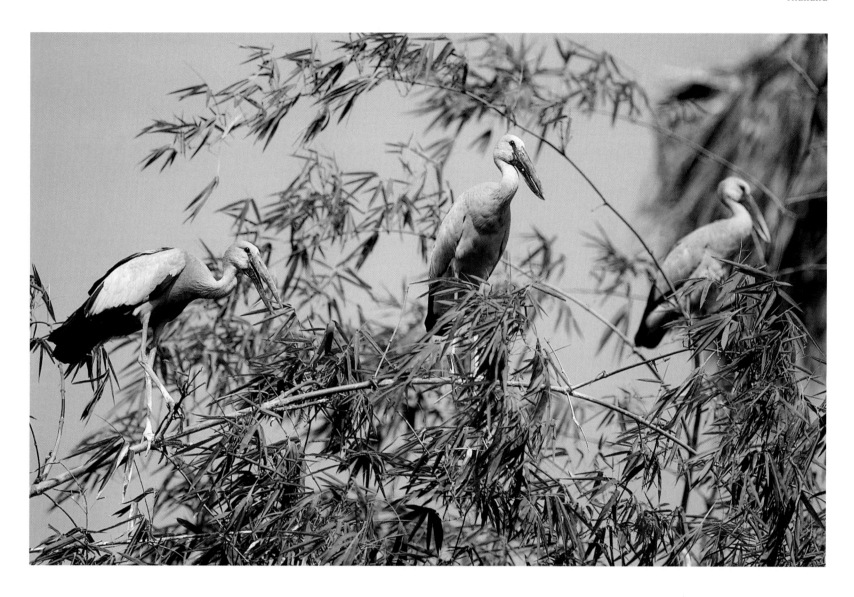

Around Bangkok

From Bangkok, it is an easy trip by water taxi to the monastery of Wat Pai Lom, where there is an excellent colony of Asian openbill storks. The trees are not too high and with searching, you can find a nest which offers a reasonably clear view. The birds can also be photographed as they fly in, sometimes with food or nesting material.

South of Bangkok, around Bang Poo, there are big areas of mud flat and mangrove, as well as muddy pools a little inland, where the local people net fish and crustaceans. Several species of waders can be photographed here. If you are heading that way from the other side of Bangkok, I would advise you to start very early, before the traffic builds up.

Asian openbill storks nest in the grounds of Wat Pai Lom

Nikon F3 with 300mm lens, Kodachrome 64, 1/125sec at f/8

Venezuela

There is no difficulty getting to Venezuela; plenty of companies will fly you to Caracas. But this is a big city with many of the problems associated with poverty and not a good place to go exploring, especially at night. From Caracas you can take an internal flight, or motor to your chosen destination, but it is a good idea to minimize the length of your drive, because the roads vary greatly in quality and can be very bad, especially after heavy rain. For most areas 4WD will be essential. Unless your Spanish is up to scratch, communication will be difficult. This is not vital when everything is going to plan, but makes for serious problems when it all goes awry. For a first trip, using a tour company may be the answer. As usual, it will cover far too much ground for good photography, but it will at least have the advantage of showing you a good deal of what the country has to offer, and you can pick your spots for a later trip. The accommodation and food will be adequate, sometimes a bit basic. Nights are generally hot; you will probably have a fan, but don't bank on air conditioning. Precautions against malaria are necessary and probably against yellow fever, too.

Venezuela holds a huge variety of birds and there is a good field guide to them (*A Field Guide to the Birds of Venezuela*, de Schauensee and Phelps). There are many mammals as well and plenty of literature on them, though no field guide. There are frogs, lizards, snakes and insects in quantity, but expect a great deal of difficulty in identifying them. Most of the bird species will be found in the rainforest. They are easy to hear, difficult to see and very difficult to photograph. With a big lens on a proper tripod, decent images will be obtainable, but they will be few and hard won. You will probably have to use flash and may benefit from fitting a condensing lens to it to concentrate the beam. This makes the flash effective at greater distances, though at the expense of making the outfit even clumsier to carry around. The places at which you stay may have feeding stations; if they do, your prospects will be much improved. Even if they don't have an established feeding place, you can put out some fruit and see if anything comes to it. The forest mammals are even more difficult and you shouldn't expect to get much on a short trip.

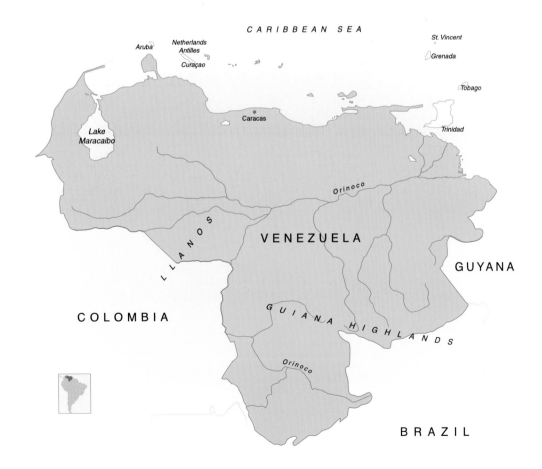

Blue-winged mountain tanager at a feeder in the Henri Pittier National Park
Nikon F4 with 105mm macro lens, Kodachrome 64, 1/250 at f/8, SB24 flash gun

Buff-necked ibis, photographed from the ranch truck ▲
Nikon F4 with 400mm lens, Kodachrome 64 1/250sec at f/5.6

Green ibis, photographed from the ranch truck ▼
Nikon F4 with 400mm lens, Kodachrome 64 1/125sec at f/8

Golden tanager at a feeder in the Henri Pittier National Park
Nikon F4 with 105mm macro lens, Kodachrome 64, 1/250 at f/8, SB24 flash gun

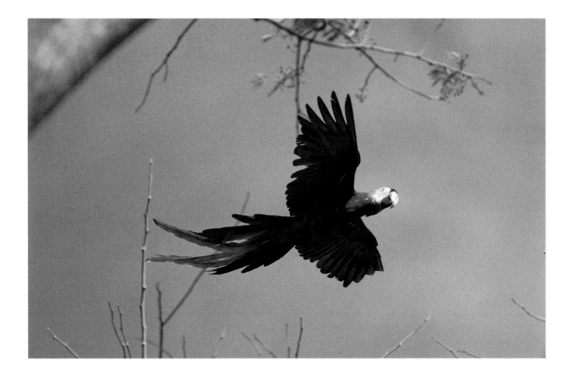

Scarlet macaws frequent the high trees near the ranch ▲
Nikon F4 with 400mm lens, Kodachrome 64,
1/250sec at f/5.6

Rufescent tiger heron ▼
Nikon F4 with 400mm lens, Kodachrome 200,
1/250sec at f/8

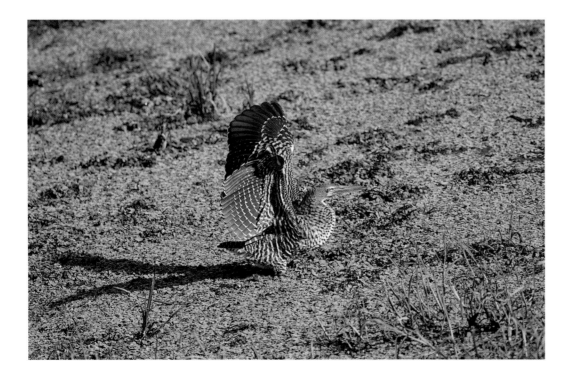

The llanos

Even on a birding trip you will probably get some time in the llanos, and there your prospects are transformed. There are several ranches on which the wildlife is conserved alongside large numbers of cattle. In the rainy season much of the land is flooded and as it dries out, large pools are left. Flocks of duck and caimans occupy them and ibises, other water birds and capybaras feed around the edges. All the usual techniques can be used, given time, but you will probably have to settle for a place on the truck that takes the birders around the ranch. There may be room to set up a tripod and to move it from one side of the vehicle to the other as opportunities occur. If not, use a beanbag. If you are with a group of twitchers, there may not be much time before the leader wants to move on, so speed is of the essence. Try to get the driver to switch off the engine when you are shooting – as some vehicles are difficult to re-start, they may be reluctant. Twitchers are a restless lot, but if you can persuade them to sit still

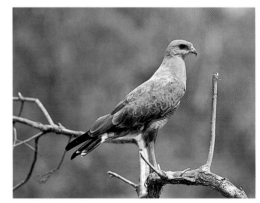

Savanna hawk ▲
Nikon F4 with 400mm lens, Kodak Elite 100,
1/500sec at f/5.6

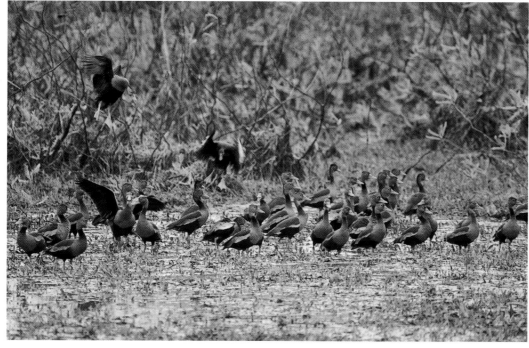

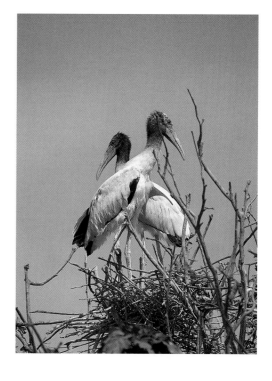

There are big flocks of tree ducks in some of the wetlands ▲
Nikon F4 with 400mm lens, Kodachrome 64, 1/250sec at f/5.6

Jabirus ▼
Nikon F4 with 400mm lens, Kodachrome 64, 1/100sec at f/11

Young wood storks ▲
Nikon F4 with 400mm lens, Kodachrome 64, 1/125sec at f/11

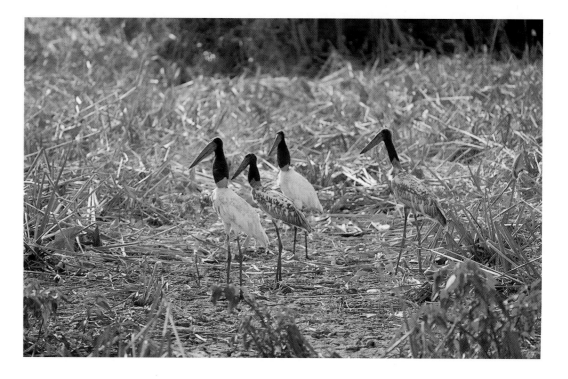

Yellow-knobbed curassow
Nikon F4 with 400mm lens, Kodachrome 64, 1/250sec at f/8

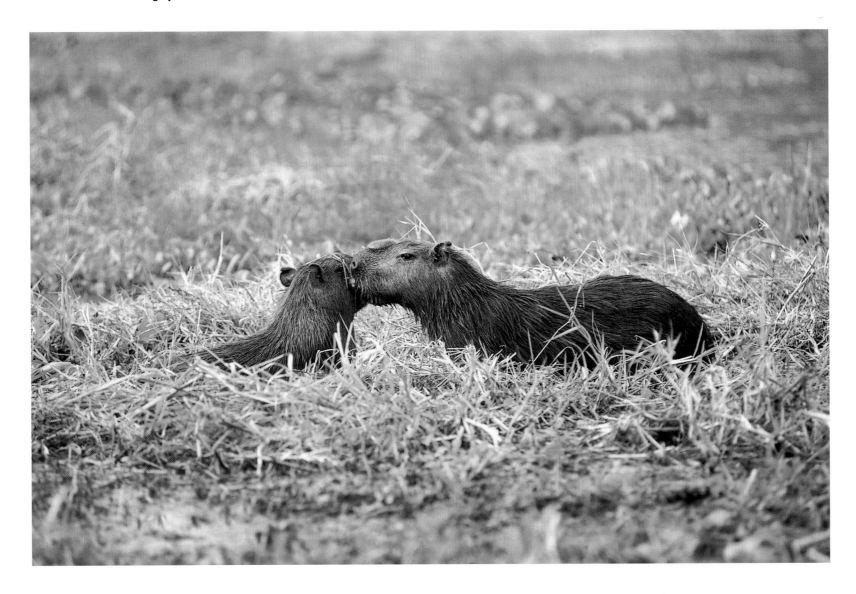

for a minute while you shoot, your pictures will benefit. The bigger your lens, the more subjects you will be able shoot, but the slower you will be to frame them.

In the dry season the light is usually pretty good, and since you will probably set off in the early morning and again mid-afternoon, it will give decent modelling. Apart from the water birds, the truck will pass trees with hawk and other birds that may be worth a try. There is likely to be an

opportunity for a short stroll, in which case keep an eye open for armadillos and anteaters as well as birds. There are two very similar species of armadillo in this area and they are fairly common even though, reputedly, they are good eating. Around the ranch head-quarters the birds will be used to people and these places should be productive for tropical kingbirds, white-winged swallows and the other birds common locally.

Capybaras are common wherever they are protected and in some areas are so numerous they can be culled for food
Nikon F4 with 400mm lens, Kodachrome 64, 1/125sec at f/8

Giant anteater. The best subjects always show up when the light is at its worst
Nikon F4 with 400mm lens, Kodachrome 200, 1/250sec at f/5.6

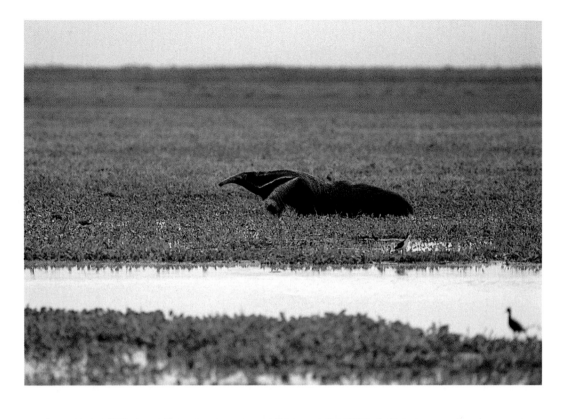

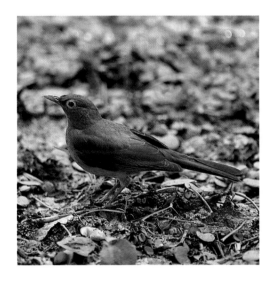

Bare-eyed thrush
Nikon F4 with 400mm lens, Kodachrome 64, 1/125sec at f/8

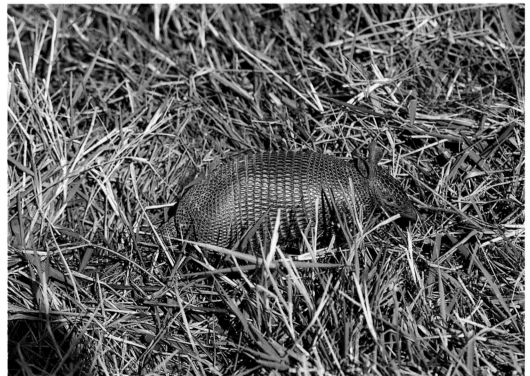

Armadillo
Nikon F4 with 105mm macro lens, Kodachrome 64, 1/250sec at f/11, SB24 flash gun

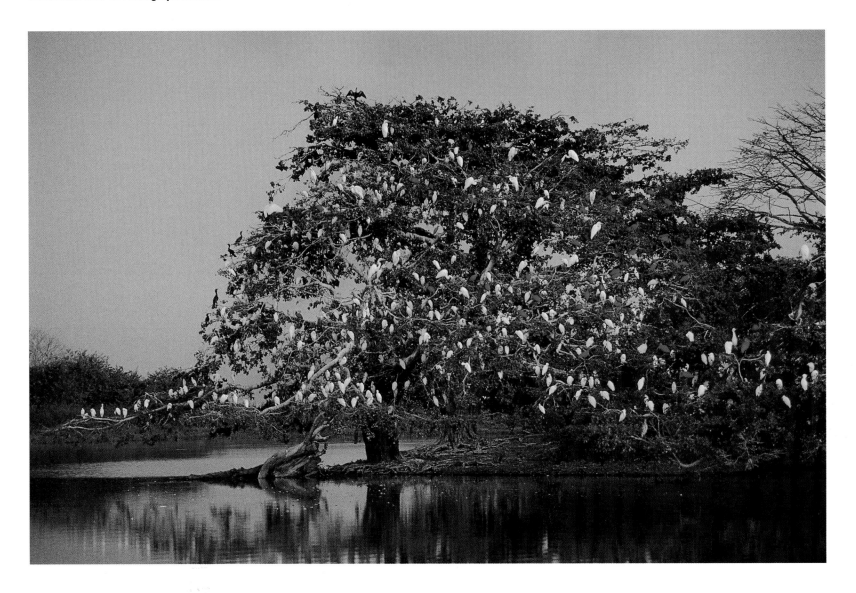

Some of the ranches offer a boat trip and this can provide the opportunity for photographing additional species. As well as the usual herons and egrets, there may be sunbittern, hoatzin and a number of kingfishers. The usual problems with shooting from boats apply, and with greater force if the boat is full of twitchers. Some ranches will also offer an excursion at night. These are always good fun and can provide nighthawks, nightjars and boat-billed herons as well as nocturnal mammals, such as crab-eating fox, and a chance of finding an anaconda. Photography will be difficult and you need to be adept at operating your gear in the dark. Even if you are, there will be times when a small torch will help to solve a problem. You can only operate within flash range, so a wide-aperture, 80–200mm zoom lens, or a 300mm, will be the biggest lens required.

Scarlet ibis fly in to roost with cattle egret as it is getting dark
Nikon F4 with 80–200mm lens, Kodak Elite 100, 1/30sec at f/2.8

Sunbittern
*Nikon F4 with 300mm lens, Kodachrome 200,
1/125sec at f/8*

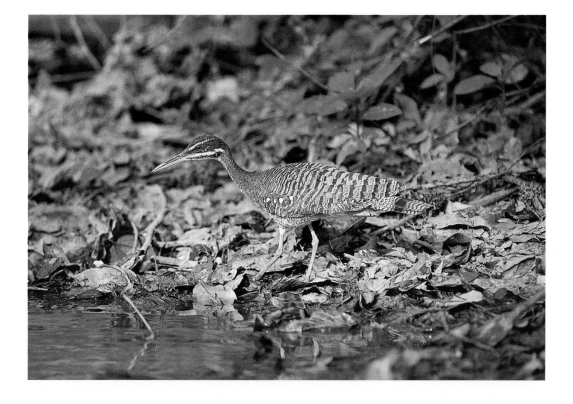

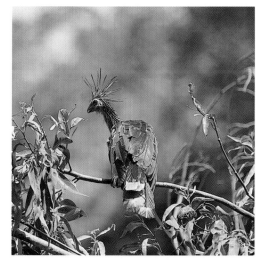

Hoatzins frequent the trees overhanging the rivers
*Nikon F4 with 400mm lens, Kodachrome 200,
1/250sec at f/5.6*

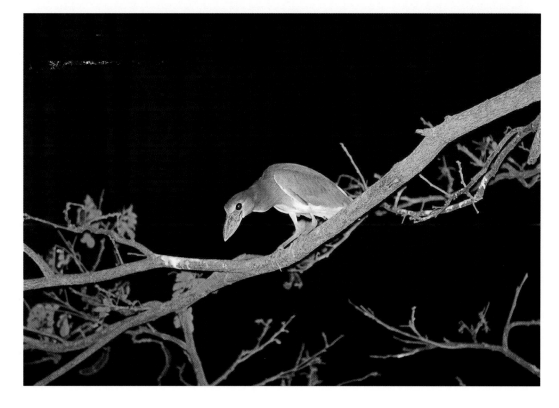

**Boat-billed herons are nocturnal. Long lenses are
usually too clumsy for this work and you have to keep
within the range of your flash. (Taken hand-held)**
*Nikon F4 with 300mm lens, Kodachrome 200, 1/250sec
at f/5.6, SB24 flash gun on TTL*

Brazil

There are many international flights into Brazil, mainly to Rio or Sao Paulo, and onward flights to the interior. The roads are of mixed quality (though 4WD may not be needed) and car hire is fairly expensive. If you do hire a car in Brazil, be prepared to bargain as the price may be negotiable. There is a definite language problem. In the countryside you certainly shouldn't bank on finding anyone who speaks English, and I have been told that conversing in Portuguese is a bit like talking to a Yorkshire farmer in England. Even where the words are the same (and they often aren't) the pronunciation may be quite different. Hence, going with a tour party is a good idea, unless you can muster someone with Portuguese, and preferably the South American version of it. You must consider protection against malaria and yellow fever.

Amazonas

There are some good lodges in Amazonas, but reaching them will probably require two internal flights, a road journey and a boat. Agencies in Brazil can fix these for you and the arrangements will probably work well, though a confirmed flight does not always mean you will get on the plane. The Amazonian rainforest holds vast numbers of bird species, not to mention mammals and the smaller creatures. Given time and some knowledge of the calls, you will see plenty of birds, but you won't photograph many of them. Most are high up in the trees, so they are distant and hidden among the leaves. The light in the forest is poor, even when the sun is shining, so flash will be needed. The birds can be surprisingly difficult to attract with food and they have plenty of water. The forest mammals and some of the birds are attracted to clay licks, patches of mud that contain minerals or material that neutralizes toxins in their food. If your

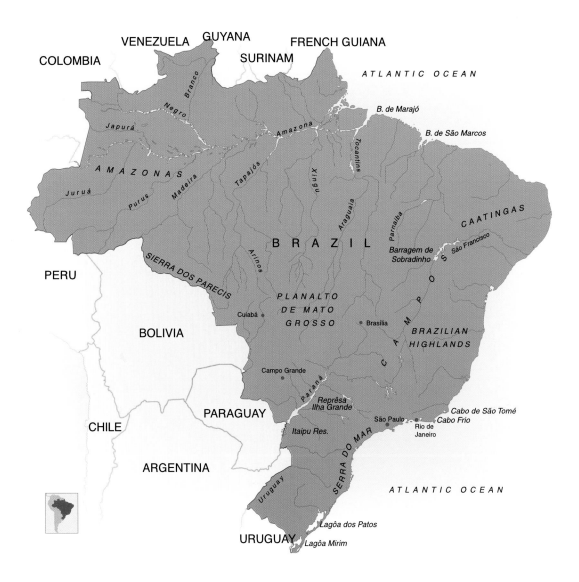

Red-throated piping guan
*Nikon F5 with 300mm lens and 2✕ extender, Fuji Sensia
100 uprated to ISO 200, 1/200sec at f/5.6*

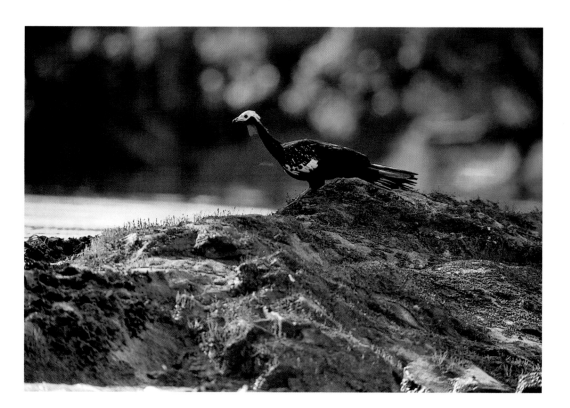

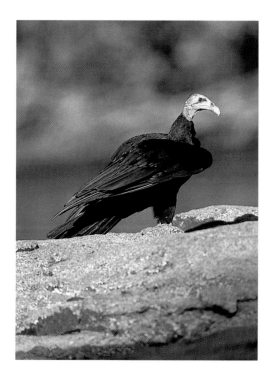

Greater yellow-headed vulture
*Nikon F5 with 300mm lens and 2✕ extender, Fuji Sensia
100 uprated to ISO 200, 1/400sec at f/5.6*

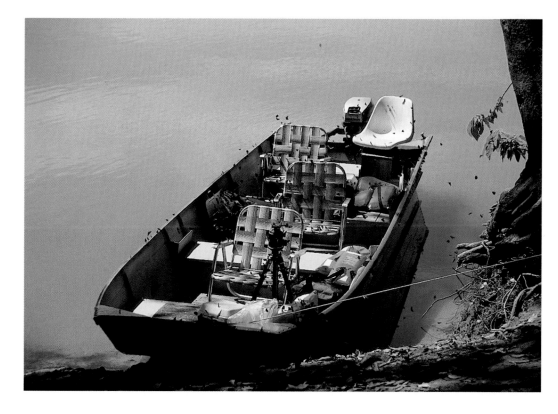

**Two photographers to a boat are plenty, bearing in
mind that there will also be a boatman and possibly
a guide as well. Most of the butterflies leave once
you are mid-river**
*Nikon F5 with 28–105mm lens, Fuji Sensia 100 uprated
to ISO 200, 1/125sec at f/11*

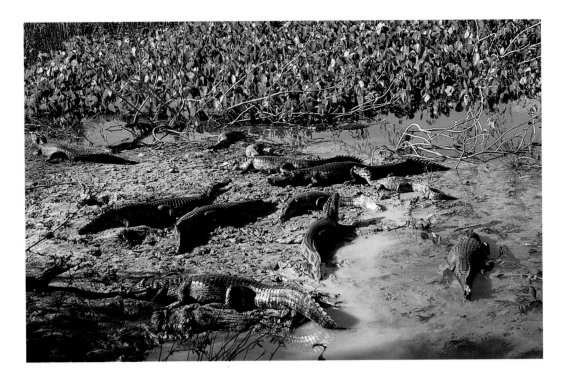

As the water levels fall, the remaining pools become packed with spectacled caimans ▲
Nikon F5 with 28–105mm lens, Fuji Sensia 100 uprated to ISO 200, 1/60sec at f/11

Spectacled caimans also occupy the rivers ▼
Nikon F5 with 300mm lens and 2✕ extender, Fuji Sensia 100 uprated to ISO 200, 1/250sec at f/8

lodge has a permanent hide above one of these, it might keep your scent away from the animals and give you a chance, though most of them are shy. Remember that there may be jaguars around.

The alternative is to take to the rivers, of which there are many, and your lodge will have boats and boatmen. Along the banks the light is good, though the birds and animals may still be in shadow. Depending on how full the river is at the time, there may be rocky islands with occasional birds on them, or bigger sandy ones on which they can feed and you can land. Capybaras and peccaries may visit the water's edge, as may jaguars, very occasionally. If there is a clay lick adjacent to the river, you should obviously keep an eye on it. There will be a good chance of giant otters swimming around. Butterflies drink from the damp soil at the river's edge, sometimes in their millions. You can

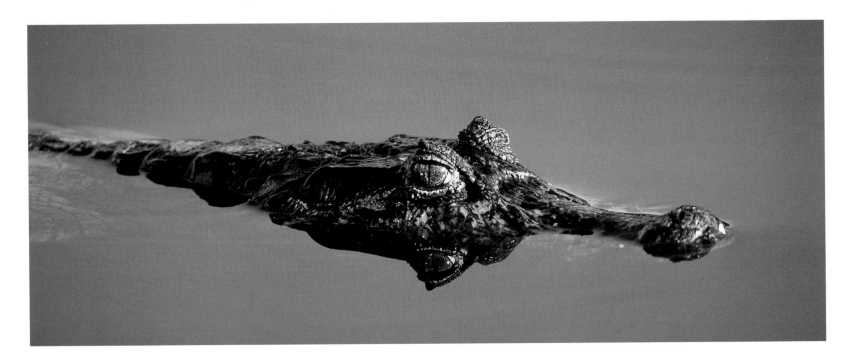

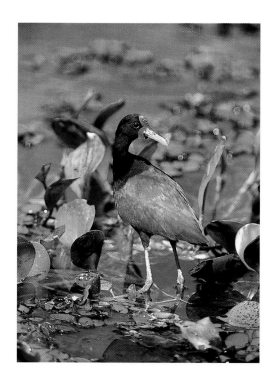

Wattled jacana
Nikon F5 with 300mm lens and 2× extender, Fuji Sensia 100 uprated to ISO 200, 1/250sec at f/8

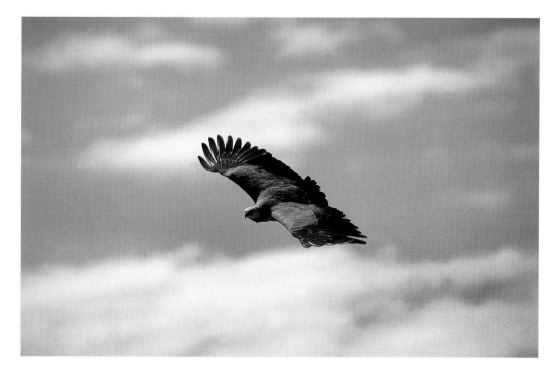

Black-collared hawks are fish eaters and frequent rivers as well as pools ▲
Nikon F5 with 80–200mm lens and 2× extender, Fuji Sensia 100 uprated to ISO 200, 1/400sec at f/5.6

Snail kites are common and can be photographed from the Transpantaneiro ▼
Nikon F5 with 300mm lens and 2× extender, Fuji Sensia 100 uprated to ISO 200, 1/250sec at f/5.6

land and use a macro lens for close-ups of them or use a short zoom for mass gatherings. If there is space in the boat, you can set up a tripod and use a big lens to get the birds and mammals, but the currents are quite strong and it is difficult to hold the boat steady enough to line up a subject, focus and shoot. If your automatic focusing mechanism is baffled, switch to manual. Alternatively, you can hand-hold with a 400mm lens; this gives greater flexibility at the expense of image size and a serious risk of camera shake – as most birds will be up in the trees – but it does have the advantage of giving a sporting chance of shooting any birds, such as parrots and macaws, which fly over. However you work, you have to be prepared to accept that each day will bring only a few opportunities and you can easily miss most of them.

The Pantanal

Photography in the Pantanal is much easier. This is a large, flat area of grazing land, flooded in the wet season, which becomes baked hard in the dry, like the llanos of Venezuela. You can fly from Sao Paulo to Campo Grande or Cuiabá and drive from there. A map is useful as there are few signposts. There are innumerable wooden bridges to cross. They look extremely doubtful propositions, but they take much heavier vehicles than yours, so press on. The roads are not good, but they don't demand 4WD in the dry. If you

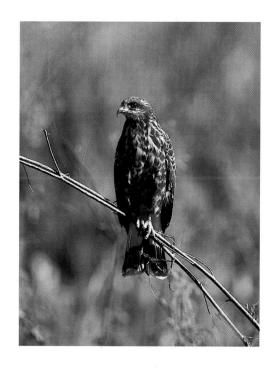

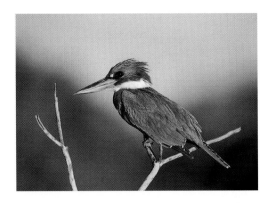

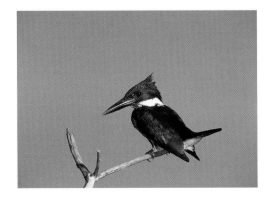

Ringed kingfisher. This is the biggest of the four kingfishers found in Brazil ▲
Nikon F5 with 300mm lens and 2✕ extender, Fuji Sensia 100 uprated to ISO 200, 1/200sec at f/8

Amazon kingfisher ▲
Nikon F5 with 300mm lens and 2✕ extender, Fuji Sensia 100 uprated to ISO 200, 1/200sec at f/8

Cattle egrets ▼
Nikon F5 with 80–200mm lens, Fuji Sensia 100 uprated to ISO 200, 1/250sec at f/8

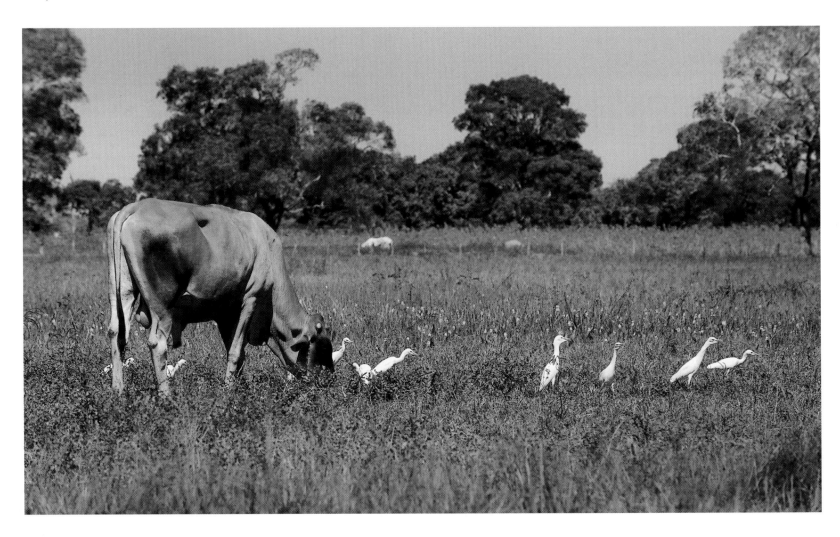

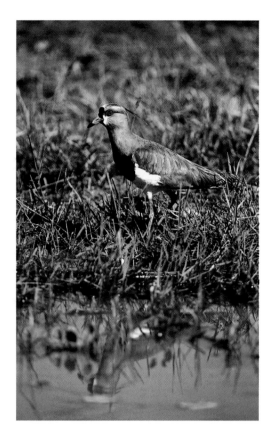

Southern lapwing
Nikon F5 with 300mm lens and 2✕ extender, Fuji Sensia 100 uprated to ISO 200, 1/250sec at f/8

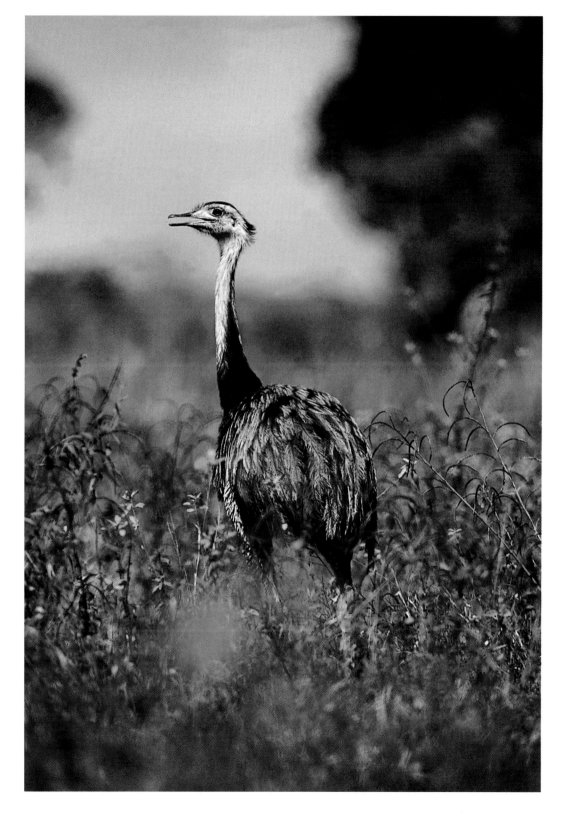

Greater rheas feed on open grassland
Nikon F5 with 300mm lens and 2✕ extender, Fuji Sensia 100 uprated to ISO 200, 1/500sec at f/5.6

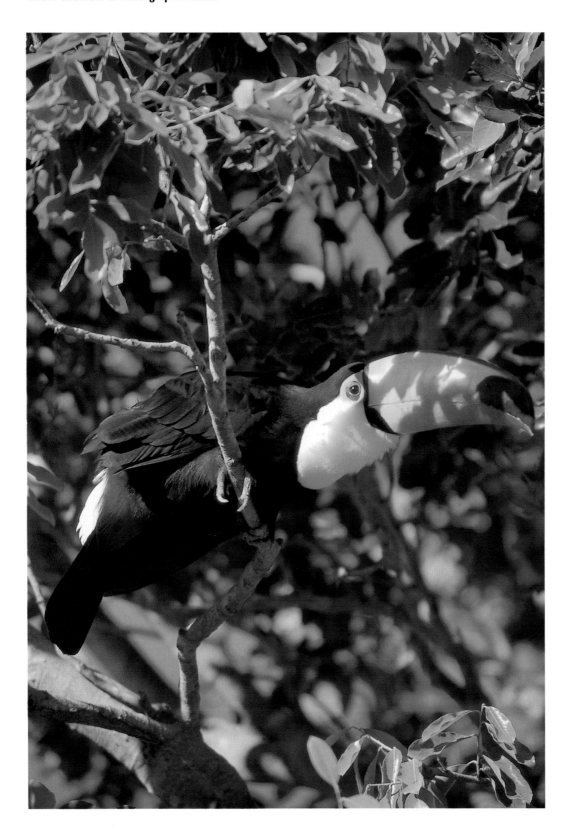

Hyacinthine macaw
Nikon F5 with 300mm lens and 2✕ extender, Fuji Sensia 100 uprated to ISO 200, 1/100sec at f/5.6

Toco toucan
Nikon F5 with 80–200mm lens and 2✕ extender, Fuji Sensia 100 uprated to ISO 200, 1/125sec at f/8

intend to go off-road, get a vehicle that can cope. There are several farms that will accommodate and feed you, and a few hotels. If you go when the flood is drying up, typically from May to June, there will probably be plenty of birds on and around the remaining water, though the seasons do vary a bit. Photography from a vehicle is a good option. It can even be done from the main road across the Pantanal, the Transpantaneiro, as there is very little traffic and there are patches of wetland at the roadside. With a 4WD, and permission to cross farmland, you can do even better. The wildlife is similar to that in the llanos, with capybaras, ducks, ibises, herons, jacanas etc. Snail kites and black-collared hawks are common and there are spectacled caimans by the hundred. Locally, these are sometimes called alligators, but the nearest true alligator is 1000 miles (1600km) away. Caimans are not as big as alligators and generally not as aggressive. There will be cattle egrets and possibly other birds following the farm animals in order to pick up the insects they disturb, and black vultures to deal with any casualties. A hide erected at a carcass would provide good opportunities, but take some drink, as it will be hot. Around the farmhouses expect small birds, such as saffron finches and red-crested cardinals. They can be baited to a suitable perch. There may be bigger ones as well, like

purplish jay, the kingbird group, and possibly crested caracara. The speciality of the area is the magnificent hyacinthine macaw. There are quite a few of them, but their distribution is patchy and you need to obtain access to one of the farms where they occur and are protected. They spend much time in deep shade, so you must either be patient and wait for them to emerge or use flash. As the trees are quite big, you will need a condenser on the flash to concentrate the light.

Bare-faced curassow
Nikon F5 with 80–200mm lens, Fuji Sensia 100 uprated to ISO 200, 1/250sec at f/8

Where to now?

The areas covered in this book represent the ones which seem to me to offer the best prospects in relation to species, cost, comfort and photographic reward. They could satisfy a lifetime of travel, but you may still want to move on. If so, consider, for a start, some other areas in the countries I have covered, such as the Pilanesberg National Park in South Africa, coastal Namibia, and Tasmania and Kakadu in Australia. Southern India has some nice parks that are not yet on the tourist route. If you want one-horned rhino, Chitwan in Nepal is an alternative to Kaziranga. North America has dozens of places – think of Texas, Yellowstone, Arizona, the Great Salt Lake area, the coast of California and Churchill for starters. Brazil and Venezuela are massive countries and I have only considered two sections of each. The Seychelles offer pleasant working conditions and a good variety of obliging birds.

There are other countries that are easily reached, but rather unsettled or disorganized at present, so I have not dealt with them. Israel is excellent for birds, especially migrants around Eilat and the desert birds further north. Uganda, Zimbabwe and Zambia have a full range of big mammals, including some that are not found further south, as well as birds. Angola is still too risky, but Ethiopia may be possible and Mozambique is recommended by the South Africans who visit there, especially for underwater work.

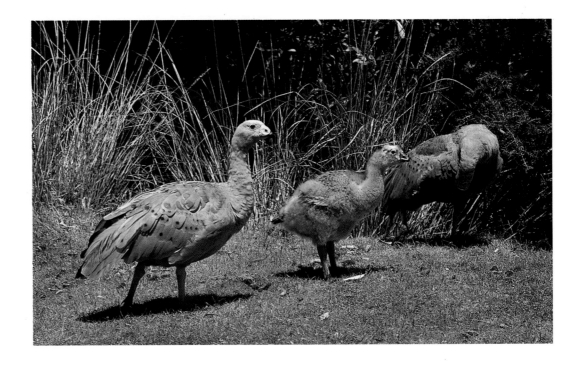

Cereopsis goose, Tasmania
Nikon F5 with 80–200mm lens and 2X extender, Fuji Sensia 100, 1/125sec at f/11

Wombat, Tasmania
Nikon F5 with 28–105mm lens, Kodachrome 64, 1/250sec at f/11, SB24 flash gun

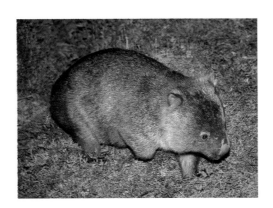

Hoopoe, Israel (taken from a vehicle)
Nikon F4 witih 400mm lens, Kodachrome 64, 1/250sec at f/8

Despite the turmoil reported in the press, these countries generally welcome visitors. Allow for a degree of disorganization in the African countries and maybe an excess of bureaucracy.

If you are prepared for a higher level of difficulty with travel and language, Madagascar has lemurs and many endemic birds, but the roads are dreadful and air travel means returning to Tana between flights. Papua New Guinea has most of the birds of paradise, but access to the more remote parts requires small planes and corresponding expense. China is becoming a top destination for twitchers, but has not made much of a hit with wildlife photographers. Vietnam is a possibility, but travel difficulties and language problems would have to be faced. The antarctic south of Chile is becoming regular tourist territory and, if you have the money and time, the islands south of New Zealand offer a whole range of different penguins and other birds, with fewer visitors.

If none of these offers the right sort of challenge, it has to be the plunge into the huge potential of South and Central America. The seas and islands of Baja California have birds and sea mammals. Costa Rica has frogs and other small creatures, as well as birds. Belize has rare herons and a horde of rainforest birds. Chile has the Andes with two species of special flamingos, condors and the giant coot, which is as big as a goose. It also has the Atacama Desert, which has its own specialities. Argentina is a huge country with corresponding potential. In all of these areas you will probably work hard for only a few decent pictures; more than elsewhere you need time to establish

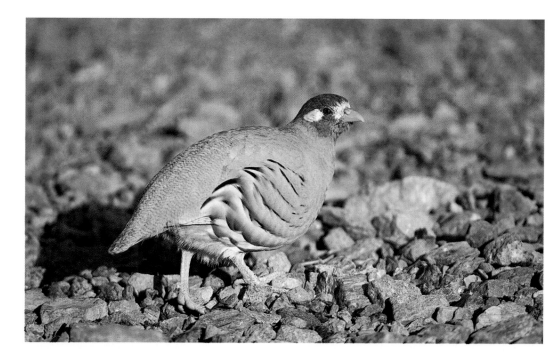

Sand partridge, Israel (partridge baited and photo taken from a hide) ▲
Nikon F4 with 400mm lens, Kodachrome 64, 1/125sec at f/8

Spotted sandgrouse, Israel (taken from a hide that was set up in the early morning, before the birds arrived to drink) ▼
Nikon F4 with 400mm lens and 1.4✕ extender, Kodachrome 64, 1/250sec at f/8

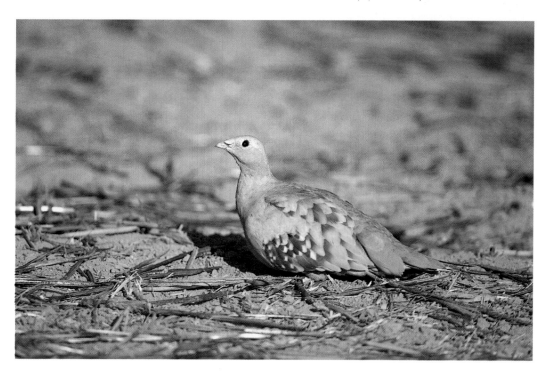

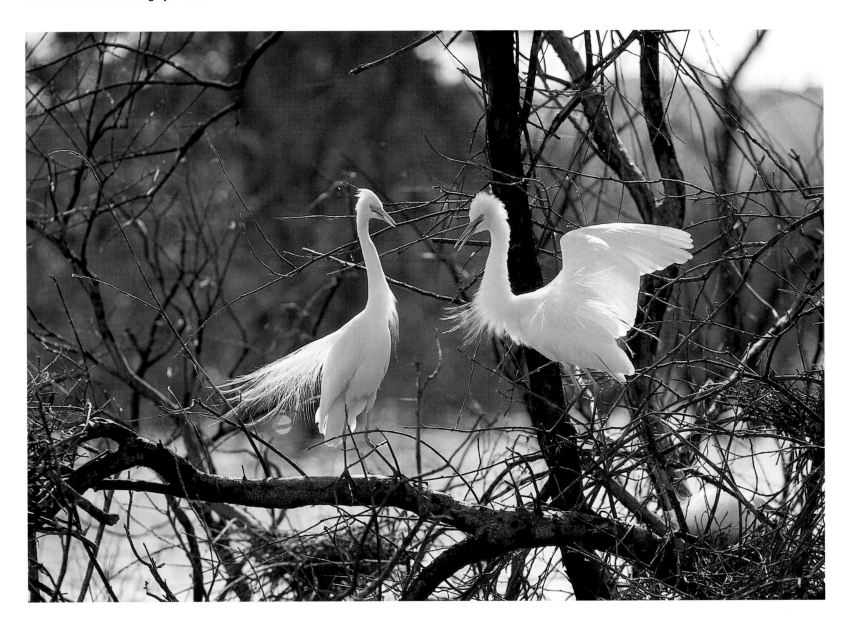

where the possibilities lie and then to tackle them. If you have been spoilt by easy pickings in Africa, you may find this hard, but the chances are there.

If you are still not satisfied, consider all the bird species I have suggested you should ignore. Little brown birds swarm in Africa, South and Central America and Southeast Asia. Many have never been photographed well, if at all; even identifying them will provide problems. Then there are all those rare species, often island species, which may become extinct before a camera records them. Perhaps you could remedy that. After that you can make a start on the bats and beetles, the hutias and hoverflies and the shrews and snails. You may run out of time, but you will never run out of subjects.

Yellow-billed egrets displaying in Zimbabwe (taken from a boat)
Nikon F5 with 300mm lens, Fuji Sensia 100, 1/250sec at f/5.6

Photographing wildlife in captivity

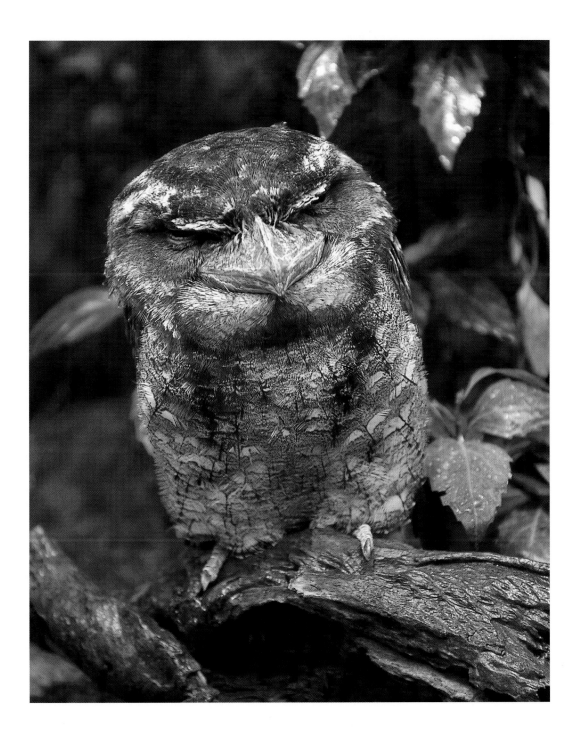

Purists may find the whole idea of photographing wildlife under controlled conditions too offensive to contemplate. However, there are times when it is the only way, even though it is very much second best. You might be surprised at how much television footage is eked out with shots of subjects taken under controlled conditions. The golden rule is that animals photographed in captivity must never be presented as wild ones.

The biggest problem – usually – is to find a background which is not so objectionable that it ruins the picture. Bars and netting simply must not appear. Shooting through netting is possible if you place your lens against it and use a wide aperture. This will also diffuse the background. Shooting through glass presents similar problems, especially when using flash, as you often must. Keeping the lens and the flash against the glass will avoid reflections, but only occasionally will you get anything really good. Modern zoos, wildfowl parks and aviaries, where there is nothing between you and the subject, are another matter. In fact, wildfowl parks are the ideal places to test out new equipment before you take it abroad. When overseas, you sometimes have to spend a day in a big town, and a trip to the local zoo or wildlife

Tawny frogmouth
Nikon F5 with 80–200mm lens, Fuji Sensia 100, 1/30sec at f/8

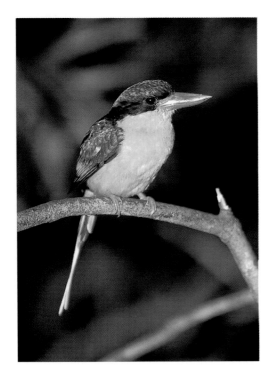

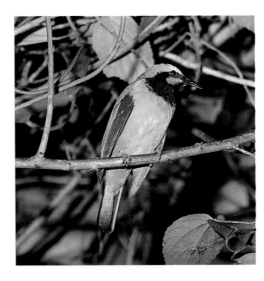

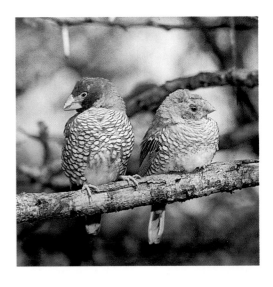

Orange-bellied leaf bird
Nikon F2 with 70–210mm lens, Kodachrome 64, 1/60sec at f/11, SB12 flash gun

Red-headed finches. Normally the light sky behind the birds would be objectionable, but with flash it doesn't look too bad
Nikon F4 with 105mm macro lens, Kodachrome 200, 1/125sec at f/11, SB24 flash gun

Buff-breasted paradise flycatcher
Nikon F5 with 80–200mm lens and 1.4✗ extender, Fuji Sensia 100, 1/250sec at f/8, SB24 flash gun

park can be a productive use of an otherwise wasted day. Zoos usually have a good showing of native species, so overseas ones will probably have more of interest than those at home.

You need take only your macro and one longer lens, preferably a medium zoom. If you find your flash gives rather harsh contrasts, fit it with a diffuser or a couple of layers of tissue. It will need the

Tasmanian devil. There is usually something which reveals that a picture has been taken in captivity. The straws in this one are a complete giveaway
Nikon F5 with 80–200mm lens, Fuji Sensia 100, 1/250sec at f/11, SB24 flash gun

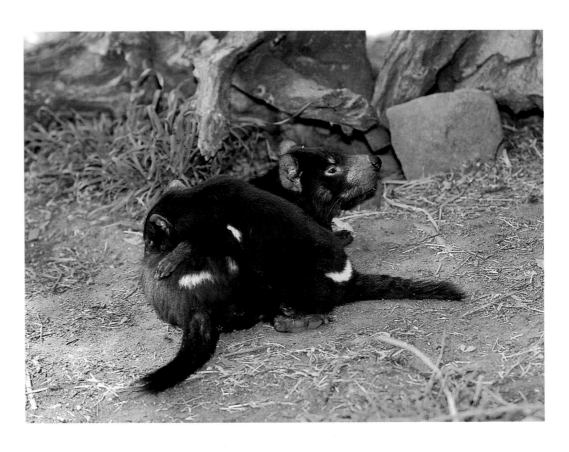

Black mamba taken behind glass, using flash
*Nikon F4 with 105mm macro lens, Kodachrome 64,
1/125sec at f/16, SB24 flash gun*

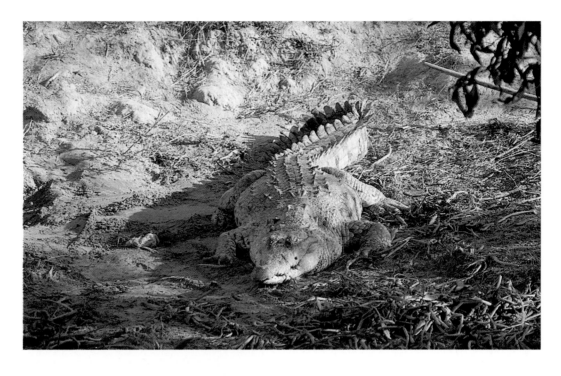

Orinoco crocodile at a captive breeding station
*Nikon F4 with 80–200mm lens, Kodachrome 64,
1/30sec at f/16*

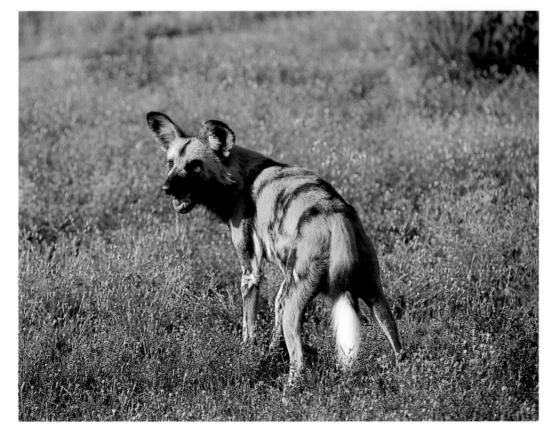

usual 81A or 81B filter. Try some indoor tests at one of the tropical houses, but give the lens time to de-mist before you get to work. There are usually only a few places where you can get rid of the background, and it is best to wait at these until a subject arrives. Butterfly houses provide an abundance of subjects, but they are too easy to provide much of a test.

If you are still contemptuous of such photography, take a look at Brian Coates' amazing two volumes, *The Birds of Papua New Guinea*. Where photography in the wild was impossible, he set up a studio and photographed in that. The results speak for themselves.

This African wild dog was one of a captive breeding group. I photographed it at feeding time, sitting on the front of the Land Rover. My feet were at dog height and the animals were curious, but not aggressive
*Nikon F5 with 80–200mm lens, Fuji Sensia 100,
1/125sec at f/11*

About the author

Peter Evans acquired his first serious camera, a 5 × 4 Gandolfi, in the 1950s. Almost all nature photography at this time was in black-and-white, but once Agfa started to produce good-quality colour material in roll-film format, he adopted this as his main medium.

He exhibited 6 × 6 transparencies widely, earning a silver medal from the Photographic Society of America. He then spent 10 years working with cine before he bought the first of a succession of Nikon cameras and began concentrating on producing 35mm colour transparencies.

Peter has travelled and photographed widely throughout the world, and his photographs are marketed by the Bruce Coleman Agency.

General index

Index of wildlife

Pages in **bold** include illustrations

Index of place names